PATTERNS OF INTENTION

On the Historical Explanation of Pictures

MICHAEL BAXANDALL

YALE UNIVERSITY PRESS
NEW HAVEN AND LONDON

Colour illustrations originated by
Amilcare Pizzi, s.p.a., Milan.

Filmset in Monophoto Garamond
and printed in Great Britain by
Jolly & Barber Ltd, Rugby, Warwickshire.

Library of Congress Catalog Card Number: 85–6049
ISBN 0–300–034565–2

PREFACE

THIS BOOK is a revised version of a series of Una's Lectures in the Humanities — lectures endowed in memory of Una Smith Ross — given at the University of California, Berkeley, in April 1982. My draft for the lectures was longer than would have been decent actually to deliver in the lecture-room: I have restored here a number of sections which I then cut, but I have not tried to modify or disguise the informality of the spoken argument.

The lectures addressed a question: If we offer a statement about the causes of a picture, what is the nature and basis of the statement? More particularly, if we think or speak of a picture as, among other things, the product of situated volition or intention, what is it that we are doing? So the question is, within limits, one about the historical explanation of pictures, though I more often speak of 'inferential criticism' of pictures because this corresponds better with the balance of my interest in the activity.

The Introduction sketches three characteristics of language that set preliminary conditions for the criticism and explanation of pictures. The problem here is the interposition of words and concepts between explanation and object of explanation. This interests me more than it seems to interest other people and many readers may wish to skip it and start at Chapter I, though I would prefer they glance at least at the short summary in section 5 of the Introduction.

Chapter I is an attempt to place the sort of thinking we do when we think in an everyday way about the causes of a complex artefact being as it is. To postpone and also accent some of the special problems of pictures, the object examined is not a picture but a bridge. A simple pattern of explanation is sketched and then the question is put of what, in the interest of a picture, this pattern most fails to accommodate.

Chapter II goes on to tackle the special problems of explaining pictures by adapting and elaborating the pattern that emerged

from Chapter I to accommodate the case of Picasso's *Portrait of Kahnweiler* 'as it is presented in the standard accounts'. I do not attempt a close or novel account of this picture; the point is to take an example from an episode in art history, early Cubism, familiar to most people. Topics successively touched on include how we describe the painter's aims, how we consider for critical purposes his relation to his culture, how we deal with his relation to other painters, and whether we can accommodate within our account the element of process or progressive self-revision involved in painting a picture.

Chapter III, an enquiry into the relation of eighteenth-century theory of visual perception to Chardin's *A Lady Taking Tea*, has several functions in the argument of the book. One is to broach the difficult problem, skated over in II, of the relation of pictures to the systematic ideas of their time. Another is to lay out a detailed piece of explanation in such a form that it is open to the reader's questioning. The detailed texture and close focus are therefore different from the rest of the book.

Chapter IV, which works to Piero della Francesca's *Baptism of Christ*, addresses two outstanding issues. The first is the issue of our relation to intentional movements of mind in another culture or period: what are we doing when we think about the intention of a picture by Piero della Francesca, a man whose mind thought with the equipment of a culture different from ours? The second is the issue of what self-critical criteria we use for assessing the relative validity of explanatory or inferential criticism.

The book, I must insist, does not urge causal explanation as the course for art criticism or art history. It seems to me absurd to claim that there is a proper way to look at pictures. Rather, the book supposes that one of a number of unforced and, as it happens, unavoidable ways in which we think of pictures is as products of purposeful activity, and therefore caused. (I do not feel it necessary to argue the point that such causal thinking about pictures is unforced and unavoidable; if I did feel it necessary to do so, one of the grounds I would start from comes up in section 3 of the Introduction.) However, once we start inferring causes and intention in a picture we are doing something that is obviously very precarious indeed, and the reflective inferrer is likely to worry about the status of his inferences. In short, we are going to do it anyway, but what is it that we will be doing?

As soon as one starts thinking about that, one finds oneself awkwardly or at least tangentially aligned in relation to a number of sophisticated running debates. The most obvious and threatening of these is the debate, conducted mainly in the context of literature, about whether reconstruction of the maker's intention is a proper part of interpretation of a work of art. If one believes one cannot exclude causal inference from one's thinking anyway, the issue is inconveniently framed and is not, as an issue, pressing. I have tried to keep a little distance between myself and this debate: in particular, in II.1 I try briefly to differentiate between the postulating of purposefulness that concerns me and the Intentionalists' 'authorial intention'. In general I have preferred the universe of historical explanation to that of literary hermeneutics as a medium for these reflections: if I do not speak of 'meaning' in pictures that is deliberate. But mass attracts, and the proportions of the Intention debate are bound to perturb my course. For one thing, I have learned from the arguments and this is registered in references I give. For another, I am aware that any book called *Patterns of Intention* — a title in which the multiple puns (I count three or four) are important to me — will be placed in a relation to the debate. I would quite like to pre-empt this placing and label my position as one of naïve but sceptical intentionalism.

The scepticism, like the naïvety, is fundamental and programmatic: its basis is most explicit in the Introduction, in I.5, in II.8 and in IV.2 and 5. However, I would claim that it is also an affirming and cheerful scepticism: it is the impossibility of firm knowledge that gives inferential criticism its edge and point. I try to suggest this, finally, in IV.9.

But to the extent that the book carries an argument, it is an argument from the pressure of sustained examples rather than from sustained ratiocination, for which I am not equipped. The fact that I intermittently try to steal fragments of ideas from rigorous thinkers should not obscure this: that is opportunist and the ideas are discrete. The useful role for historians bent on reflection seems to me not to offer loose prescriptive generalisation under the description of 'theory' but rather to test quite simple positions against cases as complex as time and energy permit. The role is not imitative of the methodologists but complementary.

So what this book is primarily concerned with is criticism, which I take in the unclassical sense of thinking and saying about particular

pictures things apt to sharpen our legitimate satisfactions in them. And it is concerned with just one element in criticism, the cause-inferring strain inherent in our thinking about pictures as about other things. Other strains (Introduction 3) are real too. There are therefore a whole lot of things the book is not about and one of these is the sociology of art: I am here concerned to situate pictures socially only to the extent that the critical ambition immediately demands. So, for instance, in II.4 I use the simple model of exchange I call *troc* for the relation of the painter to his culture rather than any of the more structured models offered by various versions of Ideology because that, I feel, is all the critic needs — and so (IV.5 and 9) can validate. If I were concerned here with the dynamics of culture, *troc* would be inadequate because, in that frame of reference, too indeterminate as a causal structure. But let me say now that when I am told that the book is inadequate as a sociology of art I shall be unmoved. Among other things the book does not address is the question of what art is, and what makes one work better than another.

* * * *

Una's lectures in the humanities are normally published by the University of California Press. The problems of book-making when thousands of miles separate publisher and author argued against this in the present case. I am grateful to Edward Hunter Ross, the Trustees of Una's Lectures, and the University of California Press for agreeing to the book being published in London.

I am grateful to the museums and libraries which supplied me with photographs and gave me permission for the reproduction of objects in their possession. I am also grateful to Eric de Maré for his photographs of the Forth Bridge, reproduced as Plates 1–6. The Photographic Collection and Studio of the Warburg Institute were particularly helpful in providing me with elusive illustrations.

Shorter versions of the book were exposed in 1982 both as lectures at the University of California at Berkeley and as seminars at Cornell University, and I had the benefit of much sharp comment. Points made by Paul Alpers, Mark Ashton, Charles Burroughs, James Cahill, Esther Gordon Dotson, Joel Fineman,

Stephen Greenblatt, Neil Hertz, Walter Michaels and Randolph Starn have particularly lodged in my mind, but many others also helped my thinking. Among those elsewhere with whom I remember discussing specific matters touched on here are Ivan Gaskell, Carlo Ginzburg, Ernst Gombrich, Charles Hope, Martin Kemp, Peter Mack, Jean-Michel Massing, John Nash, Thomas Puttfarken and Martin Warnke. But the book is intermittently about very general issues and I cannot hope to acknowledge all who have affected my thinking about those.

Svetlana Alpers read and criticized my text, and in response to her comments I made a number of changes. Michael Podro read it twice, in successive states, exposing errors of argument and taste. I owe much to his scrutiny, but also to previous discussions of the issues with him.

Finally, I am grateful to Gillian Malpass and John Nicoll of the Yale University Press for their skill and care in designing and publishing the book. It is only fair to them to state that it is at my instance that there is no index of names and also that most of the illustrations are set together at the back.

Photographic Acknowledgements

Alinari, Florence, 47, 48, 52, 53, 54, 58, 59; The Art Institute of Chicago, I, 30; Bayerische Staatsgemäldesammlungen, Alte Pinakothek, Munich, 32, 41; Clark Art Institute, Williamstown, 55; Eric de Maré, 1, 2, 3, 4, 5, 6, fig. 4; Hermitage Museum, Leningrad, 11, 13, 14, 15; Hunterian Art Gallery, University of Glasgow, II, III, 19, 36; Musée du Louvre, Paris, 37; Musée National d'Art Moderne, Paris, 16; Musée Picasso, Paris, 8, 20, 27; Museum of Art, Rhode Island School of Design, Providence, 24; Museum of Modern Art, New York, 7; National Gallery, London, IV, 26, 34, 35, 46, 50, 51, 56, 60, 61; National Gallery of Art, Washington, 25; Royal College of Physicians, Edinburgh, 43; Staatliche Museen Preussischer Kulturbesitz, Berlin, 33; Tate Gallery, London, 23; Thyssen-Bornemisza Collection, Lugano, 9; University of London Library, 44, figs. 1, 2, 3, 5, 6; Warburg Institute, University of London, 18, 29, 38, 39, 42, 45, 49, 57, figs. 7, 8, 9.

CONTENTS

INTRODUCTION:
LANGUAGE AND EXPLANATION

1. The objects of explanation:
pictures considered under descriptions

WE DO not explain pictures: we explain remarks about pictures —
or rather, we explain pictures only in so far as we have considered
them under some verbal description or specification. For instance,
if I think or say about Piero della Francesca's *Baptism of Christ*
(Pl. IV) something quite primitive like 'The firm design of this
picture is partly due to Piero della Francesca's recent training in
Florence', I am first proposing 'firm design' as a description of
one aspect of the *Baptism of Christ*'s interest. Then, secondly, I am
proposing a Florentine training as a cause of that kind of interest.
The first phase can hardly be avoided. If I simply applied 'Florentine
training' to the picture it would be unclear what I was proposing
to explain; it might be attached to angels in high-waisted gowns or
to tactile values or whatever you wished.

Every evolved explanation of a picture includes or implies an
elaborate description of that picture. The explanation of the
picture then in its turn becomes part of the larger description of
the picture, a way of describing things about it that would be
difficult to describe in another way. But though 'description' and
'explanation' interpenetrate each other, this should not distract us
from the fact that description is the mediating object of explana-
tion. The description consists of words and concepts in a relation
with the picture, and this relation is complex and sometimes
problematic. I shall limit myself to pointing — with a quite shaky
finger, since this is intricate ground beyond my competence — to
three kinds of problem explanatory art criticism seems to meet.

2. Descriptions of pictures as representations
of thought about having seen pictures

There is a problem about quite what the description is of.

'Description' covers various kinds of verbal account of a thing, and while 'firm design' is a description in one sense — as, for that matter, is 'picture' — it may be considered untypically analytical and abstract. A more straightforward and very different sort of description of a picture might seem to be this:

There was a countryside and houses of a kind appropriate to peasant country-people — some larger, some smaller. Near the cottages were straight-standing cypress trees. It was not possible to see the whole of these trees, for the houses got in the way, but their tops could be seen rising above the roofs. These trees, I dare say, offered the peasant a resting-place, with the shade of their boughs and the voices of the birds joyfully perched in them. Four men were running out of the houses, one of them calling to a lad standing near — for his right hand showed this, as if giving some instructions. Another man was turned towards the first one, as if listening to the voice of a chief. A fourth, coming a little forward from the door, holding his right hand out and carrying a stick in the other, appeared to shout something to other men toiling about a wagon. For just at that moment a wagon, fully-loaded, I cannot say whether with straw or some other burden, had left the field and was in the middle of a lane. It seemed the load had not been properly tied down. But two men were trying rather carelessly to keep it in place — one on this side, one on the other: the first was naked except for a cloth round his loins and was propping up the load with a staff; of the second one saw only the head and part of his chest, but it looked from his face as if he was holding on to the load with his hands, even though the rest of him was hidden by the cart. And as for the cart, it was not a four-wheeled one of the kind Homer spoke of, but had only two wheels: and for that reason the load was jolting about and the two dark red oxen, well-nourished and thick-necked, were much in need of helpers. A belt girded the drover's tunic to the knee and he grasped the reins in his right hand, pulling at them, and in his left hand he held a switch or stick. But he had no need to use it to make the oxen willing. He raised his voice, though, saying something encouraging to the oxen, something of a kind an ox would understand. The drover had a dog too, so as to be able to sleep himself and yet still have a sentinel. And there the dog was, running beside the oxen. This approaching wagon was near a temple: for columns indicated this, peeping over the trees. . . .

This — the greater part of a description written by the fourth-century Greek Libanius of a picture in the Council House at Antioch — works by retailing the subject-matter of the picture's representation as if it were real. It is a natural and unstrained way

of describing a representational picture, apparently less analytical and abstract than 'firm design', and one we still use. It seems calculated to enable us to visualize the picture clearly and vividly: that was the function of the literary genre of description, *ekphrasis*, in which it is a virtuoso essay. But what really is the description to be considered as representing?

It would not enable us to reproduce the picture. In spite of the lucidity with which Libanius progressively lays out its narrative elements, we could not reconstruct the picture from his description. Colour sequences, spatial relations, proportions, often left and right, and other things are lacking. What happens as we read it is surely that out of our memories, our past experience of nature and of pictures, we construct something — it is hard to say what — in our minds, and this something he stimulates us to produce feels a little like having seen a picture consistent with his description. If we all now drew our visualizations — if that is what they are — of what Libanius has described, they would differ according to our different prior experience, particularly according to which painters it made us think of, and according to our individual constructive dispositions. In fact, language is not very well equipped to offer a notation of a particular picture. It is a generalizing tool. Again, the repertory of concepts it offers for describing a plane surface bearing an array of subtly differentiated and ordered shapes and colours is rather crude and remote. Again, there is an awkwardness, at least, about dealing with a simultaneously available field — which is what a picture is — in a medium as temporally linear as language: for instance, it is difficult to avoid tendentious re-ordering of the picture simply by mentioning one thing before another.

But if a picture is simultaneously available in its entirety, *looking* at a picture is as temporally linear as language. Does or might a description of a picture reproduce the act of looking at a picture? The lack of fit here is formally obvious in an incompatibility between the gait of scanning a picture and the gait of ordered words and concepts. (It may help to be clear about how our optical act is paced. When addressing a picture we get a first general sense of a whole very quickly, but this is imprecise; and, since vision is clearest and sharpest on the foveal axis of vision, we move the eye over the picture, scanning it with a succession of rapid fixations. The gait of the eye, in fact, changes in the course of

inspecting an object. At first, while we are getting our bearings, it moves not only more quickly but more widely; presently it settles down to movements at a rate of something like four or five a second and shifts of something like three to five degrees — this offering the overlap of effective vision that enables coherence of registration.) Suppose the picture in Antioch were present to us as Libanius delivered his *ekphrasis*, how would the description and our optical act get along together? The description would surely be an elephantine nuisance, lumbering along at a rate of something less than a syllable an eye-movement, coming first, sometimes after half a minute, to things we had roughly registered in the first couple of seconds and made a number of more attentive visits to since. Obviously the optical act of scanning is not all there is to looking: we use our minds and our minds use concepts. But the fact remains that the progression involved in perceiving a picture is not like the progression involved in Libanius's verbal description. Within the first second or so of looking we have a sort of impression of the whole field of a picture. What follows is sharpening of detail, noting of relations, perception of orders, and so on, the sequence of optical scanning being influenced both by general scanning habits and by particular cues in the picture acting on our attention.

It would be tedious to go on in this fussy way to the other things the description cannot primarily be about, because it will be clear by now what I am trying to suggest this is best considered as representing. In fact, there are two peculiarities in Libanius's *ekphrasis* which sensitively register what I have in mind. The first is that it is written in the past tense — an acute critical move that has unfortunately fallen out of use. The second is that Libanius is freely and openly using his mind: 'These trees, *I dare say*, offered ...'; '*It seemed* the load had not been properly tied down ...'; 'only two wheels: and *for that reason* ...'; 'one saw only the head and part of the chest, but *it looked* from his face *as if* he was ...'; 'columns *indicated* this, peeping over the trees. ...' Past tense and cerebration: what a description will tend to represent best is thought after seeing a picture.

In fact, Libanius's description of subject-matter is not the sort of description one is typically involved with when explaining pictures: I used it partly to avoid a charge of taking 'description' in a tendentiously technical sense, partly to let a point or two

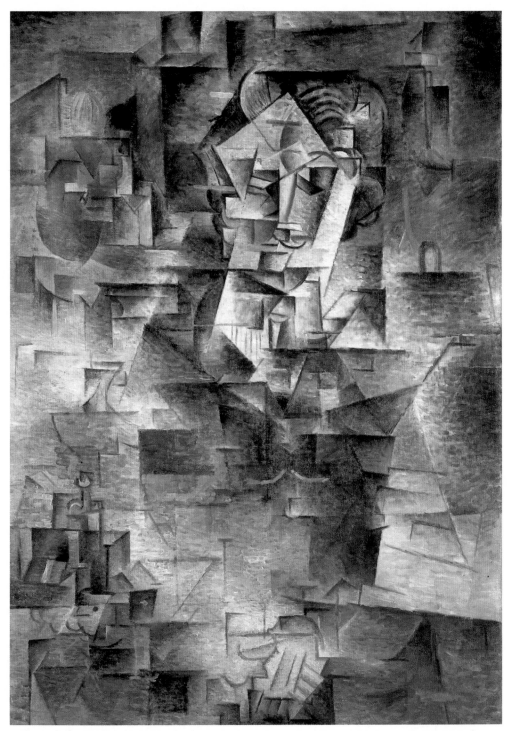

I. Picasso, *Portrait of Daniel-Henry Kahnweiler*. Oil on canvas, 1910. The Art Institute of Chicago, bequest of Mrs. Gilbert Champion.

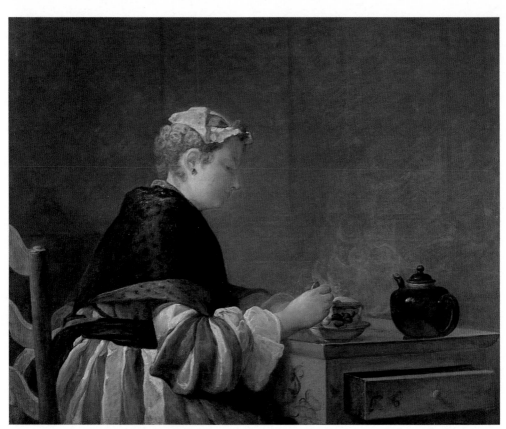

II. Chardin, *A Lady Taking Tea*. Oil on canvas, 1735. Hunterian Art Gallery, University of Glasgow.

III. Chardin, *A Lady Taking Tea* (detail).

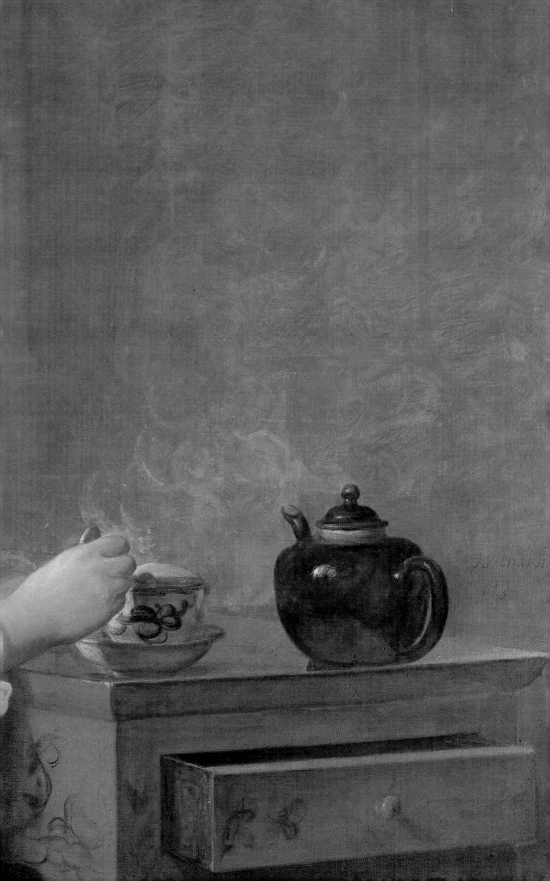

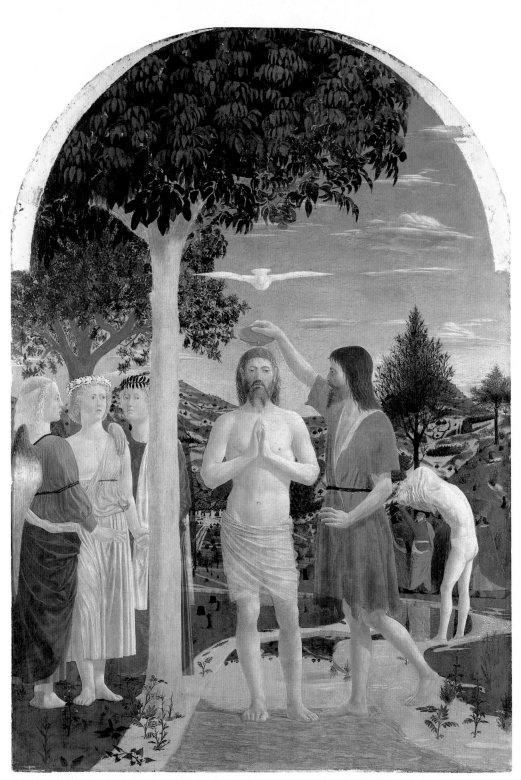

IV. Piero della Francesca, *Baptism of Christ*. Panel, about 1440–50. National Gallery, London.

emerge. The sort of description I shall be concerned with is much more like 'The design is firm', and it too can be linearly quite long. Here is an excellent passage from Kenneth Clark's account of Piero della Francesca's *Baptism of Christ*, in which he develops an analysis of a quality which might be one constituent of 'firm design':

… we are at once conscious of a geometric framework; and a few seconds' analysis shows us that it is divided into thirds horizontally, and into quarters vertically. The horizontal divisions come, of course, on the line of the Dove's wings and the line of angels' hands, Christ's loin-cloth and the Baptist's left hand; the vertical divisions are the pink angel's columnar drapery, the central line of the Christ and the back of St. John. These divisions form a central square, which is again divided into thirds and quarters, and a triangle drawn within this square, having its apex at the Dove and its base at the lower horizontal, gives the central motive of the design.

Here it is clearer than with Libanius's description that the words are representing less the picture than thought after seeing the picture.

There is much to be said, if one wants to match words and concepts with the visual interest of pictures, for both being and making clear — as Libanius and Kenneth Clark make clear — that what one offers in a description is a representation of thinking about a picture more than a representation of a picture. And to say we 'explain a picture as covered by a description' can conveniently be seen as another way of saying that we explain, first, thoughts we have had about the picture, and only secondarily the picture.

3. Three kinds of descriptive word

'… *about* the picture' is the proper way to put it. The second area of problem is that so many of the thoughts we will want to explain are indirect, in the sense that they are not pointed quite directly at the picture — considered, at least, as a physical object (which is not how, in the end, we will consider it). Most of the better things we can think or say about pictures stand in a slightly peripheral relation to the picture itself. This can be illustrated by taking and sorting a few words from Kenneth Clark's pages on Piero's *Baptism of Christ*:

COMPARISON WORDS
resonance (of colours)
columnar (drapery)
scaffolding (of proportion)

CAUSE WORDS		EFFECT WORDS
assured handling		poignant
(frugal) palette	THE	enchanting
excited (blots and	PICTURE	surprising
scribbles)		

CAUSE WORDS ⟶ THE PICTURE ⟶ EFFECT WORDS

One type of term, those on the right, refers to the effect of the picture on the beholder: *poignant* and so on. And indeed it is usually precisely the effect of the picture we are really concerned with: it has to be. But terms of this type tend to be a little soft and we sometimes frame our sense of the effect in secondarily indirect ways. One way is by making a comparison, often by metaphor, as in the type at the top: *resonance* of colour and so on. (One especially bulky sort of comparison, which we tend to work very hard with representational paintings, is to refer to the colours and patterns on the picture surface as if they were the things they are representing, as in Libanius.) And then there is a third type, that on the left. Here we describe the effect of the picture on us by telling of inferences we have made about the action or process that might have led to the picture being as it is: assured *handling*, of a frugal *palette*, *excited* blots and scribbles. Awareness that the picture's having an effect on us is the product of human action seems to lie deep in our thinking and talking about pictures — so the arrows in the diagram — and what we are doing when we attempt a historical explanation of a picture is to try developing this kind of thought.

We have to use concepts of these indirect or peripheral kinds. If we confined ourselves to terms that referred directly or centrally to the physical object we would be confined to concepts like *large*, *flat*, *pigments on a panel*, *red and yellow and blue* (though there are complications about these), perhaps *image*. We would find it hard to locate the sort of interest the picture really has for us. We talk and think 'off' the object rather as an astronomer looks 'off' a star, because acuity or sharpness are greater away from the centre. And the three principal indirect moods of our language — speaking directly of the effect on us, making comparisons with things whose effect on us is of a similar quality, making inferences about

the process which would produce an object having such an effect on us — seem to correspond to three modes of thinking about a picture, which we treat as something more than a physical object. Implicitly we treat it as something with a history of making by a painter and a reality of reception by beholders.

Of course, as soon as such concepts become part of a larger pattern, sustained thinking or sustained discourse — over a couple of pages in a book in this case — things become more complicated and less crisp. One type of thinking is subordinated to another in the hierarchy of syntax. Ambiguities or conflations of type develop, between the inferential and the comparative, in particular. There are shifts in the actual reference of terms. All this can be seen happening in the passage from Kenneth Clark on p.5. But an indirectness of mood and thought remains in a complex weave. And when I applied the thought 'firm design' to the *Baptism of Christ* it was a thought that involved an inference about cause. It described the picture by speculating about the quality of the process that led to it being an object of a kind to make that impression on me that it does. 'Firm design' would go on the left-hand side of the diagram. In fact, I was deriving one cause of the picture, 'firm design', from another less proximate cause, 'Florentine training'.

But it may be objected that to say that a concept like 'design' involves an element of inference about cause begs various questions about the actual operation of words. In particular, is one perhaps confusing the sense of the word, the range of its possible meanings, with its reference or denotation in the particular case? 'Design' has a rich gamut of sense:

Mental plan; scheme of attack; purpose; end in view; adaptation of means to ends; preliminary sketch for picture etc.; delineation, pattern; artistic or literary groundwork, general idea, construction, plot, faculty of evolving these, invention.

If I use the concept 'design' I do not normally use it in all these senses at once. If I used it of a picture in a more unqualified way — as in 'I do like the design of this picture' — surely I would be shedding for the moment that part of its sense that lies in the process of making the picture and referring to a quality more intrinsic to the marks on the panel — 'pattern' rather than 'drawing' or 'purposing' or 'planning'? In its finished reference this may

be so: I would be entitled to expect you to take it, for the purpose
of criticism, in that more limited sense. But in arriving at it, I and
you and the word would have been coming from the left of the
field, so to speak: there are leftist and centrist uses of 'design' in
current and frequent use, but if we pick on the centrist denotation
we have been active on the left at least to the extent of shelving its
meanings. In semantics the colouring of a word used in one sense
by other current senses is sometimes called 'reflected' meaning; in
normal language it is not powerful. A better term for what
happens with words and concepts matched with pictures — not at
all a normal use of language — might be 'rejected' meaning, and
one reason for its importance brings us to the third area of
problem.

4. The ostensivity of critical description

Absolutely 'design' and indeed 'firm' are very broad concepts. I
could plausibly say either of Piero della Francesca's *Baptism of
Christ* (Pl.IV) or of Picasso's *Portrait of Kahnweiler* (Pl.I) — 'The
design is firm'. The terms are general enough to embrace a quality
in two very different objects; and, supposing you had no idea what
the pictures looked like, they would tell you little that would
enable you to visualize the pictures. 'Design' is not a geometrical
entity like 'cube' or a precise chemical entity like 'water', and
'firm' is not a quantity expressible numerically. But in an art-
critical description one is using the terms not absolutely; one is
using them in tandem with the object, the instance. Moreover one
is using them not informatively but demonstratively. In fact, the
words and concepts one may wish to handle as a mediating
'description' of the picture are not in any normal sense descriptive.
What is determining for them is that, in art criticism or art history,
the object is present or available — really, or in reproduction, or in
memory, or (more remotely) as a rough visualization derived
from knowledge of other objects of the same class.

 This has not always been so to the degree it now is so: the
history of art criticism in the last five hundred years has seen an
accelerating shift from discourse designed to work with the object
unavailable, to discourse assuming at least a reproduced presence
of the object. In the sixteenth century Vasari assumes no more
than a generic acquaintance with most of the pictures he deals

with; in particular, his celebrated and strange descriptions are often calculated to evoke the character of works not known to the reader. By the eighteenth century an almost disabling ambivalence had developed on this point. Lessing cannily worked with an object, the Laocoon group, that most of his readers would have known, as he only did himself, from engravings or replicas. Diderot, on the other hand, nominally writing for someone not in Paris, actually seems never to be clear whether or not his reader has been to the Salon he is discussing, and this is one reason for the difficulty of his criticism. By 1800 the great Fiorillo was adding footnotes to his books specifying the makers of the best engravings after the pictures he is discussing and he tends to concentrate on what can be seen in them. In the nineteenth century books were increasingly illustrated with engravings and eventually half-tones, and with Wölfflin, notoriously, art-critical discourse begins to be directed at a pair of black-and-white diapositive projections. We now assume the presence or availability of the object, and this has great consequences for the workings of our language.

In everyday life if I offer a remark like 'The dog is big', the intention and effect will depend a great deal on whether or not that dog is present or known to my hearers. If it is not, the 'big' — which, in the context of dogs, has a limited range of meaning — is likely to be primarily a matter of information about the dog; it is big, they learn, rather than small or middle-sized. But if it is present — if it is standing before us as I talk — then 'big' is more a matter of my proposing a kind of interest to be found in the dog: it is *interestingly* big, I am suggesting. I have used 'dog' to point verbally to an object and 'big' to characterize the interest I find in it.

If I say of a picture, present or reproduced or remembered, 'The design is firm', the remark's force is rather specialized. What I am doing is not to inform, but to point to an aspect of its interest, as I see it. The act is one of demonstration: with 'design' I direct attention to one element in the picture and with 'firm' I propose a characterization of it. I am suggesting that the concept 'firm design' be matched with the interest of the picture. You may follow my prompting or not; and if you do follow my prompting you may agree or disagree.

So I am making two points here. As a verbalized proxy for the quality in Piero's *Baptism of Christ*, 'firm design' would mean little; but by its reference to the instance it takes on more precise

meaning. Since my remark about Piero's picture is an act not of information but of demonstration in its presence, its meaning is largely ostensive: that is, it depends on both myself and my hearers supplying precision to it by reciprocal reference between the word and the object. And this is the texture of the verbal 'description' that is the mediating object of any explanation we may attempt. It is an alarmingly mobile and fragile object of explanation.

However it is also excitingly flexible and alive, and our disposition to move around in the space offered by the words is an energetic and muscular one. Suppose I use of the *Baptism of Christ* this sentence: 'The design is firm because the design is firm.' This is circular nonsense, in a way, but to a surprising extent we have the will to get meaning out of people's statements. In fact, if you leave people for a minute with this sentence *and the picture*, some of them will begin to find a meaning in it — working from an assumption that if someone says something he intends a meaning, from the space within the words, and from the structural cue offered by the word 'because'. And what some of them move towards is a meaning that could be caricatured as: 'The [pattern] is firm because the [planning/drawing] is firm.' Within the gamut of senses of 'design' they find references differentiated enough to set against each other: and, working from 'because', they derive the less causally suggestive from the more causally suggestive — the more centred from the more left. At the same time they must have shaded the two appearances of 'firm' differently too.

But the present point is that the ostensive working of our terms is going to make the object of explanation odd. We explain the picture as pointed up by a selective verbal description which is primarily a representation of our thoughts about it. This description is made up of words, generalizing instruments, that are not only often indirect — inferring causes, characterizing effects, making various kinds of comparison — but take on the meaning we shall actually use only in their reciprocal relation with the picture itself, a particular. And behind this lies a will to remark on an interest in the picture.

5. Summary

If we wish to explain pictures, in the sense of expounding them in terms of their historical causes, what we actually explain seems

likely to be not the unmediated picture but the picture as con-
sidered under a partially interpretative description. This description
is an untidy and lively affair.

Firstly, the nature of language or serial conceptualization means
that the description is less a representation of the picture, or even a
representation of seeing the picture, than a representation of
thinking about having seen the picture. To put it in another way,
we address a relationship between picture and concepts.

Secondly, many of the more powerful terms in the description
will be a little indirect, in that they refer first not to the physical
picture itself but to the effect the picture has on us, or to other
things that would have a comparable effect on us, or to inferred
causes of an object that would have such an effect on us as the
picture does. The last of these is particularly to the point. On the
one hand, that such a process penetrates our language so deeply
does suggest that causal explanation cannot be avoided and so
bears thinking about. On the other, one may want to be alert to
the fact that the description which, seen schematically, will be part
of the object of explanation already embodies preemptively ex-
planatory elements — such as the concept of 'design'.

Thirdly, the description has only the most general independent
meaning and depends for such precision as it has on the presence
of the picture. It works demonstratively — we are pointing to
interest — and ostensively, taking its meaning from reciprocal
reference, a sharpening to-and-fro, between itself and the par-
ticular.

These are general facts of language that become prominent in
art criticism, a heroically exposed use of language, and they have
(it seems to me) radical implications for how one can explain
pictures — or, rather, for what it is we are doing when we follow
our instinct to attempt to explain pictures.

I

THE HISTORICAL OBJECT:
BENJAMIN BAKER'S FORTH BRIDGE

... we think we know when we know the cause ...
(Aristotle, *Posterior Analytics*)

1. The idiographic stance

ONE IMPLICATION of all this is that, given such odd objects of
explanation, the relation of the art historian to historical method is
likely to be a Bohemian one. The theory of historical explanation
has tended to divide into two camps — the nomological (or nomo-
thetic) and the teleological (or idiographic). On one side the
nomological people argue that it is possible, at least in principle,
to explain historical human actions within quite strictly causal
terms as examples covered by general laws, on the same logical
pattern as a physical scientist explain the fall of an apple. On
the other side are the teleological folk ho decline the model of
the physical sciences and argue that explanation of human
actions demands that we attend formal the actor's purposes:
we identify the ends of actions and rec truct purpose on the
basis of particular rather than general fac even while clearly if
implicitly using generalizations, soft rathe n hard ones, about
human nature and so on.

Now it might seem that the explanation picture is more
likely to feel at ease near if not in the teleologic mp, and indeed
we will not often be able to proceed with anyt g like a nomo-
logical gait: addressing a picture with a genera w feels rather
like addressing a peach with a billiard cue — the v g shape and
size of instrument, designed for movement in the w g direction.
But it seems best to be clear that this is a matter of s theoretical
dis-affinity.

We are going to *behave* in a more or less teleo. cal style
because this is the direction of our energy and interest. energy

within nomological explanation runs first towards generalization, towards identifying the general laws under which individual performances can be brought; our interest as historians or critics is more often idiographic, towards locating and understanding the peculiarities of particulars. We seek differentiating tools first; this does not mean our explanations could not be rewritten in a generalizing form. We do not know about that; we just have low-order tastes.

This goes with a further sub-theoretical restriction. Whereas the historian envisaged by many methodologists of history seems primarily concerned to explain actions or events like Caesar crossing the Rubicon or the French Revolution, we are typically concerned to explain certain material and visible deposits left behind by earlier people's activity — for this is one of the things pictures are. It will be said, the 'historian' too works with deposits from activity, physical records and documents, inscriptions and chronicles and much else, from which he must reconstruct both the actions or events he studies and their causes. This is clearly so. But his attention and explanatory duty are primarily to the actions they document, not to the documents themselves: otherwise one would say he was attending to an ancillary discipline, such as epigraphy. We by contrast, expect to attend primarily to the deposits, the pictures. We will certainly make inferences from these to the actions of man and instrument that made them as they are — these are involved in our language, in concepts like 'design' — but this will usually be as a means of thinking about their present visual character.

The difference is not sharp. Real historians study all sorts of purposeful artefacts, legal codes and constitutions; they study Polybius for his modes of explanation as well as for the historical actions he chronicles. As for the art historian, there are questions to ask about such things as how far he is concerned with pictures as objects and how far with their effects. But my purpose here is to make a rough distinction necessary to disengage us from unhelpful aspects of the method of history, and for this the broad point of difference is enough.

We cannot reconstruct the serial action, the thinking and manipulation of pigments that ended in Piero della Francesca's *Baptism of Christ*, with sufficient precision to explain it as an action. We address the finished deposit of an activity we are not in

a position to narrate. If there is an act we study it is Piero's relinquishing the *Baptism of Christ* as more or less fulfilling his purpose, and this, while assumed by us in important ways, is too artificial an object to be the centre of our attention. One is encouraged to take a stand here because there is a good symmetry between the focus of our attention and that of the actor's own purposefulness. Whereas the 'historian's' actor is purposeful more towards his action and its outcome than to its documentary appearance, our actor is purposeful relatively more towards the deposit of his activity and its effect than to the activity of hand and mind that produces it. We address a thing to which the maker's intention was attached, not a documentary by-product of activity.

The form of explanation one leans to, then, seeks to understand a finished piece of behaviour by reconstructing a purposiveness or intention in it. In fact, this *form* of explanation has been a widely sanctioned one: what is argued over is its status. Both the idealist Collingwood and the realist Popper, to drop just two names, men with divergent views on mind and induction and truth and much else involved in historical explanation, talk of the reconstruction of the process of thought — 'reflective consciousness' in the one case, 'objects of thought' in the other — aimed at solving problems in specific situations. Both see this as explanatory, not just a heuristic ploy, but they differ over its status. For Collingwood what we 're-enact' is the actor's reflection in a reconstructed situation; we do not reduplicate the important sensitive and emotional dimensions of his experience, as such, but there is a role for a sort of empathy to help cope with the fact that mind now is not what mind was in, say, the fifteenth century. For Popper we do not re-enact the actor's thought but produce an 'idealized and reasoned reconstruction' of an objective problem and objective situation on a level different from his actual reasoning; and the role of empathy is confined to 'a kind of intuitive check of the success of [the] situational analysis'. But the form, the procedural pattern of problems and situations and solutions, is common — to a degree reassuring to the sub-theorist. Since I want a low but sturdy platform to strike out from, it is this form I shall choose. One may have to adopt a position later about its status within what one actually finds oneself doing.

For the moment, then, let us say: The maker of a picture or other historical artefact is a man addressing a problem of which

his product is a finished and concrete solution. To understand it we try to reconstruct both the specific problem it was designed to solve and the specific circumstances out of which he was addressing it. This reconstruction is not identical with what he internally experienced: it will be simplified and limited to the conceptualizeable, though it will also be operating in a reciprocal relation with the picture itself, which contributes, among other things, modes of perceiving and feeling. What we are going to be dealing in are relations — relations of problems to solutions, of both to circumstances, of our conceptualized constructs to a picture covered by a description, and of a description to a picture.

This has all been rather a strain, and I now turn from a subtheoretical tack to an anti-theoretical tack, anti-theoretical in the sense that I want to turn away from the elegance of general forms to as untidy and complicated a particular case as I have time for. But the purposeful object I shall consider first will be not a picture but a bridge: this will let me both postpone and, by postponing, emphasize a number of special difficulties and peculiarities of pictures and their explanation. I shall introduce in the form of a narrative (sequential and to that extent tendentious), a selection (obviously simplistic) of twenty-four causally pregnant items of information about the railway bridge built over the Firth of Forth (Pls. 1–6 and fig. 5) in the 1880s, and then I shall make an attempt to sort them out. Then I shall consider briefly where the pattern of explanation derived from the case of the Forth Bridge most conspicuously fails to accommodate the interest of a picture like Picasso's *Portrait of Kahnweiler*. And this will settle my stance for addressing more directly, afterwards, some of the explanatory demands made by that picture.

2. *The Forth Bridge — a narrative*

Movement north-south along the east coast of Scotland has long been hindered by a succession of estuaries or firths extending deep into the mainland. In the nineteenth century the Tay and the Forth, in particular, were felt as obstacles to rapid movement between the three main centres of population on the east coast — Aberdeen, Dundee and Edinburgh — and also in the way of access to the first two of these from England. The dominant means of land transport for both people and goods in the later nineteenth

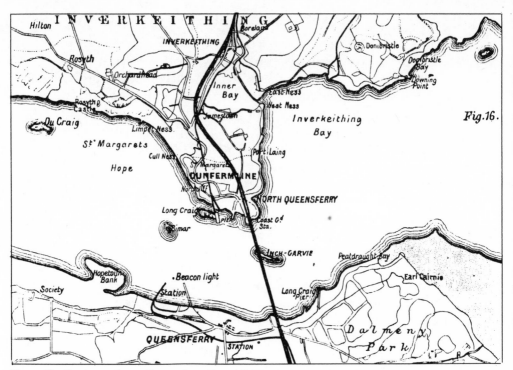

Fig. 1. The Forth crossing at Queensferry (from W. Westhofen, *The Forth Bridge*, London, 1890, p. 8).

century was the railway, and for this the long-standing means of crossing the estuaries, ferry-boats, was conspicuously disruptive, and continuity of line by means of a bridge particularly convenient. The railways in Britain were run by a fair number of regional but overlapping companies competing for traffic; it was government policy that there should be such competition, in contrast to how things were managed in, say, France. Competition for north–south and particularly English–Scottish traffic led, in the obvious context of the elongated form of Britain, to rivalry, more intense than the participants' purely commercial advantage demanded, between the companies involved in the east-coast route and those of the west-coast route. There had long been proposals for bridging the Tay and the Forth, but by the 1870s the technology of bridge-building, which had been developing quickly partly in response to the needs of railways, had advanced to a point where it was realistic to think seriously of bridging the estuaries. The North British Railway Company, on whose section of the east-coast route they lay, bridged the Tay in 1871–78 — this being much the

easier of the two because the bed of the Tay allowed fairly frequent piers and short spans. In 1873 all four of those companies who would benefit by accelerating English–Scottish traffic through east Scotland — Great Northern, North Eastern, Midland and North British — agreed to form a joint company for the much harder task of bridging the Forth.

Thomas Bouch, the designer of the Tay Bridge just finishing, presently produced a design (fig. 2) to cross the Forth at the chosen point of Queensferry, an advantageous point not just in manageable breadth but in having, roughly half-way across, a rocky islet, Inchgarvie, which was a convenient base for an intermediate pier and thus for a two-span bridge. For in contrast to the Tay, the bottom of the Forth is too silted and deep to allow foundations for frequent piers: it demands a bridge with very long spans. Besides, the Forth was a naval station with a dockyard above Queensferry and the Admiralty made stipulations about unrestricted navigation under the bridge. Bouch designed a two-span suspension bridge (three piers supporting chains which suspended the road way), and work quickly started on the central pier on Inchgarvie. At this point, 1879, the Tay Bridge blew over in an easterly gale, taking a passenger train with it. Bouch was discredited and work on his Forth Bridge ceased. What had been constructed of his central pier in the Forth now carries no more than a warning beacon.

The Forth Bridge Company next turned to two other engineers, John Fowler and Benjamin Baker. Fowler was the senior man, an accomplished organizer, and was chiefly responsible for the complex approaches to the bridge; Benjamin Baker was primarily responsible for the design and construction of the bridge proper, and I shall simplify matters by treating him as the designer, even though he was a principal rather than a soloist. Two things are particularly noticeable about Baker's background and previous career. First, he had a strong background in metal technology. His family was in the iron-founding industry and he himself had served an apprenticeship in an ironworks at Neath. He had published papers in the 1860s on the strength and resistance of metal in structural use, including one in 1867 on its use for long-span bridges — a subject on which he had developed views and ideas long before the call to the Forth. Secondly, he had something of a historical view on his art: he was interested in the work

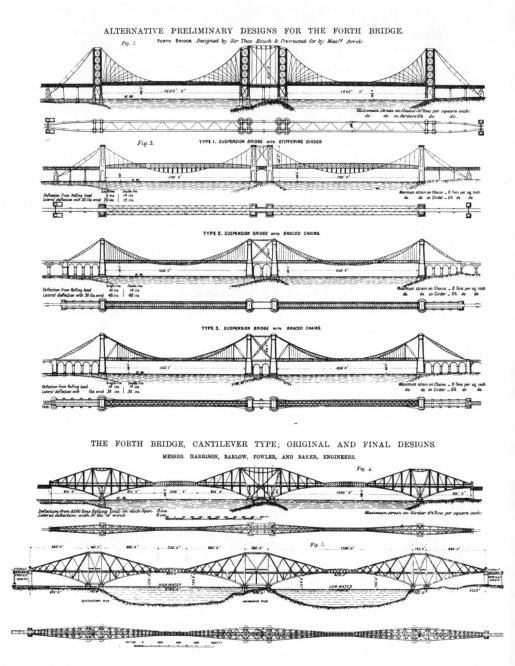

Fig. 2. Alternative projects for the Forth Bridge, including (top) Thomas Bouch's proposal and (bottom two) Baker and Barlow's first and revised plans (from W. Westhofen, *The Forth Bridge*, London, 1890, pp. 4–5).

of past engineers and had restored some of the engineering monuments of the early industrial revolution, and he was aware of bridge-building solutions outside immediate contemporary practice.

His situation was coloured by the Tay Bridge *débâcle* and particularly by the most prominent element in this, the problem of side-wind pressure from the easterly gales met in the east-coast estuaries. It had turned out that Bouch had designed his disastrous bridge on an assumption that it would have to resist side winds of up to 10 pounds to the square foot only. Baker took wind measurements on Inchgarvie and soon recorded winds of the equivalent of 34 pounds to the square foot. The Board of Trade, representing government, insisted on a designed resistance to at least 56 pounds to the square foot. Alertness to this problem is clearly registered in the design: avoiding large flat surfaces presented to the side winds, cross-strutted, and, above all, broadbased in cross-section — each pier being 120 feet wide at its base as against only 33 feet at its top. All this amounted to allowing for an intermittent lateral load on each span of 2,000 tons, compared with 4,000 and 6,000 ton forces allowed for the static tension and compression respectively within each cantilever.

In recent engineering practice a number of different spanning principles had been used for long spans: suspension from chains hanging from towers as Bouch had intended for the Forth; large rectangular self-supporting tube girders actually enclosing the road as Robert Stephenson had used at Menai; circular tube girders with the road suspended beneath as Brunel had used at Saltash — both Menai and Saltash also being two-span railway bridges. Baker went right away from these and settled on the less familiar cantilever principle, three cantilevers joined by and supporting two straightforward truss sections, making two main spans of a third of a mile each. Though a cantilever principle had been tried out on a smaller scale and in a less radical form in Germany as early as 1867, a stimulus for the cantilever bridge — which Baker himself preferred to call 'continuous girder bridge' — was from a tradition of oriental wooden bridges which interested Baker, the man of historical bent. A Tibetan example (fig. 3) had been drawn in the late eighteenth century, and an example known in England was the Wangto Bridge across the Sutlej River in India. There is also one on the Willow Pattern ceramic design.

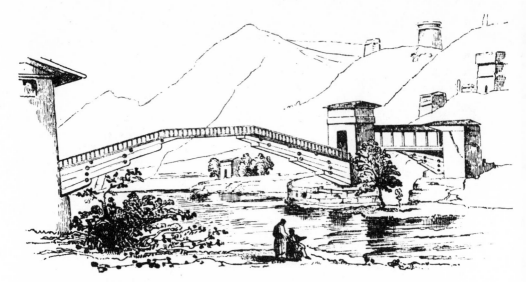

Fig. 3. Sketch by Lieutenant Davis, R.N., of a Tibetan bridge, 1783 (from W. Westhofen, *The Forth Bridge*, London, 1890, p. 6).

Baker adapted this ancient principle to metal construction on the colossal scale.

One of the advantages of cantilever bridges is that the pattern of stress is clearly and easily calculated: thus, partly, the clarity of the Forth design. In cantilever piers such as the three at Queensferry the top lateral members are in tension, the bottom lateral members in compression, as are the central vertical members (fig. 4). Baker decided that the strongest form for the girders in tension would be lattice girder composed of L-section beams and the strongest for girders in compression would be the circular tube (Pl. 1). This decision is clearly a basic and determining element in the rationale of the middle forms of the structure. Each cantilever tells its story of tension and compression in this vocabulary (Pls. 4, 5).

But the decision on the two girder forms was taken in specific relation to the properties of the metal available to him. Here one can feel a number of circumstances in play. First, as I have said, Baker was sophisticated about metal. Secondly, along with side-wind pressure, a cause of disaster identified in the inquest into the Tay Bridge affair had been a scandalous metallurgical slovenliness. Thirdly and very importantly, Baker was working up his design at a moment when mild steel manufactured in the Siemens open hearth furnace had recently become available in large enough

quantities and sizes for use in such a large structure. In the United
States it had already been used for bridge construction, though
not on this scale, but in Britain worries about its tendency to
corrode had confined bridge-builders to iron, mainly wrought
iron. Steel was an exciting new material. As Baker put it, 'You can
fold half-inch plates like newspapers and tie rivet bars like twine
into knots'. Compared with wrought iron, it was more ductile and
responsive in the working, it was of greater strength, and it came
in larger sections — for instance in plates large enough for making
Baker's tubular girders (Pl. 1). It is a prime condition of the form
of the bridge. But it is important that, while mild steel of the kind
available to Baker is absolutely stronger than wrought iron, it is
not equally so under all kinds of stress. It withstands 50% more
tension and compression but only 25% more *shear* stress — that is,
the tangential stresses leading to angular deformation and, in the
case of failure through strain, layered fracture along the beam.
Steel's relative sensitiveness to shear stress is clearly expressed in
Baker's choice of girder forms, most obviously in the lattice.

When construction of the bridge began, Baker was fortunate
in the building contractor, William Arrol, an exceptional and

Fig. 4. The structural principle of the Forth Bridge demonstrated by members of Benjamin Baker's staff,
after a contemporary photograph.

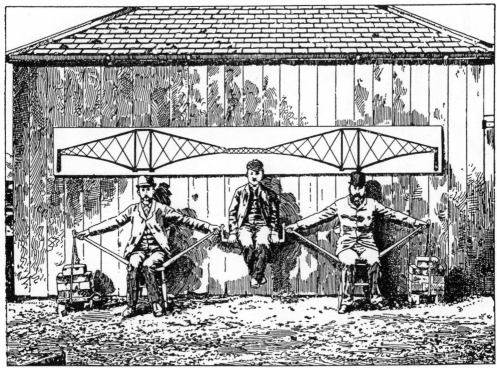

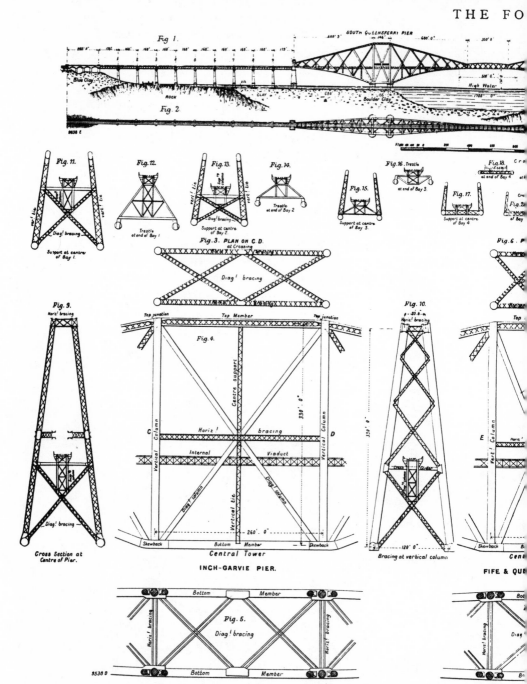

Fig. 5. The structural elements of the Forth Bridge (from W. Westhofen, *The Forth Bridge*, London, 1890).

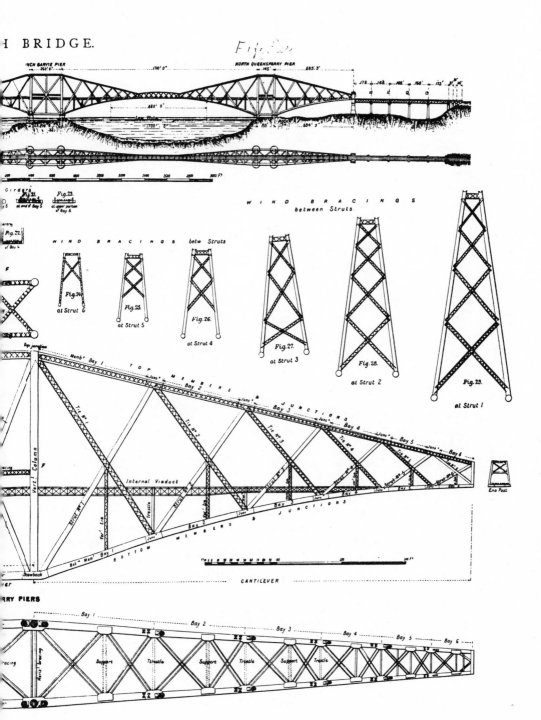

Fig.21.

resourceful man who was later to become a virtuoso executant in the new medium of mild steel. Arrol not only used the most advanced tools available — such as hydraulic presses for forming steel sheet into the great twelve-foot tubes of the cantilevers — he also invented new tools in response to the task: one was a hydraulic riveting machine to enable the driving of the seven million rivets the bridge demanded. The work was completed in 1889, having cost three million pounds and the lives of 57 workmen.

Public taste of the period identified itself across a wide spectrum. From familiar premises William Morris was negative: 'There never will be an architecture in iron, every improvement in machinery being uglier and uglier, until they reach the supremest specimen of all ugliness — the Forth Bridge.' Alfred Waterhouse, the architect of the Natural History Museum in London, was positive, from a broadly functionalist position: 'One feature especially delights me — the absence of all ornament. Any architectural detail borrowed from any style would have been out of place in such a work. As it is, the bridge is a style unto itself.' And Baker himself was pricked by Morris into producing, in an address to the Edinburgh Literary Institute, a statement of his own position, a sort of expressive functionalism. He said that he doubted

if Mr. Morris had the faintest knowledge of the duties which the great structure had to perform, and he could not judge of the impression which it made on the minds of those who, having that knowledge, could appreciate the direction of the lines of stress and the fitness of the several members to resist the forces. Probably Mr. Morris would judge the beauty of a design from the same standpoint, whether it was for a bridge a mile long, or for a silver chimney ornament. It was impossible for anyone to pronounce authoritatively on the beauty of an object without knowing its functions. The marble columns of the Parthenon were beautiful where they stood, but if they took one and bored a hole through its axis and used it as a funnel of an Atlantic liner it would, to his mind, cease to be beautiful, but of course Mr. Morris might think otherwise.

He [Sir B. Baker] had been asked why the under side of the bridge had not been made a true arc, instead of polygonal in form, and his reply was that to have made it so would have materialized a falsehood. The Forth Bridge was not an arch, and it said so for itself. . . . Critics must first study the work to be done both by the piers, and by the superstructure, and also the materials employed, before they are capable of settling whether it is beautiful or ugly. It would, he added, be a ludicrous error to suppose that Sir John Fowler and he had neglected to consider the design from

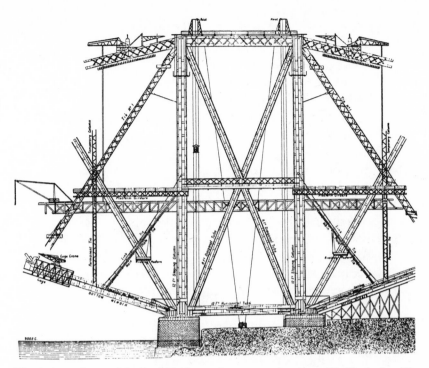

Fig. 6. A cantilever of the Forth Bridge under construction (from W. Westhofen, *The Forth Bridge*, London, 1890, p. 53).

the artistic point of view. They did so from the very first. An arched form was admittedly graceful, and they had approximated their bridge to that form as closely as they could without suggesting false constructions and shams. They made the compression members strong tubes, and the tension members light lattice work, so that to any intelligent eye the nature of the stresses and the sufficiency of the members of the structure to resist them were emphasized at all points. . . . The object had been so to arrange the leading lines of the structure as to convey an idea of strength and stability. This, in such a structure, seemed to be at once the truest and highest art.

This reads like a neo-classical statement, an argument from decorum that might have come from Leon Battista Alberti.

3. Putting questions: why at all and why thus?

It may help in what follows if I first number the main cause-suggesting features of the narrative:

 1. East-coast estuaries of Scotland
 2. Location of towns
 3. Railway's need of continuity of line
 4. Railways independent companies
 5. East–west rivalry for north–south traffic
 6. Near-competent state of bridge-building art
 7. Inchgarvie Islet in the Forth
 8. Silted bottom of Forth
 9. Admiralty's demand for shiproom
10. The Tay Bridge disaster
11. Bouch dismissed: Fowler and Baker appointed
12. Baker's sophistication about metal
13. Baker's historical bent
14. People's alertness to side-wind problem (see 10)
15. The existing range of bridge types (declined)
16. Cantilever model in Orient (see 13)
17. Tube-and-lattice theory of girders (see 12)
18. Attention to metallurgy (see 10 and 12)
19. The Siemens open hearth
20. Steel's ductility and strength
21. Steel's sensitiveness to shear stress
22. William Arrol's executive virtuosity
23. A gamut of public taste
24. Baker's 'functional expressionism'

These are not homogeneous. It would be easy to multiply them several times. But twenty-four causes seem quite enough to handle in this demonstration, and they do represent a range of kinds.

When one sets about sorting them, it is hard to proceed at all until one frames questions adequate to them. To ask simply what are the causes of or in the Forth Bridge is too unfocused to do anything with. And, in fact, both the material and the question seem to fall into two principal episodes, not so much historical as analytical. The first episode consists of a question about why there is a bridge, and material relevant to it (principally items 1–6). The second consists of a question about why the bridge has the form it does, and the circumstances of that. These were not insulated from each other, either in their historical sequence or in the actors' minds, but the distinction is necessary to our thought about the whole affair. They are distinguished for us partly by being the

immediate provinces of two different chief agents, the railway companies for the first, Benjamin Baker for the second. And they are both linked and demarcated by a two-phase event, a double decision — 'Bridge!' and (eventually) 'Baker!' — necessary for modulation from one to the next. It is the second question, the question about the form of the bridge, that is closest to the specifically art-critical concern with the visual interest of objects.

The first question, however, the question about the decision to build a bridge, is a good historical question, as would be the subsidiary question about the reasons for Baker being chosen to direct its making. We do often concern ourselves with how it was decided to have an object made — because we have a larger preoccupation with something like 'patronage' or with the predominance of a certain genre, or with the success of an artist who makes a certain sort of object, or for other good purposes. But this is precisely the crossing-the-Rubicon sort of causal question for which methodologists of history do offer broad procedures, and I shall therefore be very brief about it.

For the question about why the bridge was made, the methodologists would first point out that the circumstantial items in nos. 1–6 are obviously very incomplete: all kinds of necessary conditions are omitted, from the fact of gravity, through the buckling of Lower Old Red Sandstone across central Scotland during the mid-Devonian period that laid the foundations of the east-coast estuaries, to such matters as the social acceptance of the high mortality among workmen involved in such grand projects. And they would then offer various procedures for selecting and organizing such items into a reasonably economical and tidy account.

One procedure would be to distinguish between things which are normal and general conditions — such as gravity — and those which are specially present — such as the placing of population centres — and to prefer the latter. A second procedure would be to distinguish between things that must necessarily have been in the reflecting minds of the actors for them to have acted as they did — such as the probable competence of the bridge-building art — and those that need not have been in their minds — such as mid-Devonian geology or indeed social acceptance of high mortality among workmen — and to prefer the former. Then also we might do a rough stemmatics about immediacy, letting no. 4, for example — the larger fact of competition between independent

companies — become a more general condition from which no. 5 — east-west rivalry for north-south traffic — partly derives as a particular and immediate condition of the bridge's making. And conversely we could move up from no. 4 to a yet more general condition in the economic organization of the United Kingdom in the 1870s; and afterwards, of course, if one wanted, further up still. The logical status of some of these distinctions does present difficulties to the methodologists in the working out, but the commonsense sorting of circumstances we habitually do in this style is not outrageous.

When we had done this kind of sorting, the next question would be about which of them we should actually adduce in our explanation. Here, I think, we would be told that this depended on our frame of reference. If our frame of reference was the kind of history of social and political institutions that the methodologists oddly call 'general history' we would attend to those circumstances that derived from those institutions; so the Bridge would interest us for what it embodied of demographic, administrative and economic organization. But if it were the history specifically of *bridges* with which we were concerned, our duty would be two-phase. First, we would isolate an immediate complex of necessary conditions — dominated by nos. 1, 2, 3, 5 and 6 — that makes the particular decision to build comprehensible. And then, we would compare these with those involved in other decisions to build bridges. And, of course, a similar process would go into accounting for the derivative decision to employ Baker — for which one would start off from nos. 10, 12 and 18.

All this is very obvious. I labour it because one often meets explanatory remarks on the pattern: 'In the last analysis it is the (say) economic structure of late-nineteenth-century Britain that determined the making of the Forth Bridge.' And there seem two kinds of basis, not always very clearly distinguished from each other, for giving this kind of privilege to one class of cause. The first is that one is really studying economic structures rather than either general history or bridges: in that case one's frame of reference would indeed make it reasonable to point to the Bridge as, among other things, a monument to the fluency of the Victorian money market, competitive capitalism, a class structure that valued steel fitters less than railway directors, and the other economic facts which are undeniably registered in it. The other is that one has a

specific general theory about human affairs in which economic institutions are seen as ultimate causes of human behaviour in general. The issue of whether this theory was a good one could not be settled within the special history of bridge-building: it would take its authority from a wider universe and would be declared — either explicitly or by a consistency in the balance of explanation. And of course the same would apply to the preferring of, say, mineral facts — such as the mid-Devonian foundations of the estuaries or the laying down of the iron ores of which the Bridge is made — by a mineral determinist, or of ideas by an idealist. To special histories of things like bridges (and pictures) one brings general theories derived from a more general experience.

4. Sorting the causes of form

But it is the second question — the question about how the Bridge came to take the form it does — that I shall concentrate on, partly because it seems closest to an art-critical concern with the visual interest of such objects as pictures, and partly because one finds much less guidance about how to proceed here, either from common-sense historical practice or from systematic procedures for describing cause.

The second analytical episode begins with Baker being given a very general charge within which to act: 'Bridge!' While Baker would certainly have been aware of the circumstances (nos. 1–6 and whatever else in that category one was drawn to adduce) in which the railway companies decided to build a bridge, it does not seem necessary to our analysis of the inventive act that produced the design that we should consider them as active in his mind. It seems enough that we should treat him as having received the charge into which they had been translated by other historical agents and that he should respond to it. However, because of the Tay Bridge and Bouch episode (nos. 10–11), there must have been one special accent on the charge. Explicitly or implicitly it must have been: 'Un-Bouch-like (i.e. solid) bridge!'.

It may or may not be — I cannot judge — that our question about why or how the designer came up with such-and-such forms in the object is in principle convertible into a set of questions on the same model as the question in the first episode; that, even, it can be broken down into some negative feedback series of decisions

about whether or not to do something. Certainly the energy in current planning theory is often towards such a pattern. What is clear is that we cannot proceed in this way in our analysis after the fact. Indeed I want explicitly to eschew any ambition to construct a narrative of how Baker came to his design. It is true that with both bridges and pictures one can often distinguish phases of a design. For instance, there is an earlier design of Baker's for the Forth (fig. 2) in which cantilevers stand on two rather than four legs. One infers that a reason for him moving on to four legs was his attending to the need for stability of the cantilevers in the course of their construction, before each gave support to the next in his 'continuous girder'. But such cases offer too coarse a sequence for us to tell the story of his thinking. What we are faced with is simply the task of organizing, in relation to a complex *form*, a number of heterogeneous *circumstances* that appear to have had a part in the designer's conception.

Let us start by particularizing the general *charge* — 'Bridge!' — into a more specific *brief* for Queensferry. The Charge of 'Bridge!' embodies parts like 'span' and 'provide a way' and 'stand without falling'. What I shall call the Brief consists of local conditions in the special case. Specific items are:

7. [A mile-long crossing but] a rocky islet in mid-stream
8. The silted bottom of the Forth
9. The demand for shiproom
14. The strength of side winds

These are surely objective circumstances, in the sense of having a real presence apart from Baker's mind. However, what is less stable is their weighting, their relative mass in the thinking that made the design. For instance, 14 — the matter of side winds — is probably to be seen as affectively coloured high by 10, the Tay Bridge incident; perhaps 9 was simply anticipated by 8.

At this point some sort of demarcation seems called for between the terms of the immediate task the man addresses, the Brief, and the terms of the circumstances in which he addresses it. The pattern seems to be one of a man addressing an objective problem within a circumstantial frame of other facts that affect his perception both of the problem — laying weight on this or that specific term within the Brief — and of solution. They have the appearance of cultural facts.

I do not want to taxonomize them but they do offer themselves in three groups that are not logical but topical. One group relates to the physical medium:

19. The new availability of steel as an alternative to wrought iron
20-21. Steel's properties (ductility, strength, sensitiveness to shear . . .)
17. Theory of steel girders (tube and lattice)
22. Arrol's executive virtuosity with steel

(If one were being methodical, one would certainly want to sort this group out more tidily: thus, 19 embraces the others; 20-21 are descriptions of steel; 17 is a special description of steel in terms chosen by the historical agent for a purpose; 22 is a special remark about availability.) The second group involves facts about the history of the art of bridge-building:

10. Tay Bridge disaster
15. An existing range of railway-bridge types
16. The oriental cantilever model

(10 is an accented part of 15; 16 involves an enlarging of 15.) The third group, which consists of one, it is difficult not to call 'aesthetic':

23. A gamut of articulate visual taste, from Morris to Waterhouse

These all seem active parts in the framework from which Baker addressed his Charge and his Brief.

Several points might be made about this. One, of course, is that it is very gross. Another is that, in comparison with the nuclear four terms of the Brief at Queensferry, these are much more general in character. Most of them are facts of the mid-Victorian material and intellectual culture. If we wanted to use the bridge as a focus on mid-Victorian Britain, it is here and in the circumstances round the railway companies' decision to build the bridge at all that we would find the facts. Here in a sense is a selection from the collective resources of mid-Victorian Britain addressing a specific Brief about side wind, silt and so on. But it is a *selection* from those resources. Each of the three groups consists first of a range of options: a choice of metals and of thoughts about their qualities, a set of

types of bridge, a gamut of aesthetic positions. (The Forth Bridge might have been a wrought-iron suspension bridge with ogee-arched towers.) Who or what made the selection?

Benjamin Baker, an individual, seems to have been the agent in making the selection. It was the culture he lived in that made available to Baker a range of resources that included the possibility of knowledge of, among other bridges, oriental cantilever bridges; the Siemens open hearth together with a body of thought about its product; and a range of rationales about how things should look. Each of these has a complex history, involving in the further analysis everything from classical rhetoric to European commercial expansion. And Baker himself was culturally equipped with skills and attitudes that led him to approach Charge, Brief and resources in a certain style. Yet it was he who fixed on this or that rather than another and it was he who alloyed them all into *a* form. What do we have on Baker as a particular?

12. Baker's sophistication about metal
13. Baker's historical bent
24. Baker's 'functional expressionism'
25. Baker's evidently superior intellect, sensibility and will

Even with the overdue addition of something like no. 25 this is absurdly inadequate in all sorts of ways, and it looks unprofitable to try reducing him further along this line.

What we really have on Baker is, if not precisely the Forth Bridge, then a three-cornered relationship between the Forth Bridge, an objective task or problem, and a range of culturally determined possibilities. The intention of Baker presents itself to us in the form of this triangle. I now jump sideways and backwards.

5. The triangle of re-enactment: a descriptive construct

We have conceptualized and verbalized Baker's problem — his Charge and Brief — in such terms as 'bridge' and 'span', 'silt' and 'side winds', and so on. We have done the same with the resources within his situation: 'steel', 'tensile strength', 'cantilever', 'functional' and the rest. What about the third element, the Forth Bridge itself?

I started from the point that we explain not so much pictures

as pictures considered under a description, a conceptualized and verbalized specification. The same is true of bridges. If one went back to the narrative account of the making of the Forth Bridge in section 2, it would turn out to be made up of two ragged and unequal strands untidily intertwined. One strand, the more bulky of the two, consisted of selected circumstances — which themselves, one must say, contributed to a description by being an expanded and anecdotally based version of the kind of oblique critical language I called inferential about cause on p.6. The other strand consisted of a crude and more direct specification or description, sometimes explicit and sometimes implicit. It is of the type: '... high-level (rather than low-level) bridge on the cantilever (rather than suspension etc.) principle embodying two long (rather than, say, many short) spans, the cantilevers being structures of tube and lattice (rather than, say, of I-section) girders straddled (rather than parallel) in cross-section. ...' It has the same looseness of fit I pointed to in art-critical language. And it is this specification that the circumstances I assembled both supplement descriptively and propose immediately to explain.

The untidiness and circular potentiality of this does not seem vicious unless it is unrecognized. There is an affinity or homology between the circumstances collected and the Bridge as-considered-under-description to the extent that both are being represented by verbalized concepts. It is only this that allows us to think in an explanatory vein at all. It allows us to match in a quite rough way one representational concept with another, even to match circumstances with items in the description — *long span* with *silted bottom* and *shiproom* and so on. The matchings are very gross and very limited, and are modified in any total explanation. But they are in contrast with the impossibility of matching any circumstance directly with the Bridge.

I cannot distribute the different circumstances of the bridge among its different sections — side winds to the left, Siemens steel to the right, expressive functionalism somewhere else. In the form of the Bridge, Baker alloyed circumstances, he did not aggregate or collocate them, and we cannot follow him conceptually into the alloyed form of the Bridge. By assaying it out, in the sense of overlaying the form with conceptualizations that have at least something in common with the tissue of his own self-critical reflection, we make it treatable, to a degree.

So one might see the sort of thinking about the Bridge attempted here as a kind of rough triangle of re-enactment done between three bases: concepts pertaining to the Charge and Brief, concepts pertaining to resources used or *not* used, concepts descriptive of the Bridge. Or:

What we do if we want to know about Baker is to play a conceptual game on the triangle, a simplified reconstruction of the maker's reflection and rationality applying an individual selection from collective resources to a task. The triangle is beside the Bridge, with the description as the apex specially responsible for keeping in some sort of touch with the Bridge itself. It is a pity it can do so only coarsely, but at least two things make it better than it seems. One is that, as I have said, not only the direct description but the other elements play a descriptive part. Indeed the whole basis of what I am calling inferential criticism is that one brings all three corners of the triangle, in an active relation to each other, to description of the object. Description and explanation interpenetrate each other.

The other is, as I have also said, that we are back with the ostensive nature of the language of criticism: concepts and object reciprocally sharpen each other. For instance, if we are told or if we infer after observation that Benjamin Baker reckoned tubes best for compression lines and lattice girders best for tension lines with secondary shear stress, this surely sharpens our sense of the organization of matter within the cantilevers. But correspondingly, once one has got to this point, the object itself leads us to see the progressive sharpening of angle of the cross-tubes as one moves out on to the wings of the cantilevers (Pl. 5) and much else which one does not have to spell out. This is the nature of the critical act

we are concerned with: the concept sharpens perception of the object, and the object sharpens the reference of the word.

6. *Summary*

The methodical status of all this is very shaky; it has been arrived at by travelling a zigzag route. I started from a very low and simple theoretical stance: that historical objects may be explained by treating them as solutions to problems in situations, and by reconstructing a rational relationship between these three. I then followed the prompting of a particular: following what felt like the grain of the case of the Forth Bridge has led us to this point. And, as it has fallen out, the attempt to address the Forth Bridge as a thing made to solve a problem in specific circumstances led to dealing with matters in a sequence that swung between attention to individual facts and attention to general facts.

The sequence began by positing that the object of interest, the Bridge, was a concrete *solution* to a problem. The solution was in a sense given and visible: the problem was not, except in the guise of a mile of water. In trying to identify it one came first to the general *Charge* that the agent, Benjamin Baker, would be responding to, and noted that while it could be terse — 'Bridge!' — it was a rubric for performance that contained within it various general terms of the problem — spanning, providing a way, not falling down. From this one moved on to more specific terms of the problem, which I called the *Brief*, though the name does not matter. What does matter is that these specific local conditions at Queensferry qualified the general Charge and were necessary to make it a specific problem susceptible to a solution. Together Charge and Brief seemed to constitute a *problem* to which we might see the bridge as a solution.

But this still left out much of the circumstantial matter one wanted to bring in — partly (and this seems important) because one enjoyed thinking about it, but partly also because one sensed that it was causally involved in the form of the Bridge. In practice, these circumstances came up as general ranges of *resources* offered the agent. As it happened they fell into three topical groups — resources of medium, of models (both positive and negative), and of 'aesthetic' — but this topical division is a different sort of division from the others, and may be an accident of the case.

An individual, Benjamin Baker or X, made a selection from these resources and alloyed his selection into a form, one solution. X is elusive; very little worth saying can be said about him directly, though some broad things can be inferred from his other behaviour and from his statements. The way we are proceeding seems to entail that we are thinking of him as a compound of rationality and culture and quiddity. This means, among other things, that we could not work through our sequence from the problem to his solution if the solution were not visible, because he is an insufficiently known quantity in the schedule; instead the solution is the given and we continually refer to it. What we do about X, then, is to play a conceptual game on what I have just called the *triangle of re-enactment*. This is a very simplified diagram of quite a high level of consciousness: it is not a narrative. It is a representation of reflection or rationality purposefully at work on circumstances — and I shall insist again that this representation takes life and meaning from its ostensive relation to the Bridge itself — and we derive a sense of the agent's quiddity by relating to these circumstances the solution he actually arrived at. If we 'explain' the form of the Bridge at all, it is only by expounding it as *one* rational way of attaining an inferred end.

What happens if we go through a sequence like this with a picture? More particularly, where does the shoe pinch — in the sense of the sequence excluding or distorting the kind of matter we want to do justice to in an account of a picture?

7. *The peculiarity of the pictorial object*

I do not want to prolong this. It is possible to find objects with which one can follow something that looks a little like the Forth-Bridge type of explanation: some late Dürer woodcuts, for instance, lend themselves to it. But it will be more expeditious to put the model under heavy strain at once. In working (as I shall now) with Picasso's *Portrait of Kahnweiler* (Pl. I) of 1910, I have in mind both this and the fact that it is a picture from the most generally familiar of all episodes in the history of painting, early Cubism. This allows me to assume knowledge.

[But for those who wish to be reminded at least of the chronology of the run-up to 1910, the account current in handbooks goes in summary:

At the start of 1906 Picasso had still been producing pictures in a manner that seemed continuous with his circus vein of 1905. In retrospect, of course, there are in such paintings prefigurations of what was to come. But during the winter of 1906–1907 Picasso was first making exhaustive studies for (Pl. 8) and then eventually painting the picture that was later called *Les Demoiselles d'Avignon* (Pl. 7) which he considered an unfinished painting. The manner of this picture was not only novel, it was discrete, in that the right-hand figures and heads are in a more radically new mode than the left-hand figures. One, though only one, stimulus for this appears to have been African sculpture, which was having something of a vogue among some painters in Paris at the time. This would show itself not only in the two heads on the right but more generally in the reduction of the figures. More broadly, the picture offers little sense of represented three-dimensional space; nor is phenomenal perspective observed in the forms of the figures. In the winter of 1907–1908 Picasso painted a number of smaller pictures (Pl. 9) consolidating and experimenting with this vein, and he also met Georges Braque. Braque, unlike many of Picasso's admirers, reacted positively (Pl. 10) to the *Demoiselles* and the men became close, collaborating in many of the developments that followed in the next few years — 'two climbers on one rope', as Braque famously put it.

The second half of 1908, from the summer on, is for Picasso and Braque particularly a time of pictures (Pls. 10, 11) that show, among other things, a preoccupation with absorbing and using in new ways the advanced style of Cézanne, and particularly Cézanne's reduction of the local plane-structure of objects to a limited number of, so to speak, super-planes registering not so much the seen surface of things as a perceived underlying structure. The term *passage* is sometimes used in relation to this. The perceived structure, however, is not Cézanne's kind of perceived structure but of a kind that appears to evolve from the re-arranged element of the right-hand side of the *Demoiselles*. In particular, it conspicuously begins to presuppose more than a single angle of view on the object.

In the course of 1909, in a very complex development, this matured, and Picasso and Braque followed experimentally various consequences and suggestions within it (Pls. 12–14). Rounded forms are reduced to more rectilinear or crystalline forms. The role of relief modelling with light and shade is attenuated, and

light and dark themselves are used schematically to register the super-planes. The structure of contours and of the edges of planes is determined less simply by the three-dimensional realities out there, and responds more to a tension between these and the flat pattern on the picture plane. The use of more than one aspect, more than a single angle of view on an object is taken further: and much more — all these individual developments of course inter-acting on each other. 1909 was a very diversely experimental year.

In 1910 Picasso's paintings included a number of carefully con-sidered portraits. One painted in the spring was of Vollard (Pl. 15) the picture dealer. During the summer Picasso was in Spain and painted some pictures in which the represented planes were detached even more from the edges of the super-plane structure, were made more simple and were also less finitely circumscribed (Pl. 16). Back in Paris in the autumn of 1910 he painted the portrait of Kahnweiler, who was becoming — partly because of Vollard's dislike of Picasso's post-1906 manner — important to him as a dealer. The picture took many sittings.]

If one attempts a Forth Bridge view of the *Portrait of Kahnweiler* what seems to fit best is Picasso's use of resources. The opposite number of Benjamin Baker's medium, metal structurally deployed, has to be not so much pigments as forms and colours perceived. Then Picasso's equivalent of Siemens open-hearth steel, a novel medium with new potentialities and also new problems within it, can be Cézanne's way with super-planes or *passage*. The exotic positive model corresponding to the oriental cantilever might be the schematization of form Picasso saw in African sculpture. He has himself given an illustration of an African mask in the *Portrait of Kahnweiler*, on the wall top left. As for Thomas Bouch and the Tay Bridge, negative examples to react away from, Picasso had many of these: the most immediate in 1910, perhaps, were offered by Matisse and also his earlier self, but the underlying case would be the painting and even more the rationale of Impressionism. The Impressionists' fiction that one registered in a picture a momen-tary sensation and their frivolity in attending to hues more than volumes were things Picasso is sometimes seen as working almost programmatically against. On the other hand, Picasso left no verbalized statement of an aesthetic as crisp and clear as Baker's address to the Edinburgh Literary Institute. And the equivalent of William Arrol, the resourceful executant, was Picasso himself.

These last two points of difference are a warning that all is not well. An explanation of the *Portrait of Kahnweiler* on the Forth Bridge pattern would rather quickly show itself inadequate to the interest of the case, and particularly at two points.

The first inadequacy is the disappearance of 'process', the sense of the picture as — what many good pictures are — something progressively worked out in the course of handling the medium. At Queensferry it seemed plausible to distinguish firmly between two phases, conception and execution: Baker and his men conceived and Arrol and his men executed. But in a picture like the *Portrait of Kahnweiler* it is not quite a matter of the painter first working out a finished design and then picking up his brushes in an executive role and just carrying it out. The phases interpenetrate, and one would surely wish at least to accommodate this sense of process.

Secondly, something quite preliminary that is missing is the problem that Picasso was addressing, both general Charge and specific Brief. In 'bridge' and in 'silt', 'side winds' and the rest we had sharply focused demands on Baker. Moreover, it seems clear who had issued the Charge to design the Bridge: the Forth Bridge Company. But what were Picasso's Charge and Brief — setting a problem in response to which he painted like this — and who on earth issued it, for that matter? If we are to exercise on the triangle of re-enactment, we cannot start with one of the three bases missing. Until we know what Picasso had been set to do, we cannot think constructively about his relation to the resources of the culture.

These two kinds of inadequacy will be addressed in the next chapter. I want to finish here with a last word on the Forth Bridge. For if one looks back at it now, with the unfulfilled demands of Picassos *Portrait of Kahnweiler* in mind, it becomes clear how far the twenty-five cause sketch simplified a greater causal intricacy. With an allowance of a hundred causal items one might have brought in matters analogous to those that are so conspicuously demanding in the picture.

There *is* an element of process, though in a rather different form, hanging round the bridge. If one pursues the matter it turns out that the Forth Bridge represents a late moment in Baker's development: in 1864 and again in 1871, it seems, Baker and Fowler had proposed long-span metal bridges for quite another estuary, the Severn, and at a time when Siemens steel would not have been available. The Forth Bridge is a development of the ideas a little as

the *Portrait of Kahnweiler* is a development from the *Demoiselles d'Avignon*. Then again, the final design replaced an earlier idea for the Forth itself (fig. 2) — a study, as it were. And the final design was a response to the need to take the process of making the Bridge into account: Baker redesigned the cantilevers so that they would be self-supporting at every moment of construction (fig. 6). Baker's mind, at least, went into the execution. And his design made demands on the builder for which the tools, a resource, did not yet exist but now, in response, were developed. Conception and execution are not rationally insulated from each other.

Then again, Baker's reflective perception of his problem would have been less simple and sharp-edged than the sketch admitted. His task was not purely to span a specifically conditioned gap. It was, one could argue, also to do it neatly, impressively, expressively, and with an eye to other secondary qualities. (He made one big and odd concession to neatness: the two side cantilevers are in fact unbalanced in that they do not sustain on the shore side the half truss section they do on the water side. This had to be quietly compensated for with iron weights encased in the stone piers.) The Bridge was, in a subsidiary aspect, a publicity exercise. It became the emblem of the east-coast route, represented on posters and on bank-notes. It was to redeem the reputation of British engineering after the literally disastrous Bouch, and at a moment when Britain was beginning to slip behind the technically better educated French and Germans. It was to be strong eloquently and with panache. There were, in other words, accents on the Brief that we have not attended to. And then again, in the matter of who issued Charge and Brief, one suspects that Baker would not have considered himself as working solely to the directors of the Forth Bridge Railway Company: he was working also to his professional colleagues and rivals, and to a society.

The Forth Bridge and the *Portrait of Kahnweiler*, both purposeful objects, are not necessarily in principle different. The differences seem more of degree and of balance, particularly the balance of our interest or of our critical priorities. One of the deep subject matters of good pictures is the tissue of human intention, in general.

II

INTENTIONAL VISUAL INTEREST: PICASSO'S *PORTRAIT OF KAHNWEILER*

> Don't talk to the driver!
> (Picasso, to Metzinger)

1. Intention

A WORD must be said about 'intention', I suppose. I have declared an interest in addressing pictures partly by making inferences about their causes, this both because it is pleasurable and because a disposition towards causal inference seems to penetrate our thought and language too deeply to be excised, at least without doing oneself a quite disabling mischief. But since pictures are human productions, one element in the causal field behind a picture will be volition, and this overlaps with what we call 'intention'.

I am not aligned or equipped to offer anything useful on the matter of whether it is necessary to appeal to an author's historical intention in interpreting a picture (or, of course, a poem). The arguments for doing so — that it is necessary if there is to be any determinate meaning in a work, that the relation between intention and actual accomplishment is necessary to evaluation, and so on — are often attractive, but they sometimes seem to refer to a slightly different sort of intention (a complex word) or to intention seen from a slightly different angle from what I feel committed to. The intention to which I am committed is not an actual, particular psychological state or even a historical set of mental events inside the heads of Benjamin Baker or Picasso, in the light of which — if I knew them — I would interpret the Forth Bridge or the *Portrait of Kahnweiler*. Rather, it is primarily a general condition of rational human action which I posit in the course of arranging my circumstantial facts or moving about on the triangle of re-enactment. This can be referred to as 'intentionality' no doubt. One assumes purposefulness — or intent or, as it were, 'intentiveness' — in the

historical actor but even more in the historical objects themselves. Intentionality in this sense is taken to be characteristic of both. Intention is the forward-leaning look of things.

It is not a reconstituted historical state of mind, then, but a relation between the object and its circumstances. Some of the voluntary causes I adduce may have been implicit in institutions to which the actor unreflectively acquiesced: others may have been dispositions acquired through a history of behaviour in which reflection once but no longer had a part. Genres are often a case of the first and skills are often a case of the second. In either case I may well want to expand the 'intention' to take in the rationality of the institution or of the behaviour that led to the disposition: this may not have been active in the man's mind at the time of making the particular object. Even his own descriptions of his own state of mind — like Baker's of his aesthetic intention and, most certainly, Picasso's later remarks about his — have very limited authority for an account of intention of the object: they are matched with the relation between the object and its circumstances, and retouched or obliquely deployed or even discounted if they are inconsistent with it.

So 'intention' here is referred to pictures rather more than to painters. In particular cases it will be a construct descriptive of a relationship between a picture and its circumstances. In general intentionality is also a pattern posited in behaviour, and it is used to give circumstantial facts and descriptive concepts a basic structure. In fact, 'intention' is a word I shall use as little as possible, but when I do use it I do not know what other word I could use instead. 'Purpose' and 'function' and the rest present their own difficulties and anyway their force is different.

2. The pictorial Charge and the painter's Brief

The issue is now whether the pattern of intention derived from Benjamin Baker's Forth Bridge can be adapted to meet the demands of Picasso's *Portrait of Kahnweiler* (Pl. I). To recollect: at Queensferry Benjamin Baker was seen as being possessed of a general Charge — 'Bridge!' or 'Span!' — and a specific Brief that included such matters as strong side winds, silt, and shiproom. He selected and deployed resources to meet these. In the case of

Picasso's *Kahnweiler* it was less clear what Charge and Brief were, and also who delivered them.

A painter's Charge is indeed more elusive than a bridge-builder's. By definition, the bridge-builder's role has been to span: the manner in which he has done so has varied within his circumstances, the character of the site and of the material and intellectual resources of his culture. To find anything like as long-running a role for the painter it is necessary, temporarily, to be rather general. (The need to do so at all will shortly disappear.) In a quite arbitrary and stipulative way I shall say for the moment that the painter's role has been to make marks on a plane surface in such a way that their visual interest is directed to an end. This is less a definition of painting than a specification of the sort of painting I wish to cover. We can all think of pictures that we would say lacked visual interest, or in which the visual interest does not seem directed to an identifiable end. In saying this we would often be making a negative value judgement. In either case this would not be the sort of picture I shall be concerned with. Further, the specification — 'intentional visual interest' for short — involves a sort of demarcation against such historical objects as the Forth Bridge. The Forth Bridge is visually interesting, but is not so capitally: it does not meet its Charge, attain its end, primarily by being visually interesting. Visual interest is secondary and, even though not excluded, incidental.

This may seem an unduly exclusive stipulation, ruling out whole historical episodes in painting, but that is not so. Take, for example, the medieval religious image. To say that it is a thing of intentional visual interest may seem an anti-historical super-imposition of a modern aestheticizing point of view. But while our own culture is obviously involved in putting it in this way, in describing its role in these particular terms, the terms do not produce something untrue, just something very general that fails to describe the particular qualities of the medieval image. Medieval religious pictures — and for that matter such Renaissance religious images as Piero della Francesca's *Baptism of Christ* — were produced with a degree of conformity to a general rubric with a history of argument behind it. The thinking took its stand on the fact that, of the five senses, vision is the most precise and the most powerful in the mind, more precise and vivid than hearing, the sense which brings us the Word. Because it was the most precise and vivid

faculty given us by God, it was to be used to a pastoral purpose, and its special quality directed to three specified ends. First, it was to expound religious matter clearly: its precision equipped it and the painter's medium for this task. Secondly, it was to expound the matter in such a way as to move the soul: the vividness in the mind of seen things gave it great power here, more power (it was felt) than the word, a heard thing. Thirdly, it was to expound the matter memorably: vision is more retentive than hearing, and things seen stick in the mind better than things heard. Thus the painter's general rubric — made more particular, of course, in particular circumstances — was determined by a recognition that vision was the first sense and gave him a peculiar potentiality: he could use his medium to do things other mediums could not. If we rewrite this as 'intentional visual interest' we are generalizing it, not excluding it.

But 'intentional visual interest' is too general to be useful in the particular case. Its usefulness is purely as a nondescript base — nondescript enough to accommodate as much of the last five hundred years of European painting as I want to — on which to hang the specific qualifications involved in particular cases. The Charge is featureless. Character begins with the Brief. And since things are becoming unpleasantly abstract I shall propose at this point three elements in Picasso's Brief of 1910 — equivalents, as it were, of silt, side winds and shiproom — without attempting to substantiate them. They are, in fact, simply adapted from Kahnweiler's account of Picasso and Braque in his book *Der Weg zum Kubismus*, written about 1915 and published in 1920, which seems to me the most plausible of the near-contemporary descriptions of early Cubism. What the status of such assertions is, what they are describing, who can be considered as having set Picasso's Brief, and (eventually) how one assesses such claims about intention, are problems I shall return to once we have something concrete to think around.

One element in the Brief would come out of the fact that representational painters like Picasso represent a three-dimensional reality on a two-dimensional surface, this being a very old issue indeed. How is one both to represent things and persons, tables and art-dealers, recalcitrantly three-dimensional, and yet also positively to acknowledge the two-dimensional plane of the canvas? How does one make a virtue of this curious relation rather than

play at what can be seen as a mountebank's game of creating on the plane an illusion of depth? The issue was involved in much recent painting. Impressionism had offered canvases that played on a tension between an openly dabbed-on plane surface and a rendering of sense-impressions of seen objects that put emphasis on their hues. Matisse and others had subsequently dabbed less and played with an oscillation between perception of flatter patterns of hues on the picture surface and our inference about the patterning of the object of representation. There was a problem here.

A second element is a question about the relative importance of form and of colour, again an ancient issue in painting and in thinking about painting. Impressionist painting and some Post-Impressionist painting had made much, both pictorially and verbally, of the overriding importance to us of colour, in the sense of hues. But colour is an accident of vision, a function of the beholder not an intrinsic quality of real objects; whereas form is not only real but offers the security of perception through more than one sense, since we can apprehend form not only with vision but also with touch. How then can a grown-up spend time playing about with colour when the form of the objective world is available to him?

A third element is a question about the fictive instantaneousness of much painting. The convention (if that is what it is; I am not sure) that the painter is offering a moment of experience was in question, partly because of unease about the programme of Impressionism. Matisse, for one, raised it in an essay of 1908. The point is, of course, that in fact it takes a painter much longer than a moment to paint a picture: it takes hours or months. Might there be a case for the painter acknowledging *in the character of his depiction* the fact that this is a record of sustained perceptual and intellectual engagement with the object of representation? Should one not make a virtue, again, of the truth, which is that we do not just have a single sense-impression of an object important enough to us to paint? We have thought about it, analytically about its parts and synthetically about their constitution. We have studied it in different lights, very probably, and from different angles. And — an important point entailed in a remark of Braque's in 1908 — our emotions are less about the object itself than about the history of our minds' engagement with the object.

3. Who set Picasso's Brief?

In order to have something to work on, let us posit these three — the tension between the plane of the canvas and the three dimensions of the object; the tension between form and colour; and the tension between fictive instantaneousness and the fact of sustained engagement — as conceptualizations of three out of the specific elements in the problem that Picasso was electing to address around 1906–10. There were, of course, others.

Now clearly he would not have stated them like this; if he had heard them stated like this he would have scoffed, with one of the joky put-offs for which he was then well known. ('There are no feet in Nature', 'Don't talk to the driver', and so on.) For him these issues could not be a matter of verbalization like this. They were embodied in complex feelings about a range of other pictures, both others men's and his own — pictures he more or less liked and pictures he more or less disliked. What we are doing with our conceptualizations is trying to cover — ostensively again and for our own reflective purpose again — a balance within Picasso's attitude to pictures as we infer it, first, from the character of his pictures in relation to other pictures and, second, from the developing character of his own pictures during these years.

There is therefore a strong historical-cum-critical dimension to the painter's Brief. The specific terms of the painter's problem are liable to be primarily a specific view of past painting. The same is so of the Charge: indeed we can now let the Charge and the clumsy catch-all 'intentional visual interest' wither away. Picasso's Charge really resided in the body of previous painting Picasso would have acknowledged as painting worthy of the term, even if not of his kind or to his purpose. He may or may not have conceptualized to himself on what painting is about. One would guess he did now and then, but it is not necessary to us that he should have, and we are not concerned to reconstruct his actual thoughts if he did.

Then who set Picasso's Charge — he had no Forth Bridge Company — and Brief for the *Portrait of Kahnweiler*? A preliminary half-answer would be that Picasso at least formulated his own. The painter registers his individuality very much by his particular perception of the circumstances he must address. Indeed, if one is to think of a painter 'expressing himself', it is most of all here, in the analysis of his environment which schematically speaking

(more of that later) precedes the process of painting itself, that one can most securely locate an individuality. There is often a curious impersonality about the actual working out of a solution in the medium. The painter's medium of forms and colours and distances visually perceived and pictorially deployed is almost as impersonal as the structural properties of steel. But the painter's formulation of a Brief is a very personal affair indeed. Benjamin Baker's problem had been made up of elements — silt and side winds and so on — that were objectively pressing. He did not himself select them as the matter of his problem-solving, even though he (like Thomas Bouch) was free to put a personal emphasis, relatively, on this or on that. But the elements of Picasso's problem were rather more freely selected by Picasso out of an array, and arranged by Picasso into a problem constituting the immediate Brief.

However, if Picasso is to be thought of as formulating his own Brief, he did so as a social being in cultural circumstances. And how to think or talk tactfully about this relation between Picasso and his culture is a real difficulty. The difficulty lies in the structure of the relation: one wants to keep it very loose and very reciprocal.

4. The cultural painter: troc

There seems to me much to be said here for looking to economic theory and borrowing something like the technical concept of 'market'. A market is a coming into contact of producers and consumers of a good for the purpose of exchange. It is a model of a relation in which two groups of people are free to make choices, which interact on each other. Typically it involves a degree of competition among both producers and consumers, between whom it is a medium of non-verbal communication: parties on either side can make statements with their feet, as it were, by participating or abstaining. Any one market can be defined through the kind of commodity exchanged in it, and also geographically: within it there is likely to be a pattern of specialized sub-markets. So far as a form of relation is needed for thinking about a painter's relation to his culture, 'market' seems to me as much as is needed. The essence is that there is choice on both sides, but that a choice on any one side has consequences for the range of choice on both sides.

But it must also be said at once that the relation is much more

diffuse than the economists'. In the economists' market what the producer is compensated by is money: money goes one way, goods or services the other. But in the relation between painters and cultures the currency is much more diverse than just money: it includes such things as approval, intellectual nurture and, later, reassurance, provocation and irritation of stimulating kinds, the articulation of ideas, vernacular visual skills, friendship and — very important indeed — a history of one's activity and a heredity, as well as sometimes money acting both as a token of some of these and a means to continuing performance. And the good exchanged for these is not so much pictures as profitable and pleasurable experience of pictures. The painter may choose to take more of one sort of compensation than of another — more of a certain sense of himself within the history of painting, for instance, than of approval or money. The consumer may choose this rather than that sort of satisfaction. Whatever choice painter or consumer makes will reflect on the market as a whole. It is a pattern of barter, barter primarily of mental goods. Partly to register the element of barter and partly to distinguish the painter's exchange from the economists' money-currency market — and also because we are at the moment in Paris — I shall refer to the relation as *troc*.

I am particularly anxious not to elaborate anything like systematically regarding *troc* because its appeal for me lies in its simplicity and fluidity: it is no more than a *form* of relation in which two classes of people, both within the same culture, are free to make choices in the course of an exchange, any choice affecting the universe of the exchange and so the other participants. Probably there is a mathematical symbol for the form of the relation. As a general explanatory model this would, of course, be very weak; it is intended not as an explanatory model but as an unassertive facility for the inferential criticism of particulars. But even so there are one or two points to be made.

One is that the language in which consumers address producers in the picture-*troc* is both generic and historical. It does not have facilities for asking precisely for the particular picture the *Portrait of Kahnweiler* turned out to be. The consumer can respond or not respond to classes of things that have been made, including not just such a class as Cubist portraits but pictures classed as innovatory and pictures classed as pictures by Picasso. This in turn has a range of implications — that initiative is with the painter, who has quite

a lot of room for manoeuvre within the bands of the classes of a generic Brief; that the market can say much more than the consumers reflectively know they are saying; that attention to generic and transformational considerations by the art critic has a foundation in the causal field behind a painting — which are obvious enough for me to skip spelling out.

Another is that painting is a less pure art than bridge-building in that *how* is much more clearly contaminated by *why*. In the case of the Forth Bridge it caused little strain, I feel, to distinguish between two different episodes, one the province of the railway companies and concerned with a decision whether or not to build a bridge, the other the province of Benjamin Baker and concerned with the form the bridge should take. The two episodes are not totally insulable from each other and in principle interpenetrate but, practically, it was possible to address the *how* episode separately without losing too much. But Picasso's province is saturated with *why* as well as *how*: we would impoverish our sense of his Brief very badly if we excluded from our consideration questions about why pictures of the kind of the *Portrait of Kahnweiler* were being painted and consumed in 1910. It is a question, to which I shall only briefly return, quite how *far* into this side of Picasso's environment it is necessary to go in order to arrive at a minimal level of understanding of how the *Portrait of Kahnweiler* came to take the form it did.

Another point is that while the basic relation of *troc* is simple and fluid, in any particular case it is partly encased in actual market institutions that are less so. The *forms* of these institutions are part of the painter's Brief because they embody latent assumptions about what painting is. And the forms of the institutions are not pure expressions of immediate aesthetic impulse in a culture. Often they represent survivals from earlier moments: institutions are inertial. Often they reflect patterns and practices current in the markets of other manufactures and goods — clothes, antiques, precious metals, lectures on art, wines and so on — not specially developed for pictures. Important pictures of Piero della Francesca's period were contracted for in a form developed for the tranquil procuring and supply of general bespoke manufactures: such forms are after all great intellectual accomplishments of a culture, institutionalized as law and language, and it would be surprising if there were not a degree of assimilation. But rather than pursue such points on the general level, I shall now sketch

Picasso's market around 1910, the institutional framework that interfered with pure *troc*.

5. Picasso's market: structural cues and choice

Whereas a Renaissance painter like Piero della Francesca did a high proportion of his pictures to order, producing commissioned objects often within the terms of legal contracts, most painters in Paris around 1906–10 painted ready-made pictures that had to be marketed. Often they disposed of pictures from their studios, but even then they needed some means of making their wares known and available. There were various means to this but three were particularly important.

Firstly, there were public mixed exhibitions on a pattern going back to the eighteenth century. There was an official annual Salon, with a jury or selection committee, but this did not show the sort of painting painters like Picasso were interested in doing. Two unofficial or black Salons had evolved for them. In the spring there was the Salon of the Independents, which functioned without a jury but had a powerful committee concerned with hanging; Signac and the Neo-Impressionists had purchase here. In the autumn there was the Autumn Salon, a newer affair established in 1903; here Matisse and the Fauves carried some weight and there was a jury — which rejected some of the pictures submitted by Braque in 1908. These two black Salons may have been anti-official in their taste, open to 'the new painting' of the moment, but they had much the same structural and institutional character as the official Salon. Indeed the organizers were concerned to point to their long pedigree. The critic Roger-Marx put their view well in the introduction to the catalogue of the Autumn Salon of 1906, pregnant year:

The court of Louis XIV arranged to see brought together, every two years, the paintings and sculptures of the members of the Academy: the narrow bounds of their interest and of the exhibition called for no more than this. The age of dissident exhibitions began with Louis XIV's successors: the Exhibitions of the Academy of St. Luke, the *Expositions du Colisée*, not to mention the exciting *Expositions de la Jeunesse*. The nineteenth century was marked right to its end by a series of exhibitions, individual or collective, that sometimes took on a character of sharp protest and challenge: it was precisely this that happened in 1863 [Salon

des Refusés], under the protection of the state. Later, in 1890, the *Salon de la Société Nationale* [or Independents] was founded in opposition to the official Salon, two centuries old, and now since 1903 these two exhibitions held in May have a sequel in this Autumn Salon, a sequel unforeseen but considered *logique et normale*.

Its easy-going and accessible style [*ses libres allures*] puts it close to the Salon of the Independents or even the Impressionist exhibitions of glorious memory; but the programme is clearly wider and the elements that make it up are more varied due to its avowed ambition to sum up the new initiatives in painting, from wherever they may come and in whatever direction they may be pointing. ... Here you can follow the soaring flights of the latest newcomers, whose work could be seen in the course of the year only in a scattered, piecemeal, fragmented way; here you can taste the new talent in the sometimes slightly tart greenness of its first fruits; here you are instructed at length in what Edmond Duranty not long ago [1876] called the tendencies of the 'New Painting'.

As Roger-Marx says, black Salons were an institution with a respectable history and a sense of fulfilling a national duty: like the official Salons they consciously offered the year's art to the nation, even though the sort of painting they offered was 'the new painting'. They are institutions embodying a very old sense of art in a collective culture.

Secondly there were, and again long had been, dealers in pictures, across the same range as the Salons white and black. There were a few dealers who showed some of the new painting to a consciously progressive clientele among whom visiting or resident foreigners like the Russian Sergei Shchukine and the Americans Leo and Gertrude Stein counted disproportionately as substantial buyers. Daniel-Henry Kahnweiler, the son of a family of merchants in exotic foods and by training a stockbroker, had become such a dealer in 1907 in a modest way: he had gathered his first stock by going to the Independents and buying pictures by Derain and Vlaminck. But Kahnweiler acknowledged before him particularly two great dealers in the new painting. Paul Durand-Ruel had been very much the Impressionists' dealer; his business was a development of a family firm long established. Ambroise Vollard, a spoiled lawyer with more unassuming premises, had been the dealer of Cézanne and very many others and had exhibited Picasso's work as early as 1901. Vollard and after him Kahnweiler tended at this time to have agreements with a painter by which the painter

sold him practically his whole production, often at prices fixed by the pictures' dimensions. In ways it would be tedious to hammer away on, the form of the institution reflected the marketing of some other kinds of good, and more remotely a general economic structure.

A third element in the market was the great French culture press which again registers larger social facts of France, including the strength and range of the verbal culture, and which again had a long history and covered a wide spectrum of taste. Exhibition reports in particular had already been a developed, even an over-developed, literary genre in eighteenth-century France. In 1906–10 there were glossy art magazines like *Les Arts* with black and white Salon reports, but there was also a self-consciously avant-garde press. The most familiar operator in the latter was Guillaume Apollinaire. Apollinaire said he believed on principle in champion-ing the new and he acted as an impresario for many exponents of the new painting. It was he who popularized the wretched term 'Cubism' — like many style labels a defiant development of a term of condemnation (of Braque's 'cubes' in 1908) and a prime instance of the potentiality of language to obstruct visual perception. He formulated the new painters' intentions in inaccurate but exciting terms, published lists of adherents of 'Cubism' and invented replacement Isms after a time. Braque on Apollinaire:

[He was] attracted to the new painting by sympathy for Picasso, myself and other personalities; also he was a little proud to be part of something new. He never wrote penetratingly about our art ... I am afraid we kept encouraging Apollinaire to write about us as he did so that our names would be kept before at least part of the public.

But it was Apollinaire who introduced Braque to Picasso.

This, in the broadest outline, was a pattern of market addressed by Picasso. In some ways it was a very old pattern. In the eighteenth century Chardin, say, chose to present himself through the official Salon (Pl. 17), which was still not quite alienated from new art, to which he had graduated quite young from the Academy of St. Luke — less a dissident organization, *pace* Roger-Marx, than a down-market one. For nearly twenty years he was *tapissier* in charge of the hanging of the Salon and stayed with it through ups and downs of popularity, unlike Fragonard, for instance, who at a certain point chose to go private and sell direct to an established

clientele. Chardin like Picasso made ready-mades as well as com-
missioned pictures, but they often served as models for replicas,
sometimes a number of them, done to commission. In his career
he produced relatively few new designs, something in the order of
two hundred, but many replicas. The culture press was already
strong and there were many Salon reviews (Pl. 18) but in my view
more important than reviews in Chardin's market were the en-
gravings (Pl. 19) in which his new models were widely and visually
circulated. The main new element in Picasso's market is the
greater role of dealers.

Like most highly evolved markets, Paris 1906–10 was complex
and offered a wide choice to Picasso. This is important: Picasso
had a range of options from which he could choose a broad and, as
I have insisted, generic band of expectation. Within this band
there was much room for manoeuvre and for development of the
Brief arising out of the larger *troc* he had settled on. And Picasso's
works in turn educated and changed the band of expectation:
generic expectations are historically defined and Picasso's work
changed the history by adding to the referents. But the market
plays an elusive part in the Brief also by offering certain cues
through its structure. This is difficult to describe tactfully.

The most striking thing about Picasso's choice in the market
was that he elected to have nothing at all to do with the black
Salons: their catalogues without his name in them (fig. 7 on p. 54) are
the nearest thing to a firm verbal document of Picasso's intention
in these years. It is nowadays so usual for painters to work outside
such regular mixed exhibitions as survive and to present them-
selves through one-man shows at dealers' that the positive as
opposed to inertial implication of this needs emphasis. Picasso
was quite unusual among the considerable new painters in not
once exhibiting at the black Salons: Braque for one exhibited there
as late as 1908 and, as it happens, the man Picasso would have
appeared with in fig. 7, Ramon Pichot (or Pitxot), was the old
Barcelona friend with whom he stayed at Cadaqués in the creative
summer of 1910, just before painting Kahnweiler. From the
beginning in Paris — in 1900 a small sale to the dealer Berthe Weill
and a modest arrangement with the dealer in drawings Petrus
Mañach, the exhibition with Vollard in 1901, the ironic fantasy
strip-cartoon of 1902 which ends with the great Durand-Ruel
summoning him and giving him 'much money' — Picasso's sense

— 136 —

1338 — *Gros temps (eau-forte originale et couleurs, gr.*

1339 — *Drame au Village (eau-forte originale en couleurs, gr.*

PETIT (P. Théodoze), né à Lille. Français. — 3, cité Vaneau. (*Décédé*).

1340 — *La Plage. Le Pouliguen, p.*

1341 — *La Plage. Le Pouliguen, p.*

PFEFFERMANN (Abel), né à Kreslavka. Russe. — 144, rue du Bac.

1342 — *Sans Chemin, ou voyage des Misérables, p.*

PICART LEDOUX (Charles), né à Paris. Français. — 48, rue Durantin.

1343 — *Paysage, p.*

1344 — *Nature morte, p.*

1345 — *Sur la Plage (eau-forte en couleur), gr.*

1346 — *Perverse (pointe sèche), gr.*

PICHOT (Ramon), né à Barcelone. Espagnol. — 142, avenue de Versailles.

1347 — *Ventas del Spiritu Santo, p.*

1348 — *Jardin au pied de la Sierra, p.*

1349 — *Un marché en Espagne, p.*

— 137 —

1350 — *La Sardana (danse populaire espagnole, p.*

1351 — *Bal en plein air, p.*

PIET (Fernand), né à Paris. Français. — 38, rue Rochechouart. s.

1352 — *Marché aux Cochons (Vannes), p.*

1353 — *Marchande de lingerie (Vannes), p.*

1354 — *Lavoir du Grand Duc (Vannes), p.*

1355 — *Lavoir à Guingamp, p.*

1356 — *Lavoir à La Roche, p.*

1357 — *Lavoir à Lamballe, p.*

1358 — *Le Scorf, à Lorient, p.*

1359 — *Au Parc Monceau, p.*

1360 — *Marché aux bestiaux, à Yffiniac, p.*

PIMIENTA (Gustave), né à Paris. Français. 22, avenue Niel.

1361 — *L'Humanité (groupe plâtre), sc.*

1362 — *Tête d'Homme (étude plâtre), sc.*

1363 — *Tête de Femme (étude plâtre), sc.*

1364 — *Vieillard (tête bronze), sc.*

1365 — *Femme au Panier (statuette plâtre), sc.*

Fig. 7. Société du Salon d'Automne, Paris, *Catalogue des Ouvrages*, 1906, pp. 136–7.

of contact with a public was through the mediation of dealers, then through those of the dealers' clients who also found their way to his studio (Pls. 20, 22), and then of course through culture journalism in the Apollinairean sector. This had not been an easy road and certainly cannot be presented as a commercially directed strategy: the pattern of behaviour is not of that kind. By 1906 after some years of great poverty he was on the way to establishing himself, particularly through Vollard but also by drawings sold through the 'courageous' (Kahnweiler's word) Clovis Sagot, with some of the progressive public I have referred to. There were some buyers for the Picassos of, say, 1903–1906. Precisely at that moment, with the studies towards the *Demoiselles d'Avignon* and the consequential new pictures of 1907, he kicked away from this modest support, alienating both a client like Leo Stein and, importantly, Vollard. While relations with Vollard were certainly not broken — some pictures by Picasso were exhibited at Vollard's in the winter of 1910–11 — it was Kahnweiler who came to act as Picasso's most convinced dealer in the Cubist years.

What was positively implied by his avoidance of mixed exhibitions becomes a little clearer if one sets it against the behaviour of the 'minor Cubists' — Albert Gleizes (Pl. 23), Jean Metzinger (Pl. 24), Robert Delaunay and the others — who were black Salon men. In a way it is these men rather than Picasso and Braque who have best title to being called Cubists; they felt the need to be part of a group movement with an explicit programme. Gleizes:

... it was at this moment, October 1910 [the moment Picasso was at work on the *Portrait of Kahnweiler*], that we discovered each other seriously. ...The necessity of forming a group, of frequenting each other, of exchanging ideas, seemed imperative.

This they did, and Picasso and Braque were socially half of it, but not for exchanging ideas: the two Picasso put-offs I quoted earlier — 'Don't talk to the driver'; 'There are no feet in nature' — were replies to enquiries from Metzinger about what Cubists ought to do about this and that. According to Gleizes again, 'We should show as a group, everyone was agreed'. Not quite everyone: in 1911 the minor Cubists staged a sort of coup at the Independents', overriding the traditional ungrouped hanging and taking over Room 41 as a 'Cubist' room, but without the participation in it of either Picasso or Braque. In 1912 Gleizes and Metzinger published

their book *Du 'Cubisme'*, in which Picasso bulks small, and the group exhibition *La Section d'Or* was staged at the *Galerie de la Boëtie*.

In these two kinds of behaviour in two sections of the market two inflections of Brief seem implicit. To put a preliminary point crudely, showing in the chaotically mixed (fig. 7 again) black Salons *one* natural means of registering or maintaining a presence was to be recognizable as one of a class, or group, preferably a class that could be discussed. This is an acknowledgement of the market's generic thinking. In fact the instinct of minor Cubists to hang together, so to speak, shows itself for some years before they became Cubists. To take a slightly absurd signal of this and also to pay a last visit to the Autumn Salon of 1906:

Delaunay (Robert) . . .
 420. Portrait de M. Jean Metzinger, peinture.

Metzinger (Jean) . . .
 1191. Portrait de M. Robert D . . ., peinture.
 (Appartient à M. Robert Delaunay.)

The volubly self-expounding Delaunay was, in fact, an interesting complicating case, uneasy between a group Brief and an apparent feeling that the *great* artist is a nonesuch. He was only half disposed to group Cubism as propounded by Gleizes and Metzinger: by at least 1912 he had developed a self-differentiating derivative, for which Apollinaire provided the distinguishing term 'Orphism'.

Now if being a member of a discussible class was one way of keeping a head above the water of the black Salons, being a conspicuously individual talent was *one* way of doing so when swimming in the dealers' sector. But this is much too coarse a way of putting it: there are at once two important qualifications to be made. Firstly, it is not that the minor Cubists formed a group and Picasso acted an individualist role because these were the clever lines to take in the sub-market, Salons or dealers', they happened to find themselves in. Rather, it is that they went to those sub-markets because they were the appropriate sectors for people with a certain view both of the good artist and of themselves: that is where one would fit. They *accepted* structural elements in Briefs which, however, then surely reconfirmed their view. Reciprocity rules. Secondly, it is not that the market-structural element in

Picasso's Brief was open to only one interpretation or inflection: it is far from determinate in one sense only. Rather, it took definition from being joined with other cues. This brings us back to Apollinaire (Pl. 21), at least as a central representative of the part of the culture press Picasso could look to.

Picasso, Braque and Kahnweiler are all on record in later life as considering Apollinaire a poor critic of painting, and his accounts of Picasso do now seem overblown and unperceptive rhetoric. But looking at 1906–10 as *troc* rather than as market simple, Apollinaire's interesting role appears not as art critic but as something between ideologue and moralist. In this role he comes out as important and effective. In looking to the Apollinairean universe Picasso was going to a set of very broad ideas with deep and complex cultural and social roots which Apollinaire, among others, articulated with great élan. The assumptions were very large but explicit: for instance (and roughly), that Art is a seriously playful matter; that the Artist typically deals in modes of perception and experience; that the good Artist is one who pushes on to new modes; that these can be liberating and enlarging for a beholder disposed to be open and take pains; that certain particular artists from the immediate past, large facts and big values, exemplify this; that the good Artist learns from these and also moves from them; that the good Artist has a new and individual voice. . . .

(Since such ideas have associations with all sorts of social and economic facts — are part of an ideology, if you will — the question can arise as to how far these associations are profitably to be teased out. As with the Forth Bridge (I.3), the answer depends first on one's frame of reference — whether it is social history or pictures one is addressing — as well as one's general view of the springs of human action. If one is doing inferential criticism of pictures from other than economic determinist convictions, then the question is likely to become one of the critical yield in the particular case: of, for instance, the critical usefulness of knowing the political corollaries of the Apollinairean universe, or the retailing analogues in other manufactures of Kahnweiler and Vollard, or the class-social differences between Picasso and Braque on the one hand and Metzinger and Delaunay on the other, or of the socio-economic base of Gertrude Stein — none of these, after all, hard to pin down. In the present case (or that of, say, Chardin) I do not feel it very high on the priorities of the picture considered as an object of

intentional visual interest: but if we were considering, say, Matisse's
La Joie de vivre (or Watteau) I think it would be.)

It is with such notions as the last — that the good artist is an
individual — that the market-structural cue offered by the dealers'
sector needed to mesh before becoming fully determinate. One
would bet Picasso believed the things Apollinaire rhetoricized
long before he had heard of Apollinaire or even visited Paris, but
Apollinaire's articulation of them would have sharpened and
confirmed them just a little. It is always fortifying to hear your
feelings stylishly verbalized by someone you like. And while such
things as Apollinaire articulated are inadequate as art criticism,
taken *en troc* by a man with his own sharp vision for pictures they
play a part, how large one cannot and need not measure. To put it
another way, set — in Picasso's mind — *in a relation with his perception
of the painting of Cézanne* they could mean something much more
precise.

In a general way, then, let us say that matured art markets are
complex and offer the painter a choice of generic briefs which he
can then by his own action revise; but that such markets are much
too simple either to register accurately or to contain the larger
exchange in the *troc*. Part of the market's meaning awkwardly lies
in cues offered by structural facts rather than articulated expecta-
tion. These reflect general structural facts of an economic society,
though not always very promptly or exactly. But their meaning
only becomes really determinate in a relation to an idea. Even very
large ideas, when in very specific pictorial contexts — the general
alongside the particular — do themselves take on definition. And
perhaps this is a good moment to remind oneself yet again that
what we are describing is our thought about a picture — not the
picture, nor mental events in the painter's mind.

6. Excursus against influence

A parenthesis: Mention just now of Cézanne brings me to a
stumbling-block or scandal — the notion of artistic 'influence',
of one painter 'influencing' another — which I must spend a
couple of pages trying to kick just enough out of my road to pass
on.

'Influence' is a curse of art criticism primarily because of its
wrong-headed grammatical prejudice about who is the agent and

who the patient: it seems to reverse the active/passive relation which the historical actor experiences and the inferential beholder will wish to take into account. If one says that X influenced Y it does seem that one is saying that X did something to Y rather than that Y did something to X. But in the consideration of good pictures and painters the second is always the more lively reality. It is very strange that a term with such an incongruous astral background has come to play such a role, because it is right against the real energy of the lexicon. If we think of Y rather than X as the agent, the vocabulary is much richer and more attractively diversified: draw on, resort to, avail oneself of, appropriate from, have recourse to, adapt, misunderstand, refer to, pick up, take on, engage with, react to, quote, differentiate oneself from, assimilate oneself to, assimilate, align oneself with, copy, address, paraphrase, absorb, make a variation on, revive, continue, remodel, ape, emulate, travesty, parody, extract from, distort, attend to, resist, simplify, reconstitute, elaborate on, develop, face up to, master, subvert, perpetuate, reduce, promote, respond to, transform, tackle ... — everyone will be able to think of others. Most of these relations just cannot be stated the other way round — in terms of X acting on Y rather than Y acting on X. To think in terms of influence blunts thought by impoverishing the means of differentiation.

Worse, it is shifty. To say that X influenced Y in some matter is to beg the question of cause without quite appearing to do so. After all, if X is the sort of fact that acts on people, there seems no pressing need to ask why Y was acted on: the implication is that X simply is that kind of fact — 'influential'. Yet when Y has recourse to or assimilates himself to or otherwise refers to X there are causes: responding to circumstances Y makes an intentional selection from an array of resources in the history of his craft. Of course, circumstances can be fairly peremptory. If Y is apprentice in the fifteenth-century workshop of X they will urge him to refer to X for a time, and X will dominate the array of resources that presents itself to Y at that moment; dispositions acquired in this early situation may well stay with Y, even if in odd or inverted forms. Also there are cultures — most obviously various medieval cultures — in which adherence to existing types and styles is very well thought of. But then in both cases there are questions to be asked about the institutional or ideological frameworks in which

these things were so: these are causes of Y referring to X, part of his Charge or Brief.

The classic Humean image of causality that seems to colour many accounts of influence is one billiard ball, X, hitting another, Y. An image that might work better for the case would be not two billiard-balls but the field offered by a billiard table. On this table would be very many balls — the game is not billiards but snooker or pool — and the table is an Italian one without pockets. Above all, the cue-ball, that which hits another, is *not* X, but Y. What happens in the field, each time Y refers to an X, is a rearrangement. Y has moved purposefully, impelled by the cue of intention, and X has been repositioned too: each ends up in a new relation to the array of all the other balls. Some of these have become more or less accessible or masked, more or less available to Y in his stance after reference to X. Arts are positional games and each time an artist is influenced he rewrites his art's history a little.

Let X be Cézanne and Y Picasso. In the autumn of 1906 Cézanne died and Picasso started working towards *Les Demoiselles d'Avignon* (Pl. 7). For some time Picasso had been able to see pictures by Cézanne: in particular, his dealer Vollard had large holdings and there were large Cézanne exhibits at the Autumn Salon in 1904 and also in 1907, when there was besides an exhibition of Cézanne watercolours at the Galerie Bernheim Jeune. Many of the new painters were drawing on one or another aspect of Cézanne, never quite the same. For instance, Matisse, who had bought a *Trois Baigneuses* by Cézanne with his wife's dowry in 1899, read in Cézanne a reductive registration of the local structures of the human figure. This reading Matisse put to distinctive use around 1900 as a means to a form both energetically decorative on the picture-plane and suggestive of a toughly colossal sort of object of representation. In time this reading of Cézanne was absorbed into complex modes in which readings of other painters were also active for Matisse, who was an eclectic referrer.

In 1906–10 Picasso (one infers) saw Cézanne (Pls. 25, 26) in various ways. In the first place Cézanne was for him part of the history of interesting painting he chose to be aware of and which constituted his Charge. But then, by attending to him, he made him more than that. There were various rather general Cézannian things Picasso accepted *en troc* from the culture, as part of his Brief: one would be Cézanne as an epic model of the determined indivi-

dual who saw his own sense of the problem of painting as larger than any immediate formulation urged on him by the market; another might be some of Cézanne's verbalizations about painting — 'deal with nature in terms of the cylinder, the sphere, the cone ...' and so on — which, in the form of letters to Emile Bernard, were published in 1907. But then, too, Cézanne was part of the problem Picasso elected to address: there are indications in the composition and in some of the poses of *Les Demoiselles d'Avignon* that one of the elements Picasso was tackling here was a sense of problems left by Cézanne's pictures of bathers, a sense that these were something to tackle (Pls. 7, 26). But again, and very obviously, Picasso also went to Cézanne's pictures as an actual resource, somewhere he could find means to an end, varied tools for solving problems. The matter of Cézannian *passage* — of representing a relation between two separate planes by registering them as one continuous superplane — I have already mentioned, but there are other things too Picasso is considered to have adapted from Cézanne: for instance, high and sometimes shifting view-points that flatten out on the picture-plane arrays of objects phenomenally receding in depth (Pls. 13, 25). To Picasso different aspects of Cézanne were what 'Span!' and side winds and the cantilever principle and Siemens steel were to Benjamin Baker — or as, in what is emerging as my grossly oversimplified and over-schematic account, I described them as being to Baker.

To sum all this up as Cézanne influencing Picasso would be false: it would blur the differences in type of reference, and it would take the actively purposeful element out of Picasso's behaviour to Cézanne. Picasso acted on Cézanne quite sharply. For one thing, he rewrote art history by making Cézanne a that much larger and more central historical fact in 1910 than he had been in 1906: he shifted him further into the main tradition of European painting. Then again, his reference to Cézanne was tendentious. His angle on Cézanne — to revert to the billiard-table image — was a particular one, affected among other things by his having referred also to such other art as African sculpture. He saw and extracted this rather than that in Cézanne and modified it, towards his own intention and into his own universe of representation. And then again, by doing this he changed for ever the way we can see Cézanne (and African sculpture), whom we must see partly diffracted through Picasso's idiosyncratic reading: we will never

·see Cézanne undistorted by what, in Cézanne, painting after
Cézanne has made productive in our tradition.

'Tradition', by the way, I take to be not some aesthetical sort of
cultural gene but a specifically discriminating view of the past in
an active and reciprocal relation with a developing set of dispo-
sitions and skills acquirable in the culture that possesses this view.
But influence I do not want to talk about.

7. Angles on process: positing the intentional flux

A more pressing and interesting issue is how an account of
intention stands to the element of 'process' in the making of a
picture.

One of the apparent differences between the Forth Bridge and
the *Portrait of Kahnweiler* was that, with the first, it was not a great
strain to distinguish between two phases, a process of design by
Baker and a process of execution by William Arrol. But Picasso
acted as his own Arrol, and in the *Portrait of Kahnweiler* design and
execution must be taken to interpenetrate one another much
more. In fact the difference is hardly one of principle: there was
interpenetration at Queensferry too, since Baker no doubt modi-
fied details and Arrol certainly improvised to meet contingencies.
But it did not do much violence to the interest of the case to
distinguish quite sharply between design and execution. For many,
not all, good pictures this would be destructive.

Cézanne had said, and Picasso later quoted him with approval
as saying, that every brushstroke changes a picture. The point
they were making was not that a finished picture will look
different if even one brushstroke is removed or changed. They
meant that in the course of painting a picture each brushstroke
will modify the effect of the brushstrokes so far made, so that with
each brushstroke the painter finds himself addressing a new
situation. For instance, the addition of a new tone or hue can
modify the relationships and the phenomenal character of the
previously placed tones and hues; and because of the simultaneous
presence of the elements of a picture this effect is very powerful,
however clearly the painter has in mind a final character. This is to
say that in painting a picture the total problem of the picture is
liable to be a continually developing and self-revising one. The
medium, physical and perceptual, modifies the problem as the

game proceeds. Indeed some parts of the problem will emerge
only as the game proceeds. The sense of a dimension of process, of
re-formulation and discovery and response to contingency going
on as the painter is actually disposing his pigments, is often
important to our enjoyment of the picture and also to our under-
standing of how styles historically evolve and change. This need
not be argued out on the basis of some aesthetic theory of self-
discovery; it is intuitively obvious to anyone who has made
anything at all.

A static notion of intention, supposing just a preliminary stance
to which the final product either more or less conforms, would
deny a great deal of what makes pictures worth bothering about,
whether for us or for their makers. It would deny the encounter
with the medium and reduce the work to a sort of conceptual or
ideal art imperfectly realized. There is not just *an* intention but a
numberless sequence of developing moments of intention —
$I^1{\rightarrow}I^2{\rightarrow}I^3{\rightarrow}$. . . What is more, this process will have included not
only innumerable moments of decision and action but many
foregone or cancelled actions, decisions *not* to do or leave some-
thing — . . . $I^3{\rightarrow}[I^4{\rightarrow}I^5{\rightarrow}]I^6{\rightarrow}$. . . — which have had consequences for
the picture we finally see. Can we accommodate this sort of
complexity in an account of the intention of a picture?

The answer is clearly both no and yes. We certainly cannot
accommodate it on the level of a narrative reconstruction of the
thousands of decisions and actions and perceptions and foregone
actions that Picasso went through with his picture. Of course,
sometimes a visible pentimento and occasionally the availability of
studies related to a picture may give us a glimpse of process under
way, but not a basis for plotting it stroke by stroke. This is not
very worrying: the ambition to narrative is something we have
eschewed. And while we cannot narrate process, we can posit it. A
particular process may not be reconstructable, but a general
assumption of the fact of process can be determining in an account
of the intention in a particular picture. Practically the question
becomes one of what we think we are making inferences from and
about, when we describe intention. And the first point it is worth
being clear on is that the intentional items we infer exist on
various different levels: some are seen as secondary to others.

At Queensferry one of the primary elements of Baker's problem
was the need for a long span and another was the need for the long

span to be strong enough to withstand side winds. One of the
means he resorted to in addressing these was the use of steel. But
this set derivative problems, one being steel's relative sensitivity
to shear stress. This secondary or derivative problem, emerging
from the medium, was one of the things that Baker then solved
with his tube and lattice girder forms. Something like this is
happening in our view of the *Portrait of Kahnweiler*.

As representatives of the problem-complex Picasso evolved
from his Brief, I offered in II.2 three conceptualizations — tension
between two and three dimensions; tension between priorities of
form and colour; the contradiction between sustained experience
and the fictive instant — about the balance of his attitude to
painting in the early Cubist years. Those and some others would
be something like primary problems. Individually they advance
and recede now and then in 1906–12, but in some degree they are
continually there: *Les Demoiselles d'Avignon* had set them out
starkly. But as soon as Picasso takes them to the medium — one is
speaking schematically — and addresses them with a view to a
solution, secondary problems arise and each successive picture is
involved with a developing repertory of these. It is, no doubt,
these that the painter himself is often most immediately aware of,
and this is one reason why painters' statements about their art
often seem at odds with what the observer sees. Arriving in 1910,
the year of the *Portrait of Kahnweiler*, we are aware of the primary
problems still much in play, both as a starting point for the longer
development we are watching and as general terms within which
we can see the intention of the individual pictures. But the surface
narrative is much more complex: a whole evolving set of secondary
(and tertiary and so on) problems spring out of the canvases and
Picasso's involvement with these has much to do with his develop-
ment. And in this our sense of development, our knowing what
comes before and what comes after a particular picture, is
obviously active; we have hindsight and a sort of foresight.

Here are a few of the derivative problems we apprehend in the
Portrait of Kahnweiler. There is a problem, newly heightened by the
leaving open of the plane edges of the figure, of distinction
between figure and ground, between the man and what lies
around and behind him. The immediate solution has been to
establish the distinction tonally and by hue; the man is darker than
the ground next to him, and also less yellowish. But this sets

another problem. Given our experience of looking at nature and more especially at pictures, it is hard not to apprehend this differentiation as representational of some sort of difference of illumination. And this is related in turn to a further and large problem about what is happening to colour, in the sense of hues. This is basically a duochrome picture. The problem was to increase for a year or so yet, to the point almost of monochromy, before being partly solved and partly evaded — Braque leading on this occasion and Picasso rather hesitantly following — by detaching hue from the hued object itself and redisposing the sum of hues in a more independent arrangement. And this was in turn a solution that was always to be in tension, as a cognitive compact between painter and beholder, with the Cubist ambition about volumes and masses. Then there is a problem — and the African mask that is partly responsible for it happens to be looking straight in its direction — about the residual presence of tonal relief modelling on a basis of directional lighting from the right of the picture. It is clearest in Kahnweiler's face (Pl. I), distinguished by a thick impasto: consider the chin or the concave right cheek *à l'africaine*. The problem of the recomposition of faces was clearly exercising Picasso in 1910. If one looks back to the *Portrait of Vollard* (Pl. 28) in the spring of 1910, the problem seems simply to have been dodged: if one half-closes one's eyes the phenomenal Vollard jumps out like a photograph. Then there is a problem, which had been emerging during the summer of 1910, about the relation of scale, whether absolute or perceived, to the registration of objects. This is stated very clearly in the passage to the middle right, next to the figure. Then there is a problem about local texture. For instance, all that stippling on the periphery must have been rather uninteresting to do and is also uninteresting to see. As Kahnweiler put it — with the benefit of hindsight — there was a question as to whether oil-paint was really the medium needed for this particular enterprise. In a year or two a range of diversifying devices, Braque again leading, were to appear — collage and papier collé, decorators' graining combs, sand and fine gravel mixed with the oil paint. Above all, there is a problem stated firmly in the still life (Pl. I) in the bottom left-hand corner. We know it is a still life because of where it is and because of the readable bottle at the top. But without these clues we might as easily think it was one of the Spanish hill villages (Pl. 31) Picasso had been among that summer.

The problem is about the relative authority of the immediate object of analysis, on the one hand, and the structural schemes and analytical disposition the painter had developed during a history of looking at many different objects, on the other. Much of the interest of the next years — the so-called synthetic phase — would lie in attempts to solve this.

So Picasso's painting appears as one episode in a serial performance of problem-stating and problem-solving. In this mood we are looking forwards, as it were, towards the performance. But we also have a declaration of Picasso's intention after the fact, the picture itself — or rather the fact that he stopped work on it. When someone relinquishes a piece of work as being done with, they are making a qualified statement of retrospective intention or a retrospective statement of intention or both. It is implicit that the work satisfies them in some degree, if only as having got to a point where it seems better to leave off and start a new work in which this or that will be better and the lessons learned in a semi-failure will be put to use. This is often a difficult moment, a pause in the serial process. A short history of European art could be written round the 'finishing' agony or Protogenes predicament, and Picasso in the Cubist years would be part of it. He was a little like the ancient craftsman who signed his pieces not *X fecit* but *X faciebat*, the imperfect tense admitting no more than that he had been at work on the object. It is one of the few documentable facts about Picasso's mind in these years that he was so sensitive to this difficulty. *Les Demoiselles d' Avignon* was pronounced unfinished; it stated problems rather than solving them. Earlier in 1910 work had ceased on the *Girl with a Mandolin* only when the girl refused to pose any more: Picasso said afterwards that it might be just as well he had left it as it was. In 1912, when he made an agreement with Kahnweiler to sell him all his production, at prices fixed by size, the only real conditions he made were about retaining drawings still active in the serial process (Pl. 20) — 'drawings I shall judge necessary for my work' — and about himself being judge of whether or not a picture was finished: '*Vous vous en remettez à moi pour decider si un tableau est terminé.*' In the paintings let go by such a careful relinquisher we have a reluctant statement that the intention acknowledged at that moment — not I^1 but I^{1001} — has been, not fulfilled surely, but moved towards.

The view of the picture's intention forwards — in terms of a

man approaching problems of different orders — and the view backwards from the 'finishing' involve views of the intentional flux that are foreshortened, from either end. But the fact that we have two perspectives on it gives a degree of relief to the process. To put it at its simplest, we can compare before with after — 'before' being in practice heavily based on previous pictures, rather as we compare the face of Vollard with the face of Kahnweiler. We infer from the comparison that the second was partly an attempt to address a problem seen in the first.

Notionally we have a similar dual access to any element within the process, even down to the level of any one brushstroke. Every brushstroke is intentional in the sense that it has been made by a man whose skills and dispositions have developed in the course of purposeful activity. The fact that a brushstroke may have been unreflectively made does not isolate it from the skills and dispositions acquired in a history of reflectively purposeful activity. The downstroke I make with my pen as I write the p in 'problem' is something I do not reflect on but it is certainly intentional. Long ago I put conscious effort into learning to write p, and into learning the purposes of doing so: if challenged on why I make this unthinking movement with my hand I could produce a purposeful reason. It is intentional in two ways: it is a disposition acquired in the course of a history of purposeful activity; and it is an action that contributes to a larger purpose — writing the word 'problem'. The intentionality of a brushstroke not reflected on is similar. At the same time the brushstroke we see in the picture lets us assume a decision that it will do, or will have to do. Even in the extreme case of an accidentally made mark — and certainly in the case of a deliberately accidental mark — if it has been left, it has been judged suitable. For an incident to be serendipitous there must be serendipity criteria, and these constitute an intention.

But in fact we do not normally attempt an account of progressive intention on this microscopic level, any more than a weather chart shows individual clouds. Weather charts, positing a developing process, say something about it in a static medium with symbols that are both conventional and generalizing. We, using words, do something a little the same. We posit $I^1{\to}I^2{\to}I^3{\to}[I^4{\to}I^5{\to}]I^6{\to}\dots$ rather than describe it, and we cover its interest with large approximations that generalize about the sum of intention.

8. Kahnweiler, Picasso and problems

In talking of Picasso's *Kahnweiler* so unremittingly in terms of 'problems' I have been following Kahnweiler's Picasso:

The beginning of Cubism! The first onslaught. Desperate, Titanic wrestling with all problems at once. With what problems? With the fundamental problems of painting: the representation of the three-dimensional and the coloured on the plane surface, and their comprehension within the unity of this plane surface. But 'representation' and 'comprehension' in the strictest, highest sense. Not ['representation' as] counterfeiting of form by means of light and shade, but rather a demonstration of the three-dimensional by means of design on the plane. Not ['comprehension' as] pleasing 'composition', but rather an inexorable articulated construction. And then the problem of colour as well, and lastly the most central and difficult point, the alloyage and conciliation of the whole.

Daringly Picasso starts to grapple with all the problems at once. He puts sharply angular images on the canvas now, heads and nude figures mostly, in the brightest colours, yellow, red, blue, black. The colours are put on in a thread-like way, to serve as lines of direction and to develop the plastic effect in conjunction with the design. After months of the most intense search Picasso perceives that the problem cannot be completely solved by following this path. ...

Now follows a short period of exhaustion. The bruised and flagging spirit turns to problems of pure construction. A series of pictures emerges in which only the organization of the colour planes seems to have occupied the painter. Retreat from the diverse multiplicity of the physical world, to the undisturbed calm of the work of art. Indeed, soon Picasso will be in danger of reducing his art to decoration.

Already in the spring of 1908 we find him once again at work, now out to solve one at a time the tasks set him. It is necessary to start from the most important. The most important seems to him the demonstration of form, the representation on the two-dimensional plane of the three-dimensional object and its location in three-dimensional space. As he once said: 'In a painting by Raphael it is not possible to ascertain the distance between the tip of the nose and the mouth. I would like to paint pictures in which that would be possible'. At the same time the problem of comprehension — of construction — remains of course always in the foreground. On the other hand, the problem of colour is completely excluded.

Picasso's view of things in a statement — when modern artists talk about painting what they say is termed a 'statement' — of 1923 seems rather at odds with Kahnweiler:

I can hardly understand the importance given to the word *research* in connection with modern painting. In my opinion to search means nothing in painting. To *find* is the thing. ...

Among the several sins that I have been accused of, none is more false than that I have, as the principal objective in my work, the spirit of research. When I paint, my object is to show what I have found and not what I am looking for. In art intentions are not sufficient and, as we say in Spanish, love must be proved by deeds and not by reasons. What one does is what counts and not what one had the intention of doing. ...

The idea of research has often made painting go astray, and made the artist lose himself in mental lucubrations. Perhaps this has been the principal fault of modern art. The spirit of research has poisoned those who have not fully understood all the positive and conclusive elements in modern art and has made them attempt to paint the invisible and, therefore, the unpaintable. ...

The several manners I have used in my art must not be considered as an evolution, or as steps towards an unknown ideal of painting. All I have ever made was made for the present. ...

Perhaps Kahnweiler, a reader of philosophy, did tend to intellec-tualize; and certainly Picasso was speaking, in 1922 or 1923, at a bad moment of disorientation and split idiom, and is also enjoying himself jibing at clichés of the moment. But let us suppose, for the moment, that they are both describing Picasso in 1906–12 and are both right.

There may be a danger of equivocation here. A 'problem' — practical or geometrical or logical — is normally a state of affairs in which two things hold: something is to be done, and there is no purely habitual or simply reactive way of doing it. There are also connotations of difficulty. But there is a difference between the sense of problem in the actor and in the observer. The actor thinks of 'problem' when he is addressing a difficult task and consciously knows he must work out a way to do it. The observer thinks of 'problem' when he is watching someone's purposeful behaviour and wishes to understand: 'problem-solving' is a construction he puts on other people's purposeful activity. The intentional behaviour he is watching does not always involve an awareness in the actor of solving problems. Indeed, when the observer is of a different culture from the actor — not Kahnweiler's but the historian's case, to which I shall be returning much later — he may put the construction of problem-solving on behaviour which is habitual: the culture has taught the actor the trick of solving unreflectively

a problem he does not know exists. An attention to 'problems' in the observer, then, is really a habit of analysis in terms of ends and means. He puts a formal pattern on the object of his interest.

In logic one technical sense of 'problem' is the question implicit in a syllogism. 'All men are mortal and Socrates is a man, so Socrates is mortal'. The 'problem' implicit in this piece of ratiocination is: 'Is Socrates mortal?', and it is solved in the conclusion. But one could discourse in the propositional style of the syllogism without ever actually formulating the problem as a question: one frequently does. Nevertheless one would have solved the problem and an observer of one's reasoning could identify the problem as part of the underlying structure of one's behaviour. Solving it would be, for him, the end one was moving towards. The relation between Picasso and Kahnweiler is rather the same. Picasso went on as he did and 'found' conclusions, or pictures; Kahnweiler sought to understand his behaviour by formulating implicit 'problems'. To fault him for doing so would be to claim that Picasso's behaviour was undirected, and this would be difficult to sustain of any painter who liked some pictures more than others.

Picasso the participant and Kahnweiler the observer had different angles on the same events of 1906–12. Their experience of them also came from different levels. For Picasso the Brief and the grand problems might largely be embodied in his likes and dislikes about pictures, particularly his own: he need not formulate them out as problems. His active relation to each of his pictures was indeed always in the present moment, and at the level of process and emerging derivative problems on which he spent his time. As he says, it would feel like finding rather than seeking. In a sense, since it was his pictorial dispositions that were evolving between 1906 and 1912, his painting was at any one moment almost habitual. But even to 'find' presupposes criteria of what is a find: that he was not always reflectively aware of his criteria does not mean he did not have them. And to have criteria by which one assesses one's performance is to act intentionally.

For Kahnweiler, on the other hand, the donné was a series of difficult pictures. For him each picture was a starting-point, not a conclusion of activity. His active relation with it was as someone else's finished thing which he must understand. What to Picasso might at any moment be habitual appeared to Kahnweiler as idiosyncratic behaviour in need of understanding. Moreover his

view of events was more remote, less on the level of process in the making of a single picture, more on the level of differences between one finished picture and another and the sense this gave of development. To understand all this he assumed intentionality, which meant he must think in terms of ends and means. These he inferred from the character of Picasso's pictures in comparison with other men's pictures, and also from a change he perceived in their character over time. And he verbalized ostensively and well about the construction he put on the interest of what he saw. Picasso and Kahnweiler are not so much contradictory as differently placed.

However, the particular case of Picasso and Kahnweiler is not quite so simple. That is the way of particular cases. Kahnweiler's account of Picasso is value-laden: one does surely get the impression from him that wrestling productively with fundamental problems is a good thing to do. And the culture from which Kahnweiler derives this value was one which Picasso partly shared with him. That is to say, Kahnweiler is telling us something about what was available to Picasso in the *troc*. It is impossible to believe Picasso did not pick it up.

The extraordinary thing that happened in 1906–12 was an abrupt internalization of a represented narrative matter into the representational medium of forms and colours visually perceived. Picasso had long had some leaning towards subject-matter oddly close to the Victorian 'problem-picture': *La Vie*, for instance, but also the early idea for what became *Les Demoiselles d'Avignon* itself, with sailor, student and skull. He had also long had a leaning towards acrobats and performers in motley, often *after* performance; to himself in self-portraits; to people looking at themselves in mirrors; to strained human beings in meditative situations. In 1906–1907 these subjects practically disappeared. Instead Picasso reverted to the pure sub-narrative genres of the tradition — the nude figure, the still life, the landscape, the portrait (Pls. 9–14). At the same time the earlier narrative themes were appropriated by Picasso's own performance: what he had formerly depicted on the canvas he now enacted on the canvas as an acrobatic post-dramatic, occasionally joky meditation on his own perceptual process. Above all the pictures are problem-pictures of a new and double kind. They set the beholder puzzles, for they are difficult to understand, and Picasso surely knew it. But, more to the point, they

act out Picasso's own serial performance of problem-finding and problem-solving. Picasso became a cognitive acrobat of a conspicuous and dazzling kind. Kahnweiler's account of these years is both an external account of how things looked and a culturally internal account of an element in Picasso's Brief.

What makes the Cubist enterprise so enjoyable is, of course, a whole set of things. One is the dazzling talents of Picasso, and of Braque. (Braque's role makes Picasso's Cubist episode intermittently a conversation piece as well as a self-portrait.) Another is the stamina with which they sustained this epic serial performance over five years or more. Another is that Picasso fulfilled the first condition of effective 'research', which is to pick the right problems: precisely because they were beginning to emerge in his own idiom in the pre-Cubist pictures of 1905–1906, his idiom was a medium in which they could be developed and then addressed. When he first set them out formally in *Les Demoiselles d'Avignon* it was not an arbitrary picking of pieces of apparatus on which athletically to twirl: they were *his* problems. Again, Kahnweiler was right to call them fundamental: the problems Picasso first identified in himself and then acted out are real and important problems both of pictures and of the visible world. But in the present context what is fascinating about Picasso's *Portrait of Kahnweiler* and the pictures of 1906–12 is that the stuff of the narrative is a pattern of intention itself.

9. Summary

I began by proposing that when we speak of the intention of a picture we are not narrating mental events but describing the picture's relation to circumstances on an assumption that its maker acted intentionally; and I then suggested that the painter's general Charge to provide 'intentional visual interest' became in any particular case a specific Brief which he might well apprehend largely as a critical relation to previous painting; and I said that when we conceptualize about this critical relation we are covering for our own rational purposes a balance in his attitudes to previous painting which we infer from his painting; and I insisted that on the one hand, he evolves this Brief for himself but that, on the other hand, he does so as a social being in cultural circumstances; and I opined that for the purposes of inferential criticism a

sufficient model for his relation to these was that of an exchange or *troc* in which the satisfaction offered by his pictures reciprocated with such things as reassurance, irritation, ideas, roles, heredities, skills and coin; and I made the point that there was interference with this *troc* by forms and behests of the 'market' in the normal sense of the term; and I found it important to assert that both *troc* and market offer the painter choice and that the painter acts reciprocally back on his culture; and, after evading proper discussion both of ideology and artistic influence, I emphasized that the painter's complex problem of good picture-making becomes a serial and continually self-redefining operation, permanent problem-reformulation, as soon as he enters the process of actually painting; and I presented in the course of all this an over-schematic view of Picasso in 1910, the simplicities of which will be redeemed by the fact that it stands in an ostensive relation to the complex paintings themselves.

III

PICTURES AND IDEAS:
CHARDIN'S *A LADY TAKING TEA*

Quand j'ai fait un beau tableau, je n'ai pas écrit
une pensée. C'est ce qu'ils disent. Qu'ils sont simples!
(Delacroix, *Journal*, 8 October 1822)

1. Painters and thought

IN WHAT follows now I want to do several things which will lead
to a different texture, a closer focus and a smaller grain. First I
have to provide something that is questionable, in a sense and for
reasons I shall be returning to later. Secondly, it is time to address a
piece of detail. The account of Picasso in 1910 was very schematic
and general: it had to be, because I was trying to block in a general
scheme in relation to an already existing account of early Cubism.
But art criticism, quite apart from trying to go beyond current
accounts, typically works close to particulars. It takes its sense of
reality from close contact with detail, both specific observation of
the quality of a picture and — if it is inferential criticism — good
gritty bits of causal circumstance. Thirdly, since I made a point of
Picasso's self-formulated Brief being historical, involving classic
issues of painting inherent in the painting he saw, I should look at
one part of it in an earlier stage of its history: the issue of what a
picture represents did not originate in 1906. Fourthly and princi-
pally, I claimed in passing that one of the things a painter can
acquire *en troc* from his culture is the articulation of ideas. I want to
pick up this thread now — it is a difficult and interesting matter —
and discuss how far we can think, to critical purpose, about
relations between the visual interest of pictures and (taking the ex-
treme case) the systematic thought, science or philosophy, of the
culture they come from. I shall do this by addressing an example,
but before coming to that must make clear the limits of the exercise.

There is a preliminary disclaimer to be made. 'Thought' can
mean a range of things, and it seems important not to suggest that
philosophy or science are more or better thought than what a

painter does as he paints. We will want to take, or at any rate adapt, Delacroix's point: the typical form of thought in a picture is something more like 'process', the attention to a developing pictorial problem in the course of activity in a pictorial medium. Neither the painter nor we plot it closely on a conceptual level. It can be asked, then, why one should try to associate a style of painting with something as closely conceptualized as a position in philosophy or science. It seems tactless to link such incommensurable universes and, besides, many attempts to do so have been lax or silly.

There seem two main reasons for making the attempt. The first is that painters cannot be social idiots: they are not somehow insulated from the conceptual structures of the cultures in which they live. If one supposes they ever reflect on painting at all, then concepts and groups of concepts will have some part in it; and a man with a critical or self-critical concept is a man with an operative theory. However, it seems to me important that if a concept is active in the mind it is directed to some object, and this is so too of the more evolved sort of idea taken from a philosophy or science. *If* Picasso took on something of Bergson's sense of the part played in perception by duration of experience through time, as has been suggested, then that would bear first on his sense of relation to the object of representation. *If*, as has been suggested, he took on something of Nietzsche's sense of the superman who imposes an idiosyncratic vision of the world on other people, that would bear first on his sense of relation to an audience. Active ideas do not float, they are brought to bear.

The second reason for making the attempt lies in ourselves. Our intuitions of affinity between the forms of pictures and forms of thought can be quite pressing. The springs behind such intuitions are no doubt mixed — a desire to see human cultures and human minds as wholes rather than fractured and fortuitous; a desire to acknowledge obliquely the intellectual seriousness of the painter; a desire, certainly, to bring painting more within range of our own centrally verbal and conceptual media of reflection — but they are not really disreputable. If one is not simply going to try to suppress such intuitions then the question is: can one move from a vague sense of affinity towards something critically useful and historically sustainable? And does one move through critically interesting terrain when one tries?

Specificity of bearing and critical edge and (as I shall later be maintaining) historical status are all closely related. An observation sometimes made about the painting of early Cubism is that it was contemporary with the new physics of Max Planck and Einstein. It is hard to see what one can do with this or indeed quite what it means. First, to relate Picasso and Einstein one has to subsume them under some very general and external description — let us say, a 'representation of realities independent of limitation by the point of view of a posited observer'. Then, since the means through which a link between the new physics and painting could be active in Picasso's mind are not implicit in the observation, one would have to work out some sort of causal process through which the two could have contact. And if, as seems likely, one then fell back on some indirect relation involving mediation or independent exposure to a common factor, then the critical immediacy is gone. In other words, whether or not there is anything in it, there is not much one can do about it, as an inferential critic.

For these reasons in what follows I shall make two limiting demands of the connection between ideas and painting I want to pursue. First, the science or philosophy invoked must be made to entail fairly directly a particular thing about visual experience and so about possible pictorial character. I shall hope for a pictorial corollary, as it were, such that the scientific thought could enter the painter's self-Briefing. Secondly, I shall demand some indication that it was conceivable, in the period, for the two universes to be brought into this sort of relation. In effect this means I need to produce men capable of reflecting on the relation of painting and science that I claim existed, something it would be hard to find for Picasso and Einstein in 1906. So the form of statement I shall be aiming for is: X (or, more weakly and usually, relevant people in X's culture) can be shown to have had such-and-such a conceptual resource or disposition, functional possession of which by X would be entailed by such-and-such an observable quality in his pictures — observable, at least, by someone aware of this conceptual resource.

2. Vulgar Lockeanism and vision

The starting point is a sense that there is some sort of affinity

between a kind of thought and a kind of painting. It is a very vague sense that there seems a liaison between some kinds of mid-eighteenth-century painting — I have in mind particularly the painting of Chardin — and an empiricist strain in later seventeenth-century philosophy and science that spread out through western Europe in the course of the eighteenth century. As more than representative figures in this current of thought I have in mind Isaac Newton and John Locke. In fact Newton and Locke crystallize elements long under preparation during the seventeenth century, not all of them empiricist in colour at all. But they are particularly to the point both because they were current and discussed in eighteenth-century France and because they both spoke directly on visual perception. The sense of affinity has something to do with Chardin and Locke, say, seeming to share a distinct sort of perceptual nervousness and self-consciousness, an awareness of the complexity and even fragility of the act of perception. It is very vague indeed, and hardly historical.

Because both Newton and Locke reflected importantly on visual perception, it is possible to go a little way towards deriving relevant sorts of visual, if not immediately pictorial, corollary from their work. To do so involves isolating and coarsening parts of larger patterns of thought, but in doing this we are doing what many eighteenth-century people did. In fact, there seems an important point to make here: what one is working with historically is not so much 'Newton' or 'Locke' as kinds of vulgar Newtonianism and vulgar Lockeanism widely current in Europe. These were selective in their emphasis — for instance, much more attention was paid to the psychology implied and described in Books I and particularly II of Locke's *An Essay Concerning Humane Understanding* (1690) than to the logical and metaphysical arguments of Books III and IV — and it is this emphasis we follow. During the seventeenth century there had been a series of shifts in thinking about perception in general that directed many people's minds towards the subject in perception, towards the perceiver. Newton and Locke appeared as climactic figures in this shift.

Newton had proposed, among other things, that colours — the qualities the painter manipulates — are not objective qualities but are sensations in the mind. Colours do not exist in the objects of vision; but nor do they exist in the light that brings us visual knowledge of them and is the *immediate* object of vision:

... Colours in the Object are nothing but a Disposition to reflect this or that sort of Rays more copiously than the rest, in the Rays they are nothing but [a] Disposition to propagate this or that Motion in the Sensorium, and in the Sensorium [they are] therefore Sensations of those Motions under the Forms of Colours.

It is for this reason that Newton speaks in his stricter moments not of 'red' light, but of 'rubrifick' or 'red-making' light. Colours — red, blue, yellow and the rest — are functions of the beholder's sense and mind when assaulted by a specific condition of particle.

John Locke, who provides a psychology conformable with Newton's physics of colour, laid stress on — again among other things — our not coming into the world with a developed ability to perceive visually even primary or intrinsic or objective qualities like figure or form. We do not arrive in the world ready-equipped to *see*, say, a sphere. By experience and by comparison between senses we learn to associate specific passions of a sense with specific qualities of substance. Thus we learn empirically to associate, for example, the sensation caused by a *touched* sphere with the sensation caused by a *seen* sphere and, reflectively combining these sensations, we develop the idea of a sphere. When we have done this, we are in a position to have knowledge of a sphere.

The Newtonian sense of colour and the Lockean model of perception worked powerfully together. In 1759 William Porterfield neatly summed up five heads under which we can consider a post-Newtonian colour:

... Colours may be considered five several Ways:
 1mo. They may be considered as Properties inherent in the light itself.
 2do. As qualities residing in the Body that is said to be so and so coloured.
 3to. Colours may be considered as the Passion of our Organ of Sight, or, which is the same Thing, the Agitation of the Fibres of the *Retina* by the Impulse or Stroke received from the Light, which Agitation is communicated to the *Sensorium* where the Mind resides, else it could perceive nothing.
 4to. They may be considered as the Passion, Sensation or Perception of the Mind itself, that is, the Idea excited therein by the Agitation of our Organs. And,
 5to. Colours may be considered as the Judgement which our Mind forms when it concludes, that that which it feels or perceives is in the Body itself said to be coloured, and not in the Mind.

Not many would discriminate as carefully as this, but the effect of the new philosophy was generally to make visual perception interestingly problematic.

Of course, there is very much more to Newton and Locke on perception. I am simply locating that thrust of the new ideas about the role of the subject in perception from which I hope to find something that can be brought to bear on pictures. Through much of the eighteenth century a range of people were coming to terms with these ideas. Some developed them: in France Condillac was to restate and extend Locke (who had been translated into French in 1700) in a very stark form indeed. Many more picked up simplified and partial versions from this and that source of vulgarization: there were periodicals and encyclopedias and lively summaries like that in Voltaire's controversial *Lettres philosophiques* (XIII and XVI) of 1733/4, but also brilliant popularizing manuals like Francesco Algarotti's European best-seller *Newtonianism for the Ladies* of 1737. Algarotti on Newton's view of colour:

'To be serious', said the Marchesa, 'I have always supposed that that colour I have on my cheeks — such as it is, Sir — really was on my cheeks, whereas the colours in the prism and the rainbow only appeared to be there. Pray explain me this paradox, which in truth troubles me, and make clear to me why being assimilated to a rainbow, however fine, should not pain me more.'

'But', I replied, 'all this really makes matters more simple because it removes that distinction you previously had to make between "true" colours and "apparent" colours. The interest and self-esteem that makes you fear losing — I will speak in the high pastoral style — "your lilies and your roses" has this time prevailed over your love of intellectual simplicity. ... There is nothing else in physical bodies than a certain disposition and ordering of their smallest parts, and then in the particles of light a certain rotary movement imparted to them by these parts; and these particles of light then press and strike in a certain manner on the nerves of the retina — which is a very fine membrane or skin at the further end of the eye — and thus make us *conceive* a certain colour, which we attribute with our minds to the body from which the particles of light are coming to us. But I think people are already coming to tell us it is time to go and be sensible of such flavour as we shall this morning attribute with our minds to the soup.'

'"Attribute with our minds?"', she checked me... .

And indeed later in his dialogue Algarotti will also explain an

extreme version of the Lockean psychology. These ideas really
were accessible.

3. A Lady Taking Tea: distinctness and brightness

But when we turn back to Chardin with the ideas to hand, it turns
out that the job of liaison has not really got very far. In a general
way a picture like *A Lady Taking Tea* (Pls. II, III) is not out of
character with the complex Newtonian–Lockean sense of how we
see: it does not repel them. But they do not offer any very clearly
directed purchase on the picture, to which our primary explana-
tory duty is due.

It is still hard to bring them to bear on the things about the
picture that are puzzling, and there are a number of these. For
instance, Chardin seems to be doing something strange with
perspective here and there. The chair-back is odd: if the lady were
sitting comfortably on the chair, surely the chair-back would not
be turned to face us and the picture-plane as much as it does. The
tea-pot also is rather 1910: spout and perhaps also handle are
flattened out on the canvas. Then there are a whole range of
striking colour devices. The most obvious is the red-lacquered
table, assertive but almost unstable. And if one looks at other
pictures by Chardin, one finds other cases of reds in odd relations
to blues and blacks. Again, and very conspicuously, there seems
something extraordinarily deliberate and determining about the
differential distinctness and lighting of the picture. There is a
determinate plane of distinctness on the line of teapot, hand and
arm; and within this plane some things are more sharply focused
than others. What does all this represent?

The obvious but, as it turns out, unprofitable place to go for an
answer is the art criticism of the time. What contemporary critics
wrote about Chardin sometimes has interest, but not interest of
this kind. This is particularly disappointing in the case of Diderot.
Diderot wrote many appreciative pages about Chardin, and he
also wrote a treatise on perception in the Lockean vein, the *Letter
on the Blind* of 1749. This again raises a general problem. The
relation between period art criticism and what we are doing at
present is in any case complex. The appearance in art criticism of
an idea from an extraneous universe does not necessarily mean it
was actively in play in the painters' intention: it does mean it was

possible in the period for someone to make the connection — a necessary but not sufficient condition for its use in explanation. Art criticism is not a pure registration in words of how people saw pictures at any time. It is often much more a minor literary genre, clearly with a relation to how people saw painting, but affected by generic constraints and suggestions of a quite literary tradition and mode. At some times the conventional and normative element in art criticism is very oppressive: this was so in the eighteenth century, and quite particularly so in the sub-genre of Salon criticism, in which most of what Diderot and indeed others said about Chardin appeared. The most penetrating eighteenth-century thoughts about painting often occur not in art criticism proper or even (another problematic area I shall not be working with) aesthetics, but in eccentric materials less confined by the generic demands of art criticism (or aesthetics). From these, I think, one can develop something like an alternative art criticism for the eighteenth century, and it is one of these eccentric materials I shall now try for help with *A Lady Taking Tea.*

One of the puzzles about the picture was what the differential distinctness and brightness was about. Distinctness in vision and, by implication, in painting does have an intellectual history in the eighteenth century but it leads not to art critics so much as to scientists, medical men and mathematicians — alternative art critics of an important and helpful kind. I shall spend some time on this, partly because the matter of distinctness of vision seems to me nowadays a neglected element in our thinking about painting.

4. *Distinctness of vision: accommodation and acuity*

'Distinctness of vision' is an eighteenth-century term. It covers what would nowadays come under the two separate terms optical 'accommodation' and optical 'acuity'. 'Accommodation' refers to the capacity of the eye to change its shape in order to focus on foreground objects at different distances. 'Acuity' refers particularly to the different degrees of sensitive response at different points on the retina, and bears on degrees of distinctness across the field of vision. So 'accommodation' relates to distinctness in depth, and 'acuity' to distinctness across the field. We are concerned with distinctness of vision as a function of the subject: we

are not concerned here with objective degradation of distinctness and colour through 'aerial perspective', the interposition of atmosphere.

Accommodation:

The gross structure of the eye relating to accommodation (fig. 8) had been worked out by the early seventeenth century and was clearly and accurately described in Christoph Scheiner's book *Oculus* or *Fundamentum Opticum* of 1619. The light-bending section of the eye, the operative lens complex, consists of three main elements: cornea, aqueous humor and crystalline — each of these having a different refractive power. The most powerful is the cornea, but the crystalline has the special importance of being the variable, with which we focus for different distances. In fact, Scheiner's description was slow to prevail. Well into the eighteenth century there were still other current explanations of the focusing function and Algarotti led his patient Marchesa through some of them:

'What alteration must there be in the eye so that, when we look at those trees over there after looking at these columns just here, the rays of light that come from the trees will unite on the retina — which is to say, so that we will see the trees distinctly?'

'What will be needed', said the Marchesa, 'is for the retina to be brought nearer to the crystalline humor — just as, with a *camera obscura*, if the image of more remote objects is to be distinct, the paper has to be brought nearer the lens.'

'You have hit on it by yourself!', I replied. 'And some have said that the things that serve for this effect of moving the retina nearer to or further from the crystalline humor according to need are certain muscles that surround the eye — which also serve to raise and lower it and turn it to left or right and give it a certain oblique movement that Venus above all takes care to rule. With these muscles Love

> — sott'occhio
> Quasi di furto mira,
> Ne mai con dritto guardo i lumi gira.
>
> [— peepingly
> Views as if by stealth,
> Nor ever turns the eyes with glance that is straight.]

And with these muscles the eyes often speak to other eyes things the

Fig. 8. The Eye, from Descartes, *Discours de la Méthode et les Essais*, Leiden, 1637, II, 26 (BCB, cornea; EF-FE, iris surrounding pupil; K, aqueous humor; L, crystalline humor; EN, ciliary 'threads' to stretch L; M, vitreous humor; GHI, sensitive retina; HZ, optic nerve; O, muscles moving the eye).

tongue, Madame, does not venture to say. Well, others have said that
the retina is static and that it is the crystalline humor that moves nearer
to it; or that the crystalline humor does no more than change its own
shape, being made more convex for near objects and less so for distant
objects; and it has also been argued by someone that both these things
happen at the same time. Any of these things would have the same effect
as the retina moving towards and away from the crystalline humor —
which you may as well take as being the case because it will be the easiest
for you to imagine.'

There were other explanations too. The stumbling-block was the
fantastically complicated operation of the ciliary muscle complex
that surrounds and acts on the crystalline, something not worked
out until the nineteenth century. In the modern account, we
effectively contract the ciliary muscle complex for near vision and
this releases tension on the crystalline: when this external tension
is released internal tensions make the crystalline take on a more
convex form. This was not understood. But, as Algarotti says, the
main point is that the eye focuses for distance. If the foreground
is distinct, the distance will not be; and vice versa. This was fully
understood.

Modern accounts do not give norms for the range of the eye's
ability to focus for distinct vision. There are too many variables:
one is the progressive hardening of the crystalline with age,
another is the size of the aperture, since the degree of opening of
the pupil affects the depth of field like the stop on a camera. But
for our purposes it will do no harm to think of a nominal range of
twenty feet. To think of the eye accommodating inwards for the
last twenty feet of distance, up to about five inches away, is not
grossly wrong: upwards of twenty feet the ciliary complex is
relaxed, the crystalline under external tension, and the eye effectively
focused for infinity.

The details of the eighteenth-century investigations into the
range of distinct vision in depth are rather beyond our present
requirements, but the most influential authority of Chardin's
time — Newton's pupil James Jurin — is worth a word because
he offers a useful terminology for degrees of distinctness. Jurin,
trained as a mathematician at Cambridge and in medicine at
Leyden, and Secretary of the Royal Society in the 1720s, divided
vision into three levels of distinctness: Perfect, Imperfect and
outright Indistinct. Like many others Jurin stumbled over the

working of the ciliary muscles. Whereas modern optics sees accommodation as being purely an inward adjustment to a progressively more convex crystalline — inward from about twenty feet to about five inches — Jurin thought of the muscles working on the crystalline in both directions, inwards and outwards, from an intermediate relaxed state of both muscles and crystalline. The conclusion of a long and very mathematical argument is that, for Jurin, the relaxed eye is focused on a distance of fifteen inches, not twenty feet. From this it could move in to five inches — as in modern estimates — and out to 14ft 5ins, say fifteen feet. And this is the limit of Perfect vision: beyond fifteen feet one does not see Perfectly.

In Perfect vision the rays of a single 'pencil' of light — which consists, of course, of particles — are collected into a single sensitive unit, one *punctum sensibile*, on the retina. With Imperfect vision they are not, even though an object may not be Indistinctly seen. Phenomenally, in Imperfect vision the object will appear larger, its centre will be stronger or darker than the rest, there will be penumbra and certain colour changes too. The title-page of Jurin's paper is printed in four predetermined sizes of type for one to test these effects by looking at it from various distances up to thirty feet.

Acuity:

The period position on acuity — distinctness *across* the visual field — was based on seventeenth-century research into dioptrics and the structure of the retina. In the modern account we have two principal kinds of receptor on the retina, 'cones' which give us colour vision in normal bright light and 'rods' which give us monochrome vision in dim light. The 'cones' are concentrated at the optic axis round the fovea so that daylight acuity is concentrated here too; whereas the 'rods' are much more evenly disposed across the retina, apart from being crowded out from the centre by the 'cones' — which is why one sees things more distinctly at night if one does not directly look at them. But there are other factors at work too. On the one hand, the effect is reinforced by such dioptric effects as peripheral astigmatism, the inability of the normal eye to reunite, after refraction, light entering at a considerably oblique angle. On the other hand, the effect is modified at the

level of perception as opposed to physical function by psychological mechanisms of attention. Our attention can expand and narrow the zone of effective visual perception according to the sort of thing we are up to. For this reason psychologists of perception speak of a 'functional fovea' which is variable and not simply determined by the denseness of receptors round the physical fovea.

Though the eighteenth century did not have the means to distinguish rods from cones and thought of the retina simply as a structure of fine fibres agitated by the movement of light, the facts of acuity were very well recognized. Here is a summary account of received opinion, from a Ph.D thesis on vision presented at Leyden in 1746 by Pieter Camper:

The retina, which extends from the point of attachment of the optic nerve of the eye as far as the ciliary radial muscle, is not equally sensitive in every part. At the point of attachment of the optic nerve it is not sensitive at all. [This is 'Mariotte's blind spot', called after Edme Mariotte, the late seventeenth-century scientist who located it. Mariotte also wrote a superb anti-Newtonian *Traité de la nature des couleurs*.] Next to the point of attachment of the optic nerve it is at its most sensitive — and this is the point over against the optic axis [that is, the fovea]. It is for this reason, according to Philippe de La Hire [to whom I shall return], that we turn our eyes about, so that the image should be at that point. William Briggs [in his *Ophthalmographia* of 1686] reckons that the fibres are more closely joined here, and concludes that it is for this reason sensation is more perfect here. Robert Hooke demonstrates the same in his *Micrographia* of 1665. [Not really: he makes some incidental comparative remarks about the human eye in the course of a famous description of a house-fly's eye]. In a previous section I raised the question of whether the retinal image might not be brighter near the optic axis because the rays of light there, entering almost parallel in one single point only, are represented the most brightly on the retina. For sure, I would not want it considered a certainty that this greater brightness depends purely on the greater sensitiveness of the retina there. [Camper is here pointing to peripheral astigmatism. This had been much studied in relation to glass lenses in seventeenth-century dioptrics and was widely current as an explanation for peripheral indistinctness. It was Robert Hooke's explanation. In 1738 John Hamilton of the Royal Society stated in his *Stereography* that peripheral astigmatism on its own limited distinct vision to an arc of between 2 and 4 degrees, making no mention of the role of the fibres on the retina.]

Pieter Camper is aware, then, of both foveal sensitivity and peripheral astigmatism as causes of centralized acuity. He does not mention the psychological modification of this by attention. But this was recognized and is particularly well described by Sébastien Le Clerc in his *Système de la vision fondé sur de nouveaux principes* of 1719:

While one makes out quite well with a single glance large tracts of country, yet one notices that one sees distinctly only a little amount at a time — and there are two reasons for this. The first [physical acuity] is that objects are represented distinctly within the eyes only within a quite small angle, as we have just been seeing; the second [attention] is that the mind, not being capable of attending to a number of things at any one moment, examines objects only bit by bit. Thus, even though one does perceive at first glance a substantial object like a palace, and though an image of it is represented in our eyes which makes us form a favourable or unfavourable idea of it, yet all the same this idea lacks distinctness in the parts because the mind does not at this stage apply itself to it in a particular way ['global pre-attentive vision']. But when the mind wishes to know which order of architecture the palace belongs to, and whether it is in good or bad taste, then it runs over with the eye — or, better, with the optic axis of the eye — all its parts one after another in order to have exact knowledge of each part separately ['purposive attentive scanning'].

Between them Camper and Le Clerc cover the main features of the modern conception of acuity.

5. Chardin and past art

Returning to *A Lady Taking Tea*, it turns out that the eighteenth-century optical baggage of the last section enables one to give some description of the picture in eighteenth-century terms but does little to explain it.

The degradation of distinctness towards the back wall is surely too great to be a representation of Jurin's Imperfect vision beyond fifteen feet. It might represent a determinate focus in depth on the line of teapot, hand and arm. Across the field of the picture a more delicate game of distinctness and brightness is going on. For instance, the interior features of the face are rather blurred, whereas a centre of distinctness within the plane of distinctness is the hand in front of the cup. But it is not very useful to pursue this sort of

line further without dealing with two kinds of objection doing so is likely to encounter. The first is the point that one is ignoring the fact that Chardin is working within a pictorial tradition. The second is that the world of the scientific students of optics was some way from the world of the painter.

For the first, this does seem the moment to re-emphasize that Chardin, like Picasso, was addressing a problem set largely by the history of painting: the Brief he set himself was first of all derived from earlier pictures, his own but also other people's. It has always been realized that Chardin had taken up seventeenth-century Netherlandish genres and modes of depiction (Pls. 32, 34). At the time the Fleming Teniers was much invoked; nowadays the similarities seem closer to post-Rembrandtian Dutch painters like Gerrit Dou, Nicolaes Maes, Gerard ter Borch and Gabriel Metsu. These men often worked with lighting compositions that involved indistinct backgrounds, for instance. They are not the same as Chardin's, but they are an element in the problem he was addressing. But Chardin's relation to Netherlandish painting has been so fully studied and established I would rather point to another area in earlier painting Chardin engaged with, much more than has been acknowledged: the Diderot view of Chardin as the truthful painter of things-as-they-are dies hard.

The painting of the late Italian Renaissance, as it was to be seen in Paris, is in my view a deep preoccupation of Chardin. In 1756 his friend the engraver Cochin *fils* gave a lecture to the Academy of Painters in Paris on light. Chardin himself was in the audience. Cochin gave an account of the physics of light and spoke of lighting composition: in brief, he recommended bright foreground and dimmer background, and the two operational authorities he offered — Veronese and Guido Reni, great eighteenth-century values — are painters who surely much interested Chardin. Veronese did so in a number of ways: one obvious thing Chardin took from him was the rhetorically posed diagonal figures of his early figure paintings (Pls. 33, 35). A subdued element of this is active even in *A Lady Taking Tea*. But it is above all the kind of lighting composition represented by Guido Reni's *David* (Pl. 37) that Chardin worked on. He adapted the heroic late Renaissance formula of brightness and distinctness to his genre and still life pictures. Chardin's small *Cellar Boy* (Pl. 36) is far from Reni's *David* in many matters, but the lighting has the same underlying

arrangement: indistinct background, a left-lit and clearly relieved middle plane, and in the right foreground a local complex of brilliance. For year after year Chardin made variations on this scheme — often, as with the *Cellar Boy*, trying an accent of hue rather than lustre in the foreground — and, again, there are subdued elements of it in *A Lady Taking Tea*. Chardin was a very history-regarding painter.

So part of the problem Chardin addressed was how to marry with this heroic lighting-scheme a northern subject-matter of piles of food and bourgeois everyday scenes. If we are to think of him bringing ideas about distinctness to bear on his problem, it must be at the level of criticism and self-criticism in the process of such pictorial activity.

6. Middle-men: La Hire, Le Clerc, Camper

The second objection has to be met by producing minds capable of bringing into relation with each other the scientific and the pictorial universes we are concerned with, and of thinking about the sort of connection we may wish to make between them. In the present case this is not difficult, but I shall limit myself here to invoking just three such middle-men, all of whom I have already used as authorities on distinct vision: Pieter Camper, whose Ph.D. thesis I quoted on acuity; Philippe de La Hire, whom Camper cited for his description of what we now call 'scanning'; and Sébastien Le Clerc, whom I quoted on attention. All three were, in one or another extended sense, also painters.

La Hire (1640–1718), first, was the most prominent French mathematician of the years round 1700. His fundamental work was on conic sections, but he was also a practical man who applied mathematics: he supervised the cartographic survey of France, and he designed the hydraulic system for the fountains at Versailles. He was also Professor of Geometry at the Academy of Architecture in Paris. The work that made him an eighteenth-century authority on optics was his *Dissertation sur les differens accidens de la vue* (1685).

But La Hire had been trained as a painter. His father was the distinguished painter Laurent de La Hire, the contemporary of Poussin and himself a man of mathematical talents; and Philippe himself did not elect to become a professional mathematician until

he was in his twenties. He was studying painting in Venice at the time. Painting stayed in his mind and there is a remarkable posthumously published *Traité de la pratique de la peinture* in which he discusses with great thoroughness the material media of drawing and painting. But painting was also in his mind when he wrote on optics and this led to certain important and novel perceptions, as it were in passing. For instance, in one short passage he both anticipates by a century description of the Purkinje Shift and notes its bearing on perception of the tonality of pictures. The Purkinje Shift is the effect in which blue-hued objects become lighter-toned and brighter relative to, say, red-hued objects in conditions of dim light. It was described in the 1830s by the Bohemian physiologist Purkinje, but not accounted for until the discovery of the separate rod and cone receptor systems towards the end of the nineteenth century. Rods and cones are maximally receptive to different wavelengths and thus to different colours: the dim light receptors, the rods, are most responsive to the blue wavelength whereas the bright light receptors, the cones, are most responsive to the red wavelength.

The light which illuminates hues changes them considerably; blue appears green by candlelight and yellow appears white; *blue appears white by weak daylight, as at the beginning of the night* [my italics]. Painters know hues whose brilliance is much greater by candlelight than by daylight; there are also a number of hues which are very bright by daylight but lose their beauty entirely by candlelight. For example, verdigris appears a very fine colour by candlelight; and when it is weak, that is to say, when it is mixed with a large quantity of white, it appears as a very fine blue. Those ash pigments one describes as either green or blue appear by candlelight an extremely fine blue. The reds which contain lake appear by candlelight as very bright, and others like carmine and vermilion seem dull.

Thus, La Hire has seen that lighting conditions can change not just the hues in pictures but also the relative tonal values: blues lighten in dim light — as Purkinje, sitting in his garden at dusk, was to observe a century later.

One passage in La Hire in particular became a crux in eighteenth-century optics:

Il y a donc cinq choses qui servent à la vuë pour juger de l'éloignement des objets, leur grandeur apparente, la vivacité de leur couleur, la direction des deux yeux, la parallaxe des objets, et la distinction des

petites parties de l'objet. De ces cinq choses qui servent à fair paroître les objets proches ou éloignez, il n'y a que les deux premieres dont les peintres puissent se servir dans leurs tableaux: C'est pourquoy il ne leur est pas possible de tromper parfaitement la vuë. Dans les décorations des Theatres on joint ces cinq choses toutes ensemble. ...

William Porterfield in his *A Treatise on the Eye* of 1759 was so dependent on La Hire still that his account is, not a translation, but a mid-century up-dating:

There are then six Means which serve our Sight for judging of the Distance of Objects, *viz*. their apparent Magnitude, the Vivacity of their Colour, the Distinction of their smaller Parts, the necessary Conformation of the Eye for seeing distinctly at different Distances, the Direction of their Axes, and the Interposition of other Objects betwixt us and the principal Object whose Distance we consider. Of these six Things which serve to make Objects near or far off, there are only the three first that Painters can possibly make use of in their Pictures; whence it is, that it is impossible for them perfectly to deceive the Sight. But, in the Decoration of Theatres. ...

La Hire, unlike Porterfield, had not accepted that the eye changed its shape to focus on different distances; and he oddly omits degrees of distinctness from the painter's means of representing distance. But what he had recognized was a scientific opportunity the eighteenth century eagerly seized.

Painting excluded half of the varied means by which we visually assess the distance of objects — the muscular cues in the optic and shifting interposition or 'parallax' visible to the eye of a moving person. It depended for conveying distance on only three things — depicted magnitude in relation to known magnitude; degradation of colour; degradation of distinctness, both atmospheric and subjective. It therefore isolated these for study, and particularly for study of the issue of which was the more powerful — depicted magnitude, on the one hand, or degradation of distinctness and brightness, on the other. The effect of his point was to inject the painter's resources into eighteenth-century optics, as an issue. The Newtonian Robert Smith, for instance, whose *A Compleat System of Opticks* of 1738 was the mid-century authority on astronomical optics throughout western Europe, went around asking painters their opinions on the matter and concluded that depicted magnitude was more powerful than distinctness and brightness. The French

physiologist Claude-Nicolas Le Cat, collector of paintings and teacher of anatomy in the art school at Rouen, laid rather more weight on distinctness and brightness. The issue persisted.

Sébastien Le Clerc (1637–1714) had nothing like La Hire's intellectual brilliance but is much to our purpose. The book I cited on attention has eccentricities: Le Clerc tried to revive the old idea that the eye sends rays to the object of vision, rather than the object of vision reflecting rays to the eye — though in practice this seemed to make little enough difference and the book was widely read, by Pieter Camper among others. But by profession Le Clerc was an engraver; he was proud of his scientific interests but they were not his keep. Two things make, I think, Le Clerc a curiously long-lasting underground force in eighteenth-century art. Not only was he Professor of Geometry at the painters' Academy in Paris — therefore La Hire's opposite number — but he was followed first by his son and then by his grandson: between 1679 and 1785 three generations of Le Clerc held the post. It was Sébastien Le Clerc II Chardin heard lecture. Secondly, Le Clerc wrote an admirable practical geometry for painters of which I have noted, so far, a dozen editions between 1669 and 1835, including three in English translation. In this manual he described and illustrated the fact of visual acuity, the central axis of distinct vision and the arc of visual competence. Cochin re-engraved the illustrations for an edition of 1744.

Pieter Camper (1722–89), a generation or more younger than Chardin, sums up in his Ph.D. thesis of 1746 the scientific consensus on vision in Chardin's time. Camper later became a surgeon and anatomist, and something of an academic grandee, but only his early career is to the point here. In 1746 he was fresh from a training as a painter. Concurrently with studying medicine at Leyden he had studied painting with Karel de Moor, a follower of Godfried Schalcken (Pl. 40), something Camper himself found not odd but rather old-fashioned. His drawing, at least, he continued to keep up: when in London he went to the life class at the Royal Academy school. One of Camper's London friends was William Hunter, surgeon and Professor of Anatomy at the Royal Academy, owner of Chardin's *Cellar Boy* (Pl. 36) and, from 1765, of Chardin's *A Lady Taking Tea* (Pl. II).

What makes Camper's Ph.D. of 1746 useful is that, as he proceeds through a carefully orthodox account of how we see, he adds here

and there precisely pictorial 'corollaries'. They are not profound art theory but they act at least as markers, indicating those optical facts that have an immediate bearing on how a painter should paint. In the page reproduced on p. 94, which is about how we assess the distance and, in association with this, the magnitude of objects, there are three such corollaries.

The first two relate to the degradation of colour by distance and the need for painting to observe this. The third relates to the degradation of distinctness by distance and suggests that the paintings of Adriaen van der Werff (Pl. 41) do not register this plausibly.

One of the sections Camper marked with a pictorial corollary was the section on acuity I quoted earlier (p. 86):

Coroll . . . Manifestum hinc est, quare in tabulis tantum una pars illuminata & quam distinctissime depicta esse debeat.

(*Corollary* . . . It is clear from this why, in paintings, only one part ought to be lit up and depicted with the greatest distinctness.)

I left this out then because it is problematic and we were not yet ready to deal with it: it seems fallacious.

7. *Substance, sensation and perception*

Camper's argument is:

The retina . . . is not equally sensitive in every part. . . . Next to the point of attachment of the optic nerve it is at its most sensitive — and this is the point over against the optic axis. It is for this reason, according to La Hire, that we turn our eyes about, so that the image should be at that point. . . .

(*Corollary* . . . It is clear from this why, in paintings, only one part ought to be lit up and depicted with the greatest distinctness.)

This really is not what one was looking for because it does not describe what Chardin is doing; in *A Lady Taking Tea* and many others of his pictures there are several centres of greatest distinctness. And in any case it seems a bad argument. If our eye sees like this, and sees paintings like this, it is worse than supererogatory for the painting to be painted like this: it should instead register the field of vision offered within the frame with equal distinctness so that our eye can operate in its normal scanning way.

There is a fragmentary pre-history to Camper's idea, of which

Coroll. liquet, hoc fundamento totam unionem colorum quo ad umbras & lumem &c. in Arte Apelleâ niti.

Accidit tamen aliquando confusio quaedam,· quia picturarum objectorum vivacitas est, pro ut colorata sunt objecta (*a*) v. gr. Si objectum rubrum valde distans videmus, judicabimus, licet magnitudo apparens aequalis sit alii objecto aliter colorato, & aeque distanti, objectum illud rubrum propinquius esse, quia hujus tanta vivacitas est.

Coroll. Patet hinc hisce coloribus non uti debere Pictores in distantiis, quia semper unionem tollunt.

Ex tabula volare dicuntur tales colores. Non ergo usu veniunt nisi in planis anterioribus tabularum.

§. X. III°. Quoniam axes opticos dirigimus versus objectum ut unicum videatur, addiscimus exinde angulum metiri, qui ab axibus illis fit. Hinc quo angulus ille major eo propius, quo minor, eo longinquius distabit objectum. Idcirco uno oculo de distantia certo judicare non possumus. Licet monoculi, sed aliis utentes mediis, de illa satis bene judicent.

§. XI. IV°. Ex pictura supra hanc vel illam partem retinae factam saepe de distantiis judicamus, uti ex sequenti patebit exemplo. Homo (*b*) cui Iris post depressam cataractam tota concreverat absque relicta pupilla, semper, postquam Uvea de novo perforata erat, objecta remotiora, quam revera erant, judicabat. Quia per artificialem pupillam iu loco depressiori factam, radii colligebantur in illo retinae puncto, in quo ante remotiorum objectorum radii, pupillam veram intrantes, solebant.

§. XII. V°. Objectum propinquum judicabimus, quando partes minimae satis distincte videre possumus. & contra.

Coroll. In picturis ergo objecta remotiora minus distincte in suis partibus minimis pingi debent. 2°. Pictores hoc medio uti in suis tabulis. Quamquam *de la Hirius* (*c*) putaverit pictores non nisi magnitudine apparenti & vivacitate colorum frui posse ad distantias repraesentandas. contrarium patet in tabulis florum, regionum, ruinarum &c. prout enim haec magis vel minus distant eo minutiae minus vel plane non exprimuntur. an ideo Elegantissimi coeterum Equitis *vander Werff* tabulae prospectu longo carent & planiores justo apparent, quia hanc regulam neglexit?

§. XIII. VI°. Parallaxis nos admodum juvat in distantiis objectorum remotissimorum dignoscendis; requiritur vero varia oculi positio. Hoc modo spatium, quod jacet inter objectum & aliud punctum, cum quo comparamus, novimus; oblique.enim recedendo intervallum videmus, quod non possumus unico oculo. magnum habet usum in Astronomicis.

Hoc medio est, quo theatrorum decoramenta tantopere prae picturis excellunt; nam praeter omnia media, quae illis aeque ac picturis super tabulas communia sunt, parallaxi gaudent, quia super diversa plana repraesen-

(*a*) Ibid. §. 8. Cap. 1. (*b*) *Eames* and *Martin's* abridgment tom. 8. p. 493. by *Cheselden.* (*c*) Differens accidens de la Vue p. 237. §. 9.

Fig. 9. Pieter Camper, *Dissertatio Optica De Visu*, Leiden, 1746, p. 15, with three corollaries on the painter's use of colour.

the best-known episode is — and probably also was, though Camper shows no sign of knowing it — a passage in the last book of the art theorist Roger de Piles, the *Cours de Peinture* of 1708. It is a prominent passage because it is the matter of the only two illustrations in the book. De Piles is arguing for the type of centrally unified composition known as 'Titian's bunch of grapes': such compositions avoid, he says, 'dissipation of vision'. And one of de Piles's arguments is from the optical fact of centralized acuity (Pl. 39). As we have seen, this was very accessible in La Hire and even more in Le Clerc. But his argument is not the same as that of Camper, a position which he explicitly disclaims. De Piles had delivered this chapter of his book as lectures at the Academy of Painters in Paris in 1704 and had evidently run into misunderstandings or objections, and he lays out very carefully in an appendix what it is he is claiming. He spells out the fallacy in the Camper argument much as I just have; and he explains that his argument — an almost metaphysical and really extraordinarily weak one — is that the centralized acuity of our vision is Nature's sign that centrally unified compositions are good. One suspects de Piles might have liked to use Camper's argument but saw, or perhaps had been made to see, that it would not do.

So what are we to think of Camper's bald, strong and apparently fallacious claim? It seems dangerous to use stupidity as an explanation for peculiarities of historical thought or historical behaviour unless there is no other way; Camper was not usually stupid, and he had studied these matters for some time. It is proper to ask two questions. First, had something happened between 1708 and 1746 which made it rational for Camper to claim what de Piles could not? Secondly, can the position entailed by Camper's claim be given a rational description? One answer to the first is that in those years the Lockean view of human perception had been diffused through western Europe. A Lockean answer to the second might be that Camper's claim would be rational if a picture is thought of not as a representation of substance — or Nature, as it had been called since the Renaissance — but as a representation of an act of perception of substance.

(Locke's own terminological fluidity and the simplified level of the vulgar Lockeanism in question excuses one from a rigorous fixing of terms. In any case, the distinctions involved here are very broad ones. 'Substance' is the material support we posit for the

qualities we perceive. 'Sensation' is what substance gives rise to in the sense. The mind derives 'ideas' of various orders from sensation. This activity of the mind is 'perception'. In fact Locke uses the word 'perception' in several different ways, some of them rather close to sensation, but it is easiest to use it in the familiar sense of active comprehension by the mind: a *sensation* of a shaded circle is *perceived* as a sphere. 'Attention', of which Locke gives an admirable account, is used in the modern sense.)

If we distinguish between depictions of substance and depictions of perception (or indeed of knowledge) and suppose a picture to be the latter, then Camper's corollary is rational. Selective distinctness, distinctness concentrated at one or several points whether across the field or in depth, registers a balance of perception, a selective attention — perceptions unattended to fade, 'leaving no more footsteps or remaining characters of themselves, than shadows do flying over fields of corn' (Locke) — or a partial knowledge, or something of the sort.

This is to move a little too fast. If one is to claim that Camper was more aware than de Piles that the sort of picture painters paint may be considered a representation not so much of substance or Nature as of visual perception of substance it does seem desirable to be sure that such a distinction was conceivable in his culture. One might also ask whether he and his culture could conceive of a visual representation of substance itself, and what this would look like.

From Camper would have come the answer, short and sharp, that a representation of substance would look like one of his own anatomical drawings (Pl. 43), in contradistinction to the anatomical illustrations (Pl. 42) of his teacher, Bernhard Siegfried Albinus of Leyden. The matter was later to emerge in the 1760s as a public controversy between Camper and Albinus. Camper's central objection to Albinus's illustrations was that they were done with vanishing-point perspective: this indicated substance with a magnitude that diminished sensationally with distance in relation to the position of a posited viewer. Instead, Camper was to say, they should have been done with 'architectural' perspective, what we would call orthographic projection: the viewer would be supposed to be at infinity and the projection rays from the object would meet the picture plane at right angles, not in a perspectival pyramid to the eye.

Means of registering visually the substance of objects as opposed

to their sensational visual character to a beholder did exist. The development of orthographic modes of technical drawing was particularly a French achievement, the classical phase running from the projective geometry of the architect Gérard Desargues (1593–1662) — whose principal disciple was Philippe de La Hire's father, the painter Laurent de La Hire — to the systematization of descriptive geometry into multiple-view first-angle orthographic projection by Gaspard Monge (1746–1818). It was a high intellectual achievement of the period, but it was also quite widely diffused in provisional forms long before its Mongean perfection. In eighteenth-century France various kinds of people, from army officers to masons, were being trained in styles of geometric technical drawing which break away from vanishing-point perspective (Pl. 44). Orthographic projection was only part of this. Oblique projection, used as a matter of course in Diderot's *Encyclopédie* for the representation of things of which the three-dimensional character has importance (Pl. 45), offered side-views of an object bent forty-five degrees oblique to its face; the objective dimensions of the orthogonals were registered at least in their proportions to each other, and could be registered in their proportions to axes on the plane by the choice of one or another convention — the *Encyclopédie* often using a system something like 'cabinet oblique', in which half an oblique equals a whole on the plane. The eighteenth-century public was expected to recognize and read a range of objective drawing systems in a way that argues real vernacular skill in handling them. This demanded awareness, though not necessarily in our terms, that both perspectival (or 'sensational') depiction and objective (or 'substantial') depiction were possible. To the extent that it avoided an accident of vision, technical drawing depicted substance; and it placed the painter's kind of picture, with its phenomenal foreshortening — not to mention its imitation of the sensational accident of hue — as a depiction of something else. It might be 'sensation' or it might be 'perception', but what had certainly happened was that the old Renaissance simplicity of depicting 'Nature' was gone.

8. *A pictorial corollary approximated*

I have been making heavy weather of a remark by Pieter Camper that may anyway just be an error. But, in the course of seeing

whether his remark could be construed as reasonable or whether there was an intellectual context in which such an error is understandable, we have backed, as it were, into something that comes near to being a pictorial corollary of vulgar Lockeanism. It is, however, very untidy, and it demands more than Locke: it also needs Distinctness, and colour and perspective.

There is a question or problem or equivocation implicit in the intellectual culture of Chardin's time about what it is that painting represents. It does not represent substance: if it did it would be something like an architect's plan for a building and would, no doubt, eschew an accident like colour. (At a different moment in art history, if we believe Kahnweiler — a reader of John Locke, as it happens — it might be like Picasso's *Kahnweiler*.) But if painting represents visual perception of substance, then there are questions about how much perception is being represented. A picture might represent a snatch or moment of perception: in this case the focus in depth — which the painter cannot in any case leave to the beholder — and the fixations across the field would be determinate and limited. But there is then an ambiguity about the status of the representation. The picture might represent momentary perception, the moment we take to go through one, two or three intent fixations: Camper's corollary might seem to entail something like this. But it might also represent a finished total of sustained perception in which a certain balance of attention is registered, in which the continual return of the eye to one or two or three centres of interest is acknowledged. *Or* it might be the second masquerading as the first.

This last is what I shall claim for Chardin: that he is working within this equivocation or fiction. We saw that one of the things he started from was an old heroic formula for lighting composition found in such as Guido Reni; he transferred this to domestic scenes and to food on tables. But he worked on it and effectively transformed it, not least by distinguishing more sharply between illumination and distinctness, distinctness and force of hue, force of hue and lustre. In effect he asked what the old formula could be seen as *representing*, and by making it represent perception he made it something else. To pose the substance, the matter and the light, in such a way that the beholder is offered — as de Piles wished him to be — a preternaturally undissipated (or centralized) visual experience is one thing. To compose the elements of sensation, the edges

and tones and hues, in such a way that they represent a determinate perception of substance is another. The equivocation and the fiction are witty: they offer the product of sustained perception in the guise of a glance or two's sensation. We know perfectly well such a picture took weeks to paint and we ourselves take many minutes to inspect it, but it plays at a new sort of momentariness — not so much the Renaissance or Baroque momentarily caught action as the momentarily caught instant of perception of a state or object. To this extent both the equivocation and the fiction are rather like those of a lyric poem which represents itself as a minute of instantaneous speech articulating an immediate experience or state of mind, even though we know it took more than a minute to think up and has been worked over a bit. We can go along with the fiction over repeated readings of the poem, or over sustained inspection of the picture: experience of the genres has taught us to do so.

9. *A Lady Taking Tea: Lockean viewing*

Pursuing Distinctness so much in isolation has meant taking a quite one-angled view of *A Lady Taking Tea*: there were puzzles about its colour and perspective too. I want to return to it once again for a more relaxed Lockeanistic viewing.

It is an early picture, of 1735, and in Chardin's large format, about a metre wide. This bears on the base viewing distance: four or five feet away, which is quite close, would have been La Hire's recommendation and this works very well. (In 1703 La Hire took the leading part in a series of three meetings at the Academy of Architecture in Paris during which the academicians worked out the distance from which, given the limits of distinct vision, discriminating perception of buildings was henceforth to take place. It was decided that the distance should be one and a quarter-times the breadth or two and a half-times the height of the building, whichever was the greater; this assumed a 45° arc or rather cone of vision effective enough for some global sense of the whole, taking in the building itself plus 10% of framing space each side, and also allowed the beholder to be close enough for good attentive scanning of particulars.) It is not that one limits oneself to this distance, of course, nor that one takes La Hire as authority, but it is the distance from which the picture makes its most characteristic effects.

The lady is depicted in a modified version of the Reni-esque heroic lighting composition: dim background, middle foreground strongly lit from the left, and an accent front right. The accent is not so much of highlight or lustre as of hue, and this is something Chardin is progressively to develop and refine in later pictures: we shall come back to it. And this red table is not sharply removed from the determinately focused plane of distinctness on the line of teapot, hand, arm and shoulder. Behind this we are aware of panelling on the wall, the verticals of which do play a background part in how we scan the picture, but we are not quickly drawn to attend to it for itself. Instead we are likely to attend to a drama, another Lockean drama, but this time of colour, in the front plane of distinctness.

One of the eighteenth-century lines of thought running through and from Newton and Locke is about the perception of the distance and magnitude of differently hued objects (fig. 9). Low-refracted light — 'red-making' light — impinges on the retina more forcibly than high-refracted light — for instance, 'blue-making' light. In fact, if we focus for the middle-spectrum yellow, the point of refocus of reds will be behind the retina, of blues before the retina — when yellow, red and blue are at the same objective distance. Because of this, objects reflecting red light appear closer to us than blues. Pieter Camper marked the pictorial application of this phenomenon with a simple corollary advising against the use of red except in the foreground — an apprentice cliché that runs back to the Renaissance. In practice the effect is used by painters in many different ways. Chardin often has a reddish object — such as a woman's dress — in the background and a blue equivalent in the foreground, leading to an effective contraction of the distance between them. But Lockeanism was clear we have minds and that these process sensations into ideas, and this leads to an odd thing. If a red object appears *closer* than it is, it will be perceived as *smaller* than it is. A red vase will seem closer than a blue vase of the same size, and since our minds form an idea of the vase by setting size in relation to distance we will judge the blue vase as, substantially, the larger. There is an interesting degree of tension between sensation and perception.

So the front-plane display of colour activity has a double plot. Reds (and, differently, lights) come forward and blues (and darks) drift away: if the teapot were white it would fall off the table. But

at the same time reds — and specifically that table — diminish as blues and darks expand. By making his accent the purely sensational one of hue, Chardin retains the perceptually more complex phenomenon of lustre or scintillation for something else.

Behind all this colourful bustle, a little behind even her dress, is the lady and it is in her plane that Chardin is playing a complex and delicate distinctness game across the field of vision. Where Pieter Camper marked up the issue of acuity for the painter with a simple corollary about having a single point of maximum illumination and distinctness, Chardin is more elaborate and much more subtle. He plays illumination and distinctness a little against each other, and he does not limit himself to one fixation. If he had, the beholder's stance would be flat-footed: one of the things Chardin's imitators never understood was how he keeps the beholder on his toes by teasing him between one point of fixation and another. There are two points of high illumination, one at the back of the lady's head, the other on the hand before the cup: these are spot-lit from upper-left, but the second is given particular emphasis by distinctness, in the sense of sharpness. They are two poles within the picture and much of our sense of its precarious balance lies in our sensing their action as nodal points in an invisible underlying grid based on rough thirds.

These are quite strange high-spots really — the back of a head, and a hand concealing what would, we infer, have been the strongest highlight in the picture. It is a transformed version of the hand and candle-flame of many Netherlandish nocturnes (Pl. 40). Yet behind all the bustle up front they are the real dramatic centre of the picture. After all, this is a representation of (an act of perception of) a person. She is leaning slightly away from us, in a transformation of the Veronese lean that Chardin — and for that matter Watteau too, though differently — used out of Veronese's linear perspective contexts to register a suggestion of mobility and thus relation between object and observer. Her face is relatively shadowed and indistinct. Faces often are indistinct in Chardin's pictures, not because he could not paint them but, it looks, because he was sensitive to the problem of the inordinate attraction of faces on our scanning patterns and attention. In a picture like *The School-mistress* (Pl. 46), for example, he keeps us mobile between three prime fixation zones linked by glances — distinct table-top, semi-distinct but lost-profile girl's face, and indistinct and half-shadowed

child's face. He keeps sharpness and illumination and the attraction of faces in balance.

But in this case the indistinctness of the face goes with a number of other effects of withdrawal or inaccessibility: the slight lean away, the hidden highlight on the cup, the glance directed to something we cannot see. If one looks at the reflection on the teapot, even, one can make out the cup and the corner of the table but not the lady, though she should really be there. Even her stole is elusive in space: the blues are recessive, the black speckled with scintillation is spatially unplaceable — as Camper and other eighteenth-century opticians explained scintillating objects must be.

By this time the odd perspective of the chair-back and of the teapot's spout and handle hardly needs explanation — at least, not if one is standing four or five feet from the picture. They only look odd if one looks at them, which one has no business to be doing. In Lockean terms the chair-back is a sufficient fragment of a complex idea of a ladder-back chair to register on the periphery of the visual field — fix the eye on the lady's hand and see the chair-back then — without giving rise to the uncertainty about what it is that would pull attention away from the action, as a fore-shortened perspective view certainly would. The teapot may be quite 1910, but it is a manifest teapot, its characteristic features laid out plain: attend closely even to the reflection on its lower belly and feel the assurance about it being on a teapot. It is a solid teapot in the mind.

Chardin is one of the great eighteenth-century narrative painters: he can and often does make a story out of the contents of a shopping bag. He narrates by representing not substance — not figures fighting or embracing or gesticulating — but a story of perceptual experience masquerading lightly as a moment or two of sensation: sometimes he jokes about this fiction with momentary substances like spinning tops or frozen steam from a tea-cup. There is a degree of symmetry between the experience he represents and our experience of his picture but the symmetry is not complete. What we have in *A Lady Taking Tea* is an enacted record of attention which we ourselves, directed by distinctness and other things, summarily re-enact, and that narrative of attention is heavily loaded: it has foci, privileged points of fixation, failures, character-istic modes of relaxation, awareness of contrasts, and curiosity about what it does not succeed in knowing.

I want — because in the next chapter I shall be concerned with the issue of truth in thoughts about pictures — to push this view of the picture to a questionable point. So I shall say that we have here a sort of Lockean *Apollo and Daphne*, a re-enactment of bafflement by the elusiveness and sheer separateness of the woman — who is, I can by now say without colouring your perception too much, probably Chardin's first wife a few weeks before her death. Lockean pictures represent, in the guise of sensation, perception or complex ideas of substance, not substance itself.

<div align="center">

* * * *

</div>

On inquiry the intuition about an affinity between Chardin and Locke did not lead to a simple relation or pictorial corollary but to one corner of an eighteenth-century web of preoccupation. Lockeanism — and I had better say again that I mean by this a general current of empiricist psychology seen at the time as originating with John Locke — proved necessary, I would claim, but not sufficient. To produce something that bore on Chardin's pictorial problem, I had to move rather briskly to a puzzle in the picture. This, Distinctness, was immediately visual and much of the current thinking about it had pre-Lockean origins. The Lockean element that seemed necessary was a simple one, the firm and radical distinctions between 'substance' and 'sensation' and 'perception'. It could have been transmitted simply through currency in context of the words, but in fact it was also embedded in such eighteenth-century behaviour as acceptance of two styles of depiction, substantial and sensational-perceptual. Certainly there was no need for Chardin to *read* Locke: the culture was Lockean. It is we, outside, who need Locke, as a means of getting some sense of the pattern of the eighteenth-century mind. 'Lockeanism' was necessary to articulate the pictorial deployment of Distinctness; on the other hand, Distinctness was necessary to give the Lockean distinctions specific pictorial presence.

This begs various questions. One question is about whether an inquiry of this kind is justified by its critical yield. This one has been particularly heavy-handed because I was attempting a demonstration and so was obliged to argue the legitimacy of connections: the point would normally have been more economically made. But in a general way a positive taste for circumstantial information

of this kind does seem necessary if such inquiries are to be tolerable; they are worth the trouble if there are secondary satisfactions, such as enjoyment in regarding a picture partly as a window giving on to a culture. On the other hand, without the detail that makes a connection between ideas and pictures properly complex and specific it seems to me such connections cannot stand at all and are better not invoked. It is a special taste.

Another question is how true it, or any part of inferential criticism, can be considered actually to be.

IV

TRUTH AND OTHER CULTURES: PIERO DELLA FRANCESCA'S *BAPTISM OF CHRIST*

'You don't say?'
'I do, indeed. And I know what I'm talking about. I move in art circles, myself. That's how I came to see that catalogue.'
(Dornford Yates, *Cost Price*)

1. Cultural difference

For some time two related issues have been hanging around this discussion of intention. One is the question of how far we are really going to penetrate into the intentional fabric of painters living in cultures or periods remote from our own. The other is the question of whether we can in any sense or degree verify or validate our explanations. I shall discuss these in order. But it will be better to work to an example culturally more distant from us than Picasso or even Chardin, and I shall return now to Piero della Francesca's *Baptism of Christ* (Pl. IV). This is the central panel, five and a half feet high, from a fairly small altarpiece now dispersed. It was painted for a church in Borgo Sansepolcro, Piero's native town, around 1450, plus or minus a dozen years. Most, not all, experts have dated it on the basis of style early in Piero's career, not long after 1440; I agree with them, but it need not become a matter for debate here.

What is obvious is that the broad Brief Piero della Francesca took from mid-fifteenth-century Sansepolcro was very different from the Brief Picasso (say) took in 1906–10. It was, in the first place, a Brief to address a different state of the art of painting, the central Italian painting of about 1425–50. And the market was structurally different: Piero painted such pictures to order, within the terms of a legal contract, and he painted them for men with complicated fifteenth-century needs embodied in subtly and implicitly defined fifteenth-century genres. The generic demands in 1450 were very different. Not to multiply too much, the picture

falls into three preliminary main classes: (1) it is an altarpiece picture; (2) it is a picture of the Baptism of Christ; (3) it is a picture by Piero della Francesca. All three would have been stipulated by the client. The contract for this picture does not survive, but that for a similar format picture by Piero contracted for in Sansepolcro in 1445 does, and it is specific about the painting being an altarpiece, that the subject-matter agreed is to be followed by Piero, and that no painter may put his hand to the brush other than Piero himself.

To take at this point only the first — 'altarpiece' — it is not, in the sense it had then, a category of our own time. What did it mean? It meant, first, a religious image — a sensitive class of thing that had three canonical functions: to narrate scripture clearly, to arouse appropriate feeling about the narrated matter, and to impress that matter on the memory. But an altarpiece is a specialized religious image: it stands on the altar, the table of the Lord. It is very immediately present at the administration of the Mass and dignifies the Mensa on which the sacrament is conducted. It has less freedom than some picture in a fresco cycle on a chapel wall or in a devotional book and it is present as a focus for the mind at the most important moment of devotion. Yet it can also have a secular tinge. An altarpiece of the moderate size of this panel would have been on a side-altar in a church, furnished by some individual parishioner or family or confraternity. There are many indications that such donors wanted their gifts to God to be publicly worthy of them, as well as of God. Indeed, one reason for stipulating that the picture be by Piero della Francesca, the best-known painter of the town, would be the desire to be done proud. For the moment, to summarize, let us say simply that it is implicit in the genre 'altarpiece' that the picture be among other things a clear, moving, memorable, sacramental, creditable representation of its subject.

But if we posit cultural difference with any seriousness at all, we are likely to go beyond the Brief and postulate basic differences in cognitive and reflective disposition: it is to be supposed that both Piero and his customers perceived pictures and thought about pictures differently from us, in that their culture equipped them with different visual experience and skill and different conceptual structures. What was offered to Piero *en troc* was a range of facilities different from those offered in Paris in 1730 or 1910, or in London or Berkeley now.

Cultures do not impose uniform cognitive and reflective equip-
ment on individuals. People differ in occupational experiences, for
example. A medical man perceives a human body differently from
the rest of us: he has learned certain kinds of alertness and discrimi-
nation and he has terms and categories to help him with many of
them. The Paduan doctor Michele Savonarola, a contemporary
of Piero, observed particularly the proportions of human bodies
depicted by various painters — he names Giotto (Pl. 47), Jacopo
Avanzi of Bologna, Giusto de' Menabuoi (Pl. 49), Altichiero and
Guariento — and noted that they vary in this. Medical men then
attended closely to human proportion for Aristotelian purposes of
diagnosis, and under certain circumstances such a professional
disposition and skill would transfer to other situations, such as the
judgement of painting. At any time painters have special occu-
pational ways of seeing too, and these are obviously powerfully in
play in pictures. But cultures also facilitate certain kinds of cognitive
development in large classes of their members. Living in a culture,
growing up and learning to survive in it, involves us in a special
perceptual training. It endows us with habits and skills of discrimi-
nation that affect the way we deal with the new data that sensation
offers the mind. And because the trick of pictures — that is, marking
a flat plane to suggest the three-dimensional — puts a premium on
expectation and visual inference, it is sensitive to otherwise mar-
ginal differences in the beholder's equipment.

One aspect of Piero della Francesca's way of painting represents
both a culture making a skill available and an individual electing
to take it up. Fifteenth-century Italy was a culture in which a
distinctive sort of commercial mathematics was highly developed,
energetically taught in the schools, and widely known. A certain
kind of geometry was learned for gauging barrels and packs, and a
certain kind of proportional arithmetic was learned for calculating
such things as partnership dues and rates of exchange. Both were
almost fetish skills of the time and they provided a resource for
both painters and their middle-class public. Seeing was 'theory-
laden'. Piero is a man who stands for the continuity between the
merchants and the painters in this: he wrote treatises both on
commercial mathematics and on pictorial perspective (using the
geometry) and proportion (using the arithmetic). Perspective, pro-
portion and the Euclidean analysis of forms are very conspicuous
in his painting, registering this element in the culture. Both he and

his clients were differently equipped from us. But it was Piero who chose to take this resource up; there were other painters who did so much less.

This was a matter of a skill and disposition of visual perception; it involved concepts like 'pyramid' and 'proportion', but these had fairly direct visual application. Other intellectual dispositions offered by the culture might be less visual and more external but still were relevant to reflection on pictures. To take an instance that gets very near our knuckle, educated fifteenth-century people had a rather different equipment from us for thinking about the causes of things, including the causes of pictures: the structure of explanation was different, not least in relation to purpose and intention. To simplify: a picture could have been seen as the product of two main kinds of cause, efficient cause and final cause. The efficient causes were persons or things which by their agency produced effects — pictures being among other things effects. The final causes were the ends to which activity was directed. In this causal structure the client was more broadly causal of a picture than was the painter. The client who ordered the *Baptism of Christ* was an efficient cause of it in that he effected that Piero should make the picture; he was also a final cause of it in that the picture was made for him, for his use or at least disposal. Piero was also an efficient cause of the *Baptism of Christ* — as were his brushes and assistants — his activity producing the picture as an effect; but, since the picture was not destined for him, he was not a final cause of it — except in rather elaborate and extended senses fifteenth-century people did not think about. And if one wanted to characterize the picture as registering the personality of Piero, rather than of the client who willed it for a purpose of his own, then one would do it mainly by drawing up a balance sheet of his relative competences as an *efficient* in the different departments of his art — 'colour' and 'design' and 'composition' and so on. Or if one were very educated one might think of Piero as pursuing an 'idea' in the *Baptism of Christ* — a sense of intention even more remote from problem-solution. The fifteenth-century style of thinking about the causes of the *Baptism of Christ*, and so fifteenth-century expectations of the *Baptism of Christ*, and so also Piero's notion of what he was doing in the *Baptism of Christ*, were all rather different formally from our style of explanation.

So how far do we reconstruct the intention of Piero della

Francesca, a man culturally different from us in his knowledge of pictures, in his assumptions about what his pictures are for, in his perceptual skills and dispositions, and even in his thinking about causes and about intention itself?

2. *Knowledge of other cultures: participant's understanding and observer's understanding*

It is best, first, to be clear about our investigative purpose and posture: it is peculiar and limited. We are interested in the intention of pictures and painters as a means to a sharper perception of the pictures, for us. It is the picture as covered by a description *in our terms* that we are attempting to explain; the explanation itself becomes part of a larger description of the picture, again in our terms. The account of intention is not a narrative of what went on in the painter's mind but an analytical construct about his ends and means, as we infer them from the relation of the object to identifiable circumstances. It stands in an ostensive relation to the picture itself.

It is usual, when discussing the 'understanding' of other cultures and actors in them — an issue discussed a great deal — to start from a distinction between *participants'* understanding and *observers'* understanding. The participant understands and knows his culture with an immediacy and spontaneity the observer does not share. He can act within the culture's standards and norms without rational self-consciousness, often indeed without having formulated standards as standards. He does not, for example, have to list to himself five requirements of altarpiece paintings: he has internalized an expectation about these over a period of experience of altarpieces. He moves with ease and delicacy and creative flexibility within the rules of his culture. His culture, for him, is like the language he has learned, informally, since infancy: indeed his language is one large articulating part of his culture. The observer does not have this kind of knowledge of the culture. He has to spell out standards and rules, making them explicit and so making them also coarse, rigid and clumsy. He lacks the participant's pure tact and fluid sense of the complexities. On the other hand, what the observer may have is a perspective — precisely that perspective being one of the things that bars him from the native's internal stance: the

burghers of Sansepolcro in 1450, to make a particular point which is important for us, had not seen the painting of Chardin and Picasso. The observer typically works from comparisons not made by participants to generalizations participants would find offensively crude and crisp. Moreover he will give special prominence to certain elements in the life of the culture because, from his comparative stance, they seem special to the culture: the participant is not likely to have the same sense of some institutions in his life being constants of human society and others — intensive education in a certain kind of commercial mathematics, for instance — being local peculiarities of his time and place. Yet again, he would be contemptuous of the simplistic and tactless account the observer would offer of them. Any burgher of Sansepolcro in 1450, if he heard what I have said about the culture of fifteenth-century Italy so far, would just laugh, or shake his hand with exasperation — itself a very cultural thing to do.

Seen schematically, participants' and observers' understanding are different in kind, then, and each has its limitations and its special prospects on a culture. The theoretically important issue of whether, in principle, one could ever modulate from the observer's condition to the participant's — rather as, if one has learned a foreign language very well indeed, one begins to forget the rules once formally learned — is not very important for us now, since it is no part of the programme of inferential criticism to hang around in Sansepolcro 1450, or anywhere else, long enough or, even more, exclusively enough for this to come into question. But another long established distinction is worth pointing to in passing because it bears on such sense of being a participant in another culture as one sometimes has. Enquiry is often seen as consisting, again schematically, of two stages, discovery and justification. In the first it is licit to play all sorts of heuristic tricks, including imagining one is a fifteenth-century Italian, or even Piero della Francesca himself, something which involves suppressing, so far as one can, concepts and knowledge of one's own as well as trying to take up those of another. This can lead to insights and intuitions that may appear in the explanation. Moreover, there is no reason why these exploratory stances should not be spoken of in the explanation: on the contrary, there seems much to be said for openness about them. But a moment comes when the explanation must be offered as something that can be scrutinized and evaluated,

and this moment must be in our terms and external to the mental universe of the object of study. If it were not, we ourselves would not have mental access to it for the purpose of scrutiny and criticism. It is not to Piero we are explaining Piero; the explanation must be to ourselves.

What will be reconstructed of Piero della Francesca's culture is going to have to offer itself for scrutiny as external understanding. Any information I pick up and retail about expectations of altarpieces or interest in certain kinds of mathematics or notions of cause is observer's not participant's knowledge of Piero's world. It is crude, over-explicit, and uninteriorized. It also involves a direction of emphasis on aspects of his world which he would not have chosen to emphasize in the same way. My emphasis derives from comparison with other cultures, particularly my own; I point to what seems peculiar or different, not to what would have been largest in Piero's mind.

But a point that is important to me is that it does not stand alone; it stands in a relation to Piero's *Baptism of Christ*. I started from this point: that what we say in the course of inferential criticism takes its meaning and precision from the reciprocal relation between the words we offer and the present work of art. If our concepts are simplistic, rigid and external, the painting offers the participant's knowledge — complex, fluid and implicit. While one may acknowledge the externality and crudity of any conceptual account one may oneself offer of the artist's culture — and so of the 'problem' he was addressing or the 'intention' of the object he made — one may also claim rather more for it when it stands in a working relation to a particular piece of subtle insider's behaviour, the *Baptism of Christ*. So, cheerfully agreeing that we are observers, not participants, in what we say and think of the intention of the picture, let us proceed.

3. Commensurazione — an old word

Having said this, I shall now do something that may seem to go against it. I shall use a participant's concept and say: — The *Baptism of Christ* is remarkable for its *commensurazione*. The first thing is to give *commensurazione* a sense — one additional to the element of ostensive definition implicit in using it with reference to the *Baptism of Christ*.

Piero himself offered a formal definition in the context of a division of the art of painting into three parts at the beginning of his book on perspective:

Painting consists of three principal parts, which we call *disegno*, *commensuratio* and *colorare*. By *disegno* we mean profiles and contours which enclose objects. By *commensuratio* we mean the profiles and contours set in their proper places in proportion. By *colorare* we mean how colours show themselves on objects — lights and darks as the lighting changes them.

This is interesting, but short formal definitions in limited contexts have limitations, and the sense of *commensurazione* is larger and richer than Piero covers here.

Its origin is as a post-classical Latin translation of the Greek word *symmetria* (a word, as Petrarch noted, the classical Romans lacked) and the Latin translation of Aristotle gave it currency by using it for this purpose: for instance, 'Beauty of the parts of a body seems to be a certain *commensuratio*.' It was also used in musical theory. In fifteenth-century vernacularized uses — and it is not a vastly common word — it seems to mean something near proportion or proportionality itself. For instance, the Platonizing philosopher Ficino criticized the Aristotelian conception of beauty thus: 'There are people who are of the opinion [*wrongly*] that beauty is a certain placing of all parts of a body, or *commensurazione* and proportion between them, along with a pleasantness of colour.'

But in Piero it takes on a special accent from its introduction in this context of painting's three principal parts. Earlier in the century it had been usual to consider painting as having two parts, *disegno* and *colore*: Cennino Cennini's treatise, for instance, states this a generation or two before Piero. Looking at fifteenth-century painting, one can see why just two parts might come to seem inadequate, and in 1435 the humanist art critic Alberti had taken the step towards a part of painting that would give some account of how outlines and colours are arranged within the picture as a whole: he brought in *compositio* (Latin) or *compositione* (Italian) as a third part. It is to this that Piero's *commensurazione* broadly corresponds in the triplet. But there is an important difference between *composizione* and *commensurazione*. Alberti's concept is a metaphor from our use of language: it sees the picture as a hierarchy of bodies, members of bodies, and planes, corres-

ponding to the hierarchy of clauses, phrases and words in a sentence. Piero's concept is a term from numerical analysis. He replaces the model of language with the model of mathematics, and it is clear that for Piero mathematics had the same paradigmatic authority as language had, in this respect, for Alberti – who was himself, it should be said, a very numerate man and an exponent of perspective and proportion. In the book from which I took the division and definition, the treatise on perspective, it is specifically geometrical linear perspective that Piero is denoting by *commensurazione*; but it seems that *commensurazione* normally extended out to cover more than just setting contours in their proper places by perspective method. It is an expansionist concept, and its range is quite well caught by Piero's own pupil Luca Pacioli, even though the term he is using, because of *his* context, is *proportion*:

You will find that proportion is the queen and mother of all, and that without her nothing can be carried through. Perspective proves that in pictures. In pictures, if one does not give the size of a human figure its proper bigness in the eyes of a beholder, it never answers well. Again, the painter never prepares his colours well if he does not attend to the strength of this one and that one; I mean that in painting a figure's flesh, for instance, so much white or black or yellow and so on need so much red and so on. Then in the planes, too, where the painters have to place the figure, it is very important that they should have a care to set it with a proper proportion of distance. ... And so it is too with all the other lineaments and dispositions of any painted figure. As confirmation of all this – in order that painters should know how to arrange things – the sublime painter Piero de li Franceschi (still living in our own time and like myself a man of Sansepolcro) wrote not long ago a worthy book on just this 'Perspective'. ... In that book nine out of ten words are about proportion.

Commensurazione's reference can be taken as to a general mathematics-based alertness in the total arrangement of a picture, in which what we call proportion and perspective are keenly felt as interdependent and interlocking.

4. Three functions of old words: necessity, strangeness and superostensivity

Why should one go to this much effort only to half-retrieve a participant's category of visual interest? It would be bad to revert to the ambition to reproduce the intentional workings of Piero's

mind in a narrative mode. In fact, the inferential critic's taste for
using participant's terms is often misunderstood in this sense:
people insist on reminding us yet again that it is *not* possible to
enter into other-cultural minds and indeed that if we go on trying
we may do ourselves harm. It had better be justified, then, and
leaving aside minor motives — enjoyment of period lexical
repertories, for instance, or pleasure in displaying the word to
declare inferential or 'actor-oriented' tastes — there seem three
main justifications.

The first and most obvious is that we now have no category or
concept quite like *commensurazione*. Here one must tread carefully,
for it is not true to say that we share no categories with fifteenth-
century Italy: Euclid stands through time and so does a verbal
concept like 'proportion', even if they spelled and spoke them
differently then or even used a word of quite different form. The
concepts are, if not universal, shared by many cultures and periods.
If we use them across time, however, to link our minds with
theirs, they are very general concepts, almost as general as the
mathematical signs (like ÷ or :) that are used to stand for some of
them. It is very much a matter of the purpose for which we want
them.

But what we are interested in is particular quality: our aim is to
differentiate and so to de-generalize or qualify 'proportion'. It is
the distinctive colour of proportionality in Piero we are after, and
this is likely to mean that we are going to need to move down the
order of generality to categories that are less persistent and more
bound to a particular culture — whether ours or theirs. Our culture
does not offer a word with this particular meaning. *Commensurazione*
takes much of its meaning from the history of use I have sketched:
translation from the Greek, and Aristotelian beauty, the stealing of
aspects of Cennini's *disegno* and *colore*, the mathematical term
ousting Alberti's language-model term *compositio*, 'perspective'
and 'proportion' interlocked. These are not weak associative
meanings of *commensurazione*, though its affective value may have
been strong: they are a part of a conceptual range established in
use, a distinctive sector and arrangement of experience. We need
the word to group a set of related qualities in Piero.

The second justification is that *commensurazione* helps to make
Piero and his picture 'strange'. Many pictures, including the
Baptism of Christ, are enclosed in a terrible varnish or carapace of

false familiarity which, when we think about them, is difficult to break through. This may be partly a matter of the museum-without-walls syndrome but it is even more a matter of the medium of the art, the fact that most of us are not, at least at this level of accomplishment, skilled executants in the medium. The contrast with language, a medium in which we are all incredibly skilled executants, is the most obvious. We find old language immediately remote because of its difference from the medium we use ourselves. The fifteenth-century picture, apart from such details of its subject-matter as costume, is less clearly remote from us than fifteenth-century English; in some ways its medium is less remote than that of Picasso's *Kahnweiler*. A first task in the historical perception of a picture is therefore often that of working through to a realization of quite how alien it and the mind that made it are; only when one has done this is it really possible to move to a genuine sense of its human affinity with us. We have to push Piero back a little before we can approach him, as he is. By alluding to the notion of 'making strange', of course, I do not mean to claim a poetic function for this activity, but it is, in a sense, a romantic thing to do: as Novalis put it, the business of romanticism is to make the familiar strange and the strange familiar, and this seems a fair critical programme. Also, a failure to do this is a main cause of plain historical error.

In this process alien concepts like *commensurazione* have an important part not only because we apprehend historical distance in the course of learning them but because, in the texture of our conceptualization about the picture, they stand for the contrast between those people and us. In a way they are a declaration precisely of our inability fully to re-enact. *Commensurazione* is a token presence of Piero's mind in our thinking: if we admit it we have a bit of theory on our hands because it takes its sense from a set of distinctions from, pairings with, alignments towards and derivations out of other alien concepts. There is a marvellous hard alienness about such words. Though they can eventually lose their strangeness, their half-life is remarkably long. And, what is curious, the distancing effect is particularly strong and persistent in those cases where one of our own concepts is a mutated descendant of them. Consider the tension between *splendor* (thirteenth century) and our 'splendour', *disegno* (sixteenth century) and 'design', *sentimental* (eighteenth century) and 'sentimental', *impression* (nineteenth

century) and 'impression'. So the critical use of participants' terms is a sort of linguistic declaration of our separation from another culture's thinking. Their intermittent presence in our text is representative of an intentional mode in which we cannot ourselves operate.

The third justification harks back yet again to my starting-point in the language of art criticism, so I will indicate it briefly only. I suggested then that the relation between concepts and picture was a reciprocal one: we use the concept to point in a differentiating way at a picture, and its meaning is sharpened for us by the relation between it and the painting we perceive. This process is good for us: we have to work at it and this work leads us to a closer perception of the picture. In this respect concepts like *commensurazione* are exceptionally stimulating. Because our hold on them is not a relaxed and internalized one, we have to work hard between them and the picture. They are super-ostensive.

5. Truth and validation: external decorum, internal decorum and positive parsimony

So far we have noted that Piero's Brief would have included demands that the painting be of the Baptism of Christ, be by Piero, and be an altarpiece; we have broken the genre 'altarpiece' roughly down into an expectation that the picture be clear, moving, memorable, sacramental and creditable. We have noted a special resource within Piero's culture, a type of mathematical skills and dispositions which he possessed to a quite exceptional degree and his clients had to a lesser but still superior degree. We have invoked the complex concept of *commensurazione* which, since it is a concept of Piero's, is implicitly identified as an active element in his intention. The function of all this inferred intentional matter is to interact ostensively with the picture. It is quite vapid on its own.

But how true is it? Or, to generalize the matter, how do we assess the relation of inferred intention to the truth? I put the question in a naive form since what follows is going to be one of the more naive parts of this book — partly because it verges on philosophical issues I cannot handle, partly because for many people it is anyway a naive and inappropriate question to raise in the course of interpretation of works of art. But it will be clear by

now that I am avoiding the notion of 'meaning': I do not want to address the *Baptism of Christ* as a 'text', either with one meaning or with many. The enterprise is to address it as an object of historical explanation and this involves the identification of a selection of its causes. These are necessary not sufficient conditions of the picture. They are chosen for critical purposes; they are not complete. But they can be *incorrectly* chosen, or in plain language untrue.

Let us agree first that by truth we will mean correspondence with reality and that the reality we want to correspond with is not just our sense of the presence of the picture but mental and physical events that actually happened in Sansepolcro in or about 1450. It is a matter of choice: 'Piero was very fond of making clay models which he would drape with wet cloths arranged in very many folds and then use for drawing and similar purposes.' This is something said by the greatest of all art historians, Giorgio Vasari, and any attentive reader of Vasari learns to recognize this sort of remark as Vasari chancing his inferential arm: it is unlikely he had the sort of evidence for this practice that would let us nowadays feel happy making the statement so firmly. This does not matter. Vasari's own generic character places his remark for what it is — a critical truth, so to speak, as one sees when one matches it with, say, the white middle angel in the *Baptism of Christ* — and no reader of Vasari's own time would have had a false sense of its historicity. Indeed Vasari's nimbleness between the critical and the historical is enviable; but we live in more muscle-bound times in these matters and if I said such a thing about Piero so flatly now you would be entitled to expect me to have actual collateral of a kind I could not produce.

Let us agree also that any account we give of the historical reality will correspond to it in a very summary and diagrammatic form. It is a little like the correspondence between the schematic maps of the Bay Area Rapid Transport System or London Underground and the knotted complexities of the real things: (1) the diagram leaves much out; (2) it is a small-scale registration of a large thing, and a static registration of a moving thing; (3) its emphasis is much distorted by the demands of its own form, whether symbolic lines or symbolic words; (4) the medium is conventional and demands understanding itself; (5) it is directed to a specific sort of use; (6) its meaning lies in its relation to a more complex reality. But the point is that it is *within its own limits*

correct; it could be incorrect within its own limits. If the map showed BART going to Palo Alto it would not correspond with reality even in its own terms. The difference is that whereas we can go out and check the BART map by matching it directly with the running of the trains, we cannot go to the Sansepolcro of 1450 and match our diagram directly with Piero's thoughts and acts. We must find more indirect ways of validating our accounts.

Now (it need hardly be said) the scientific thing is to derive predictions entailed by our account of a thing and test these predictions. If the predictions fail, we are wrong. There are dilute elements of this in much that a historian does: or rather, much that a historian does can be restated in a form that approximates such a procedure. For instance, the notion of 'genre' I have been using — as in the genre of 'altarpiece' — is, in a way, a theory. It can be re-written as predictions, five predictions, about altarpieces and these can be tested with a limited degree of rigour by looking at fifteenth-century altarpieces. As is usual in a humane science, one has to retreat smartly from a demand for a hundred-percent success to a hope for a fairly high correlation between altarpieces and the five points: there are indeed fifteenth-century altarpieces not fully like this. The theory is about probabilities not universal recurrences.

Besides, the genre is not my first concern. It is a means to an end and in testing it I am testing one of my tools, not my account of the particular, the *Baptism of Christ*. And when one is concerned with a particular, direct forms of prediction become both trivial and weak. For instance, I suppose I have hypothesized by impli-cation that Piero's category of visual interest *commensurazione*, or something like it, was present in his mind while he was painting the *Baptism of Christ*. A sort of prediction can be derived from this, that a relatively great alertness to proportion and perspective in close relationship should be discernible in the painting. But this is unsatisfactory in at least two ways. First, it is self-evident and boring. Secondly, it is weak, because whereas the scientific pre-diction will be a general law that can be tested many times, my prediction, which is in any case of discussible precision — 'rela-tively great alertness. ...'! — is testable only the once. And any attempt to restate it in general terms — 'painters who have a particular category of visual interest present in their minds etc.' — becomes vacuous. In short, the strict predictive pattern does not

offer the means of validation we need for our complex and
particular explanations of pictures. We need something more
oblique.

This is heavily trodden ground in the methodical discussion of
several disciplines. The philosophy of historical explanation points
particularly to a set of tests for external appropriateness. It would
urge us to test any intentional account of an action for consistency
with other performances by the same actor, with any statements
he may have made about his intention, with the capacities of the
culture he belongs to. We have done a little of that: we have
elevated Piero to a genre; we have snatched the programmatic
term *commensurazione* from his lips; and we have pointed to the
special mathematical skill of his milieu. It might also urge us to
construe the internal rationality of intentional behaviour as a sort
of acted-out logical statement, a 'practical syllogism'; and since
the statement comes in the final form of a finished work the effect
of this is inevitably to refer us on to the more traditional method
of interpretation. Hermeneutics — though I do not want to get
involved in it — would also demand consistency with facts and
performances outside the immediate object of attention: 'legi-
timacy' and 'generic appropriateness' urge us to check that what
we claim is so is conceivable in the culture and does not ignore its
sense of kind. But it also points more insistently to the need for
internal adequacy in explanation. Not only should what we say be
consistent with the painting in every part, it should be actively
consistent both with those parts constituting a whole and with
that whole standing in a legitimate relation to the external facts.
However, this may seem to say rather little about the functional
look of good explanations, and for this one falls back on weak
forms of old general criteria: economy and pragmatic utility. The
simpler way of reaching a certain level of coherent explanation is
likely to be the more attractive: there is an obligation to demon-
strate the need to invoke this or that bit of circumstance. The
explanation must pay its way, and the most obvious style in which
it can do this is to solve an observed puzzle in the object or to alert
us to a peculiarity in the object not previously observed.

This is all very cursory and brusque, but the universes I am
invoking are well-known and accessible, and I am still anxious to
elude methodical rigour of an inhibiting kind. If you take matter
like that of the last paragraph and shake it, it sorts itself out into

three intercommunicating criteria or — as I would prefer — three
self-critical moods of a commonsense sort. As a student of the
classical tradition I think of these as external decorum, internal
decorum, and parsimony; but you will prefer me to refer to them
as (historical) *legitimacy*, (pictorial and expositive) *order*, and (criti-
cal) *necessity* or fertility. They are not modes of proof but stances
from which one may reflect on the probability of one intentional
account as against another.

The first, legitimacy, is a matter of external propriety. Much of
this is straightforward, a normal avoidance of anachronism. We
try not to suppose things in the painter's culture which are not
there. We look at one picture by a painter in the light of other
pictures by him, with an expectation of some continuity, however
much development — particularly in cultures like Piero's where
the painter's own work is seen as a genre. And we lean heavily on a
sense of kind or genre for the finer points, the more elusive
discriminations about manner. But delicacy is needed particularly
at two points. One is not to drive a demand for legitimacy so hard
and unidirectionally that originality or inadvertence or defiance are
quite ruled out: many great pictures are a bit illegitimate. The
other is in distinguishing between levels of authority. I might
produce a contemporary text to show a certain notion was avail-
able in fifteenth-century Italy; but against this I might also know
that in a certain genre, such as the altarpiece, notions of that
complexion did not occur. The more general, the second, would
have tentative priority over the less, but might have to yield if the
larger framework of explanation demanded.

The second, order, is a matter of adequately comprehending an
internal organization, posited in the object one is addressing and
reflected, in a different and informal guise, in the nature of one's
explanation; both have an internal consistency. If the word did not
have technical senses in both hermeneutics and the philosophy of
truth I would have liked to call it *coherence*: 'order' sounds bland.
The area I have in mind is articulation, system, integrality, en-
semble. That positing an intentional unity and cogency entails a
value judgement and hypothesizes a high degree of organization
in the actor and the object will not worry us. Only superior
paintings will sustain explanation of the kind we are attempting:
inferior paintings are impenetrable. What may appear as a lack of
unity or organization in the explained painting is liable to be a sign

of incompleteness in the explanation, a failure to take into account a circumstance that resolves this or that apparently detached element into an intentional unity. Thus, on the whole, the explanation positing the more complete and embracing order is preferable.

The third mood is critical necessity or fertility. One does not adduce explanatory matter of an inferential kind unless it contributes to experience of the picture as an object of visual perception. This has implications to which I shall return. But there are many fifteenth-century circumstances that one could adduce as *consistent* with Piero's *Baptism of Christ* which one does not adduce because they are not necessary to the purpose: which is inferential criticism. It is a pragmatic mood, a demand for a sort of actuality.

These may appear blunt tools but energetically applied together, trident-like, they can cut radically. A look at the problem associated with the *Baptism of Christ*'s intended significance as a religious image — a much discussed issue so far evaded — will give an opportunity for trying them out.

6. Three iconographies

Most accounts of the *Baptism of Christ* address the picture through certain principal peculiarities and differences from other representations of the scene. They demand explanation. One is the oddity, prominence and seeming separateness of the three Angels in the left foreground. A second is the shifting of the spectators, all but one man stripped for baptism, into the right background; and the dressing of them in a sort of Byzantinizing costume. A third is the change in the water around Christ's feet: in the background and middle-ground it is reflective but in the foreground it becomes transparent or, on some readings, dries up. For some observers a fourth is that the landscape looks like Sansepolcro and the upper Tiber valley in which Sansepolcro lies.

These peculiarities, problems set the observer, have given rise to some very elaborate explanations of the picture's significance. One scholar's explanation sees the three Angels, with their handclasp, as carrying a triple meaning — reference to the Trinity, to Christ's marriage with the Church, and to the decree of union between western and eastern Churches signed after the Council of Florence of 1438–39; it sees the background figures as referring

both to the Byzantine Church and to the Epiphany, the manifestation of Christ to the Magi; it takes the representation of the Baptism as happening on the Tiber near Sansepolcro to be an assertion of the primacy of Rome — an issue at the Council of Florence; and it sees the odd river as halting in its course and flowing, as it were, both ways, from and to Christ, to and from the Holy Sepulchre (or Sansepolcro).

Another scholar's explanation sees the Angels as an allusion to marriage, and specifically the Wedding at Cana, which was celebrated at the same festival as the Baptism and Epiphany and interpreted as symbolic of Christ's marriage to the Church. The background figures represent the Epiphany, the fact that there are four rather than three Magi being explicable in turn by the Bible not specifying three but indeed having a reference in Psalm 72 to four Kings, interpreted by some Church Fathers as a prefiguration of the Magi of the Epiphany. The use of Sansepolcro and Tiber, and also of a dominant walnut tree that invokes an old name of the valley, Val di Nocea or Walnut Valley, involves a set of intended allusions, but particularly to Sansepolcro's sense of itself as a sort of new Jerusalem: the town's name comes from a legend about pilgrims bringing relics of the Sepulchre there and the Church of the Camaldulensian house in the town was seen locally as a replacement of the Church of the Holy Sepulchre in Jerusalem itself. The odd river represents a sudden transparency which, while rationally explicable in terms of the angle of reflection of still water, nevertheless has a suggestion of dryness that alludes to a medieval legend about the River Jordan standing still at the moment of the Baptism, as God's sign of Christ's mission and divinity.

Summaries of such learned and ingenious readings, high iconography, cannot do them justice: they depend on argument from collateral, much of it late antique and medieval, and it would not do to scrutinize them on the basis of such undocumented summary as I have given. Besides, they are not the kind of explanation a stance in the three self-critical moods leads the inferential critic towards. The criterion of legitimacy would raise questions precisely about argument from late antique and medieval, rather than fifteenth-century, texts and artefacts; and indeed about whether such layered and multiple intention was compatible with either the theory or the practice of the fifteenth-century altarpiece image.

The criterion of order is worried by the darting about of attention the readings demand, back and forth across field and in depth, and also by their detachment from strong pictorial suggestion in the painting's own organization. The criterion of necessity finds the readings unparsimonious in offering such multiple explanations involving so many external circumstances: things seem over-elaborate. The same four peculiarities can be more economically, as well as more legitimately and more coherently explained, with a piece of low iconography like the one that follows.

The visually dominant oddity of the picture is the insistent and obtrusive presence of the three Angels. A key to them is a simple homiletic reference to the doctrine of the Three Baptisms. The Baptism of Christ was the occasion of the institution of the sacrament of Baptism, the first sacrament, and expositions of the Baptism of Christ — as in sermons on the Feast of the Baptism — naturally used the opportunity to lay out the nature of Baptism. The Three Baptisms were a fifteenth-century preoccupation, in fact, and the only reference book we need is something like the mid-century *Summa Theologica* of S. Antonino of Florence, speci-fically the sermon on the Baptism of Christ and the chapter on Baptism. Indeed, if Piero went to church during his journeyman years in Florence, he could have heard S. Antonino preach.

The Doctrine of the Three Baptisms had been developed to meet the difficulty that, if the unbaptized are damned, some classes of souls that do not deserve it — unbaptized martyrs, for instance — are excluded from Purgatory and condemned to everlasting punish-ment. It was therefore held that, in addition to Baptism by Water, the sacrament proper, there were also Baptism by Blood (*Baptismus sanguinis*) which was allotted to those who died for Christ, and Baptism by the Spirit (*Baptismus flaminis*).

But if one could gain the essential remission of original sin without actual Baptism by Water (*Baptismus fluminis*) there was, it was felt, a danger of people being less urgent about going through or submitting their children to the normal sacrament of Baptism. The point was therefore made that, unlike the other two, Baptism by Water not only cleansed us of original sin and so remitted eternal punishment, but also impressed an actual 'character' to good upon our souls, rather as ordination impresses a character on a priest: 'it diminishes the inclination to sin and illuminates the mind, especially in respect of those things that are of Faith'. So

Baptism by Water had a special power which Baptism by Blood and Spirit did not.

Thus the peculiarity of the three Angels in the picture. All angels are Spirit; the right-hand Angel wears in addition a wreath that one could identify with the Martyr's Laurel. But the middle Angel, dressed as if prepared for Baptism by Water, is being referred on by the others to Christ's example, and its white balances that of the baptized man on the right.

Such of the other oddities as are real oddities now fall into place. The spectators — whose Byzantinizing gear is Piero's usual oriental local colour — have been moved back so that they do not confuse the burden of the foreground and particularly do not detract from the solitary baptized man balancing the middle Angel.

The water round the baptized Christ's feet is transparent because this is symbolic of the effect of the material cause of Baptism by Water. According to S. Antonino, 'Water is a diaphanous, that is, a transparent body, whence it is susceptive of light; thus baptism confers the light of faith; whence it is called the sacrament of faith.'

As for the Sansepolcro-esque landscape, it was not unusual to set the religious stories in landscapes that are more or less in the character of the locality. A devotional reason for this is given in devotional handbooks of the period:

The better to impress the story of the Passion on your mind, and so to memorise each action of it more easily, it is helpful and necessary to fix the places and people in your mind: a city, for example, which will be the city of Jerusalem — taking for this purpose a city that is well known to you.

That was for the purpose of private meditation: to offer a generically familiar setting in a picture was to fulfil the image's duty to be memorable and vivid. But Piero's standard of city portrait was high (Pl. 52) and by it little is made of Sansepolcro here: too little, I feel, to demand further explanation.

This account seems to me to explain the four peculiarities of the picture with more regard to legitimacy, order and necessity than those of high iconography. As inferential criticism it seems more valid. It will at least give us something off which to bounce the ball, and because questions of validity are questions of relative

validity we need this. It is now possible to move on and, in the course of locating the vices of the account I have just offered — which I am sure is incorrect — and working out a more valid explanation, to locate also several requirements of serious self-criticism within the three self-critical moods.

7. Plain reading of the picture

The main sources of error in my explanation also seem three. The most obvious and disastrous is to have neglected the premise — previously insisted on at, I am sure, tedious length — that a picture may profitably be construed as a piece of problem-solving. Falling back into the habit of looking for 'meaning' one sought 'signs' and of course immediately found them. The second source of error was to attend too little to Piero's peculiar pictorial idiom, described earlier as no less than generic. This compounded very badly with the first, because part of Piero's problem was certainly Piero's idiom. The third was that the sense of legitimacy, order and necessity (hereinafter L, O and N) was coarse, and insufficiently radical.

Both the pictorial centrality of Christ (O) — the proper part of the picture to start from — and the functions of religious images (L) would lead us to expect that the matter of the picture is the Baptism of Christ — not the theological doctrine of Baptism (nor the Council of Florence, nor a triple Festival). A first question, then, is whether (N) there are things in the picture that are not explained by its being simply a literal registration of this and its straightforward religious significance. It will be best first to remind oneself of the story (Matthew 3, translated by Tyndale):

In those dayes Ihon the Baptyst came and preached in the wildernes of Iury, saynge: Repent, the kyngdome of heuen is at honde. This is he of whom it is spoken by the Prophet Esay, which sayeth: The voyce of a cryer in wyldernes, prepare the Lordes waye, and make hys pathes strayght.

This Ihon had hys garment of camels heer. and a gerdell of a skynne aboute his loynes. Hys meate was locustes and wylde hony. Then went oute to hym Ierusalem, and all Iury, and all the region rounde aboute Iordan, and were baptised of him in Iordan, confessynge their synnes.

When he saw many of the Pharises and of the Saduces come to hys baptim, he sayde vnto them: O generacion of vipers, who hath taught

you to fle from the vengeaunce to come? Brynge forth therfore the
frutes belongynge to repentaunce. And se that ye ons thynke not to saye
in your selues, we haue Abraham to oure father. For I saye vnto you,
that God is able of these stones to rayse up chyldern vnto Abraham.
Euennowe is the axe put vnto the rote of the trees: soo that every tree
which bringeth not forthe the goode frute, is hewen doune and cast into the
fyre.

I baptise you in water in token of repentaunce: but he that cometh
after me, is myghtier then I, whose shues I am not worthy to beare. He
shall baptise you with the holy gost and with fyre: which hath also his
fan in his hond, and will pourge his floure, and gadre the wheet into his
garner, and will burne the chaffe with vnquencheable fyre

Then cam Iesus from Galile to Iordan, vnto Ihon, to be baptised of
hym. But Ihon forbade hym, saynge: I ought to be baptysed of the: and
commest thou to me? Iesus answered and sayd to hym: Let it be so now.
For thus it becommeth vs to fulfyll all rightwesnes. Then he suffred
hym. And Iesus assone as he was baptised, came strayght out of the
water. And lo heuen was open over hym: and Ihon sawe the spirite of
God descend lyke a doue, and lyght vpon hym. And lo there came a
voyce from heven sayng: Thys ys that my beloved sonne in whom is my
delyte.

The main points of the narrative are: John came to the Jordan, in a
garment of camel's hair and a leather girdle, and the people came
and some were baptized; but John rebuffed the Pharisees and
Sadducees with a remark about barren trees being cut down and
their wood burned; he also spoke of a mightier one than himself
coming after, and Christ indeed came, and insisted on John
baptizing him; God sent down the Holy Spirit in the form of a
Dove and spoke of his satisfaction.

What was seen as the significance of the story? If we stay with
the Sermon on Baptism by the contemporary S. Antonino (L) there
are three dominant elements in this. First, it is the first and great
manifestation of the Trinity through God sending the Holy Spirit
as dove. Secondly, it is the institution of the primary sacrament,
Baptism, the ritual of cleansing through which our implication in
original sin and so our eternal punishment are, at any rate,
remitted. Thirdly, and very importantly, it is a stunning exemplifi-
cation of Christ's humility: he *descended* to the Jordan and, sinless,
insisted on being cleansed, and by a man less than himself. These
three are the key mysteries and Antonino's choice is orthodox:
other sermons and handbooks of the time expound them as well.

And Piero sums them up (O) in the privileged section of the picture running down from the Dove (for the Trinity), through the Bowl and the water (for the sacrament of cleansing) to Christ's head with its downcast eyes (for humility). This, centrally, is what the picture is about.

But of course this still leaves the three peculiarities — the four men in the background perhaps, the odd river-bed, and the obtrusive Angels — which led to the elaboration of explanation. The first step is to start thinking about the complex problem Piero was addressing in the picture. Piero was working in a pictorial tradition of the Baptism of Christ (Pls. 47–51): from this came the Angels, not specified in the Gospel, and the precedent for a group of onlookers. But his performance in this tradition was complicated by two special things. One — something I believe essential to it — is that there was not a strong tradition for pictures of the Baptism of Christ in a fairly large-scale and large-figure vertical format like this. The tradition lay most in small-figure vertical panels and large-scale horizontal Baptisms in fresco; and Piero had to deliver the full homiletic charge expected of the central panel of an altarpiece. The other special thing was Piero's own idiom.

One can think of the implications of this in terms of a special difficulty and a special resource. The difficulty was foreground congestion: quite simply, in the large vertical format there was a shortage of room for onlookers at the sides of the picture, if the central group of Christ and John was not to be jostled and devalued. Moreover Piero's monumental figure style was precisely one not to facilitate squeezing secondary figures into a narrow foreground row: he was a painter who needed some lateral space for this and whose spectator figures are never unobtrusive. But he also had special resources, and one was what he would have called *commensurazione*, which includes the ability to register through systematic perspective recession and organization in depth, in-wards into the picture. This enabled him to retain the figures of the baptized and the onlookers without crowding Christ and John out of the foreground dominance they need. Piero's solution is marked by a characteristic piece of space-time lucidity that organizes the matter of the first half of Matthew 3 in a forward sequence (O) through the picture space: the hills John and Christ came down from; John's hearers; the tree-stumps he compared some of them with; a representative object of his baptism; and along down

the river to the central matter of Christ and John. This, I feel, accounts sufficiently (N) for the four richly and orientally dressed figures: they are not the Byzantine church nor Four Magi but just Pharisees and Sadducees and so on.

The second oddity of the picture is the sudden break from mirror-like to transparent water in the foreground: I invoked S. Antonino on the penetrability of the baptized to the light of faith (and others have invoked more remote matter) and this had some appearance of a chronologically legitimate and not anti-articulate explanation. It is not, however, necessary and must be rejected in favour of a more intrinsic pictorial matter. Again both the pictorial tradition and Piero's idiom are involved. It was Piero's practice to represent rivers in the mirror-like mode (Pl. 53) of the middle-ground: he was clearly interested in the optical adjustment of reflections. But this set him a small difficulty here. Imagine Christ's figure, in Piero's idiom, *without his feet*; worse, imagine it with, instead of feet, a Pieresque reflection of calves. But the pictorial tradition contributed what was both another element in the problem and a means to solution. Indeed, if the picture had not lost most of its gold-leaf heightenings, one would not have had an oddity to explain. Originally the Angels, Christ and John had gold haloes and there were other gold touches on wings and hems, but above all there was a sort of gold shower of rays of light coming down from God. This was common in Renaissance pictures of the Baptism of Christ. The striations of the gilding are still clear in the area round the Dove in Piero's picture. This was God's light shining down on Christ and of course on the water round him: Christ stands in a kind of divine spotlight. This not only justifies the transparency but is (O) more fully realized visually by the transparency. It is not the light of Faith but the light of God.

The third oddity was the obtrusive Angels (Pl. 56) — indecorously read as the Three Baptisms (or the union of Byzantine and Roman churches of 1438–39, and Christ's marriage with the Church, and/or the Wedding at Cana). Everyone agrees there is nothing odd about the presence of Angels at the Baptism of Christ; they may not be in the Bible but for centuries they had been a standard part of the representation (Pls. 47, 48). But these are felt to be abnormal in various ways. It is pointed out by the iconographers that they are not performing their usual function of holding Christ's outer garment while he is baptized. This is just an

error of observation. Angels in Piero do not wear over-shoulder stoles; and in Piero's one surviving depiction of Christ with an outer garment, the *Resurrection* at Sansepolcro, it is of the same rose colour — an important colour for Piero — as the garment over the right-hand Angel's shoulder here. Yet again it is Piero's idiom that has to be taken into account: a display like that of angels found in some other painters' pictures would be absurd in his ambience, like bull-fighters' flapping capes.

It is also pointed out that these Angels are abnormal in not venerating the event before them. Perhaps it is time (L) to ground our sense of the angel in general a little more firmly. Turning to S. Antonino we learn, very orthodoxly, that of the nine orders of angelic being what we usually refer to as 'angels' are the lowest; and that, with limited participation by Virtues and Archangels, they are the only ones who converse with Man. They aid our piety and are a source of intellectual inspiration by the Holy Spirit. For this they can assume human form, symbolically youthful and beautiful, to appear to us specifically when we are making our devotions. Above all, they are present to us when the Priest says Mass at the Altar; and this picture is an altar-piece. What Angels were not was mummers who would act out the Three Baptisms (or the Council of Florence, or the Wedding at Cana). They were spirit, not impersonators. In fifteenth-century art they performed their function of intellectual inspiration in various ways — (left to right in Pl. 59) cueing us to devotion by their action, referring us by direct gesture to what we should attend to, or reminding us of specific points about the particular mystery, in the extreme case with a scroll and text.

I think Piero's three Angels are doing all three of these things, but in a Pieresque way. Generically his angels are not demonstrative but very subtly concerned with engaging us in his underplayed representations. In the simplest form (Pl. 55) the angel looks at us and gestures to the object of devotion; more delicately (Pl. 54), one angel looks at us and another looks at the object of devotion — the mediating function being split between two members of a class. In the *Baptism of Christ* Piero achieves the most complete of all his solutions: of three very kindred heads, one catches our eye, one registers frontal straight attention, one turns its body and with a gesture refers us to the central scene. And at an even more subtle and Pieresque level (O) the middle Angel directs

us to the fact of Baptism by completing a triplet of whites with Christ, at the centre, and the bending man on the right. Instead of carrying a scroll with an inscription — say, 'Wash me and I shall be whiter than snow' (Psalm 51: 7) — it fully pictorializes its cue in the medium of ordered colour and tone.

Is there, then, no puzzle in the Angels needing explanation? It seems to me that we have here reached a point where individual response must take over; certainly your feeling about this has quite the same status as mine. My feeling is that there still is something to explain: the rest of this section will attempt to do so.

The need for further explanation, it seems to me, lies in a departure from Piero's normal idiom in three particulars. First, the Angels really are quite unusually complex and differentiated in their interacting group. This is not just a matter of the handclasp and the hand on shoulder but is more particularly involved in the relationships of their feet: feet are often conversational in Piero. Secondly, there is no other angel in Piero with off-the-shoulder drapery like that of the white Angel here. Thirdly, while there are angels wearing a diadem or a rose crown elsewhere in Piero's work, there is no other angel with a wreath — of whatever it is: it is so generalized, surely, that it could be myrtle or bay or olive or almost anything.

The master-problem addressed by the picture was, I repeat, Piero's idiom coming into contact with the pictorial tradition on a relatively large vertical panel. Piero's usual conception of the angel as a statuesque, not to say stolid, adolescent presence near-adult in scale made his task difficult here. Three of these apparitions in an undifferentiated rank would have come near to taking the picture over. They could not be pushed off into the background without weakening their choric function. They could be grouped tight and the tree could be used to make a side-niche for them; and another tree behind them could even offer a sort of echo of the foliate or tracery canopy that niches had once been crowned by. There is a reminiscence of the old triptych form here.

But they still needed to be diversified and lightened if they were not to be an oppressive and inert mass. It was, in fact, a general mid-century development to establish relations between the Angels, but the lightness needed was not a strong element in Piero's own inventive bent and one might expect him to look around for lightening motifs to develop. It has been suggested

that one source might have been a classical group of the Graces (Pl. 57) and indeed there is some obvious similarity. It may be a source, but precisely because the similarity is obvious the inferential critic will not enjoy this explanation; it smacks too much of 'influence' and allows too little for the active transforming individuality of Piero and his idiom. What we want is not something that looks like Piero's Angels but something that, having been transformed by Piero, would look like Piero's Angels. What we would enjoy most of all is something that looks very unlike Piero's Angels but reference to which, in the course of solving the larger problem of the picture, would have disturbed Piero's usual angel mode into something like the Angels here.

The first fact known about Piero's career is that in 1439 he was working in Florence as an assistant to Domenico Veneziano. Events in Florence in 1439 included not only the Council of Florence but also (L) the finishing of Donatello's great Cantoria with its extraordinary frieze of dancing and singing angels — some of them (Pl. 58) with off-the-shoulder drapery and wreaths. The Cantoria was one of the greatest public works of art in the 1430s and a pattern-book for hyper-active angels. The juxtaposition with Piero's group is absurd in just the right critical way: it accounts for oddities while being dissimilar enough to throw light on Piero's particularity, as indeed on Donatello's too. The inferential critic will rest here, with a claim that reference to Donatello at a moment of need for diversified angels disturbed Piero's habit with angels to the limited extent we see: Cantoria angels transformed by Piero would be like the Angels in the *Baptism of Christ*.

8. The authority of the pictorial order

A self-critical explanation has led, then, to a reading of the picture that is iconographically minimalist: the painter met his Brief of producing in his idiom an altarpiece image (with all that implies) in which the main heads of the matter of Matthew 3 are effectively treated in an active relation to a pictorial tradition itself constituting part of the problem. That is all: no hidden meanings are necessary to explain it.

This involves drawing a firm line between, on the one hand, what we take to have been immediately active elements in the

painter's intention and, on the other hand, what some people of
the time, including Piero himself, could have thought while
looking at the picture. In systems like classical mythology and
Christian theology, matured and elaborated over centuries, almost
anything can signify something — trees, rivers, the various colours,
groups of twelve, seven, three or even one; many things can
signify various things. There is an intolerable quantity of legitimate
matter offering itself for the *Baptism of Christ*. To go no further, S.
Antonino provides enough for several lectures: there are seven
distinct significances of the water of Baptism, for instance, and the
Dove God sent down at the Baptism is expounded under three
main heads: (1) its simplicity or lack of guile (*Estote simplices sicut
columbae*, Matt. 10); (2) its earlier role in bringing the branch of
olive to Noah as sign of coming safety or salvation; (3) the seven
natural characteristics of doves as significant of the seven gifts of
the Holy Spirit. Very likely Piero himself knew these things;
certainly some of his contemporaries would have had them brought
to mind by his picture of the Baptism of Christ. This *Baptism of
Christ* does not bar them. They are even in a more remote sense
causal of the picture, in that they are part of the rich potentiality
for significance of the Baptism of Christ that was a positive
circumstance in Piero having come to paint the *Baptism of Christ*,
and with such seriousness. But they are not immediately or
individually necessary to the intention we construct as organizer
of forms and colours in the peculiar way we see them in this
picture. We have no basis for seeing them as specifically activated
here. Intention, then, in the weak sense sketched in Chapter II.1 of
a posited purposefulness, turns out a sharp razor: circumstances
are attached to forms and colours by a sort of practical entailment
we cannot break. If the character of the forms and colours does
not demand or manifest them, we do not invoke them.

It is to the authority of the pictorial character, forms and
colours, I want briefly to return. The self-critical tool I cited least
often in the last section was the inadequately named 'order'. It is
the one least easy to verbalize directly, except on the rather crude
level of pointing to a triplet of whites or to a narrative temporal
sequence through represented space. The deliberation of Piero's
commensurazione makes it possible and less than usually philistine to
think about it diagrammatically (Pl. 62): Piero's squaring up of his
design for transfer to the panel would have shared elements of

this. Since the picture is roughly 3:2 in its proportions we sense at some level the inherent role of halves, thirds and quarters in its organization. Even narrative or iconographic matters such as those we have just been considering interlock with our sense of these relations — the emphasis on Angels' choric glance at half way, for instance, and S. Antonino's three mysteries of Trinity, Cleansing and Humility summed up in that privileged section from Dove to Christ's face. In a verbal explanation of a picture the authority of such matters, as compared to the significance of something or other found verbalized in some directory of symbols, is difficult to drive home. But their authority is primary, if we take the visual medium of pictures with any seriousness at all; they, not symbols, are the painter's language. Good inferential criticism observes this authority even if it is not up to invoking it. It is possible to give a shadow-account of articulation by not flouting it.

For instance, there are various reasons for not reading the plants in the foreground of the *Baptism of Christ* in a symbolic sense of healing, as is sometimes done. One is that such plants are found elesewhere in Piero's work. Another is that a medieval herbal is in any case a medical directory to the healing properties of plants: that five of them appear in herbals as having healing properties is a fact about herbals, not about the picture. Another is that they have sufficient narrative justification as one more registration of the fertility of the valley: John (Matt. 3:1) has just come from the wilderness and Christ (Matt. 4:1) is immediately after to go out into it. But, for me, the finally decisive thing is a rather elusive matter of pictorial organization I would not normally try to spell out: it sounds so fragile, and aesthetical, and also it takes so long. I will give a last hostage by making the attempt.

Piero was much given to *commensurazione*, which included systematic perspective. The effect of this is to give further weight to the representation of space in the picture: we have seen him using this to solve a problem of narrative lucidity and composition. As so often, however, a secondary problem seems to have emerged from this resource: one infers this from the picture. It was a problem for him, and another man might not have felt it. In modern terms the problem is that the picture *plane* was losing its weight, or that the relation between picture surface and picture space was losing its balance. He would not have described it like

this and very likely did not conceptualize it very far at all. It might have been just a liking for the feel of certain earlier pictures with a good relation of this sort; or it might have been something like a craftsman's consideration for the look of his work in the very odd and varied conditions of illumination found in a Renaissance church. In talking about a balanced relation between picture plane and picture space I am obviously being external, an outsider, and I am also being ostensive: I shall resist the temptation to bring the relation under the generous cloak of *commensurazione*, or proportion, though we have in Piero a coherent personality enough.

Now we can, I suggest, see Piero addressing this problem with various means in the *Baptism of Christ*. It is as if he were counter-balancing, on a sub-representational level, the energy of his representation of spatial depth. For instance, the Dove in the foreground is almost one with the clouds in the distant sky: the surface of the picture here has a pattern or composition distinct from the composition we derive from the picture when we accept it as representation of something in three-dimensional space. We can move between the two, and apprehended at a lower level experience of this comes to offer deep satisfactions, a sense of the material reality of the picture as an object, a sense of ordered complexity. Another means by which he addressed the problem was through what I shall call accommodation paradoxes, of which there are a number in the picture. A simple and minor example is offered by some incongruously sharp and bright blooms he has chosen to paint on the bushes (Pl. 61) behind the newly distanced onlookers. The effect is both to soften, in the picture-plane register, the violence of the spatial distancing in the picture-space register and, by acting on our attention, to compensate on a straight narrative level for their diminution.

The plants in the foreground are deeply involved in this game and share elements of both devices — variants, that is, of both dual-register composition and accommodation paradox. They pick up the surface patterning, hues and tonality of the section of distant hillside above them, conciliating depth and surface (Pls. 60, 61). They are sharply focused silhouettes marginally in front of the principal narrative plane of the represented space. This, not redundant symbolism, is their intention.

I am sure many of you will reject this, on various grounds — 'probably just over-cleaning', 'influence of Fra Angelico',

'inadvertence oversubtly read'. In fact, I am less concerned to persuade here than to make a position clear: this is the sort of medium in which I think pictures signify. That it is not practical always to spell it out does not mean good criticism cannot observe it. The tacit shadow-account we give of order is a cognate of our positing, but not describing, 'process'. As it happens, the Piero of *commensurazione* offers unusual opportunities for the demonstration of one kind of articulation, or order: it is untypically there to be seen on the panel. But one can observe order in anything from the shape of a baroque painter's brushstroke to the precedent restructuring of visual experience implicit in Picasso's *Kahnweiler*; and also in Chardin's manipulations of Distinctness. Behind a superior picture one supposes a superior organization — perceptual, emotional, constructive.

9. Criticism and questionability

From the start I have been at pains to insist that the line of thinking about pictures sketched in this book is not *the* proper way to think about pictures. There are many proper ways, which in normal perception we combine. Rather, the issue has been one of — supposing that we cannot totally exclude from our response to pictures an ultimately historical sense that they were purposefully made by someone — what it is we are doing in that bit of our minds; and then by implication whether we can develop this sense without becoming irrational and wild. I have tried to suggest we can, so long as we are aware of the limits and odd status of what we are doing. Critical inference about intention is conventional in various senses (Introduction 5; I.8; II.1) and also precarious.

But somewhere in that last precarious quality is the basis for a modest claim to virtue. It rests on the point that you may well have disagreed with what I have said about Piero della Francesca's *Baptism of Christ*: indeed towards the ends of IV.7 and IV.8 there are observations intended to be provocative, or at least conspicuously disagree-able. More programmatically, the whole of my account of Chardin's *A Lady Taking Tea* as, briefly, a Lockean 'Apollo and Daphne' (III.8–9 particularly), was designed to be questionable, in the sense of open to question by *anyone* to whom it is submitted. It has no authority. Because I had gone off

and picked up some historical information, I had a certain initiative in proposing, but you dispose.

What lies behind the accountability is the candid and deliberate yoking of history with criticism. It stands on two legs. Apropos of the *Baptism of Christ*, I did not mention, though it is a historical fact, that Piero was moderately involved in ownership of agricultural real estate of the kind we see in the background of the picture: it would not contribute to sharper perception of the pictorial order and character. Nor did I mention, though it might have enriched your sense of that order and character, that Piero adapted the figure of St John from a figure of Victory crowning an Emperor in a second-century triumph relief, because this is not, so far as I know, 'true' (IV.5). If I wanted to pursue this appealing thought, I would do so not in the causal but in the comparative register (Introduction 3). The three self-critical moods all contribute to maintaining the balance. But it is the demand for critical necessity or fertility, positive parsimony, that keeps the link between them active. What is not critically useful is not criticism. And the test of usefulness is public.

It seems to me an important and attractive irony that here history should be the more scientific, in a sense, the more it tends to criticism. In invoking 'science' I am not harking back to the matter of the forms of explanation, which we cannot aspire to, but referring to the scientist's peculiar sense of publication. The scientist must make public not only his results but also his procedure in getting them: the point is that the experiment must be repeatable and open to testing by other people. If it is not repeatable by other people, the results are not accepted.

This is a little like the position of inferential criticism. One reports an aesthetico-historical experiment and its results. The explanatory or historical or intentional thing claimed of a picture is tied by entailment to an observation about the visual order of the picture which can be tried out for effectiveness by other people: history is committed to being good criticism. We are wide open to scrutiny. There are no experts with special authority: there are specialists in a historical area able to initiate explanations as non-specialists cannot, but they must submit to lay judges of their explanations. If all that historical information I laid out — about ideas on distinctness, substance and perception and so on — does not prompt other people to a sharper sense of the pictorial

cogency of Chardin's *A Lady Taking Tea*, then it fails: I reported an experiment and it has been found not repeatable. Not only my critical points but my historical claims are thrown out.

This is good. The exposure is bracing, and it lends to a rather self-indulgent pursuit a social virtue and dignity it would not otherwise have. Newly professionalized and academicized activities like art criticism tend to don special authority rather fast, and our developing entrenchment behind a clerkly apparatus the laity do not share — knowledge of a specialized literature, access to the systematic index of this and that, the prestigious conceptual model borrowed from here or there, even the putatively trained eye — seems to me medieval, and unnecessary. Inferential criticism reduces that apparatus to the heuristic convenience it is, and restores the authority of common visual experience of a pictorial order. It is conversable and it is democratic.

If one looks at the origins of modern art history and art criticism, which are in the Renaissance, it is noticeable that really it arose out of conversation. The germ even of Vasari's great *Lives of the Artists* lay in dinner conversations at Cardinal Farnese's, as he says himself, and the most vigorous roots of his book run down to workshop argument, two or three centuries of it. After all, why else than for dialogue do something as hard and as odd as attempting to verbalize about pictures? I shall claim inferential criticism is not only rational but sociable.

INTRODUCTION

1. The point that it is only phenomena as covered by description that are susceptible of explanation is one learned from Arthur C. Danto, *Analytical Philosophy of History*, Cambridge, 1965, pp. 218–20, though I have pressed it in a simpler sense than his.

2. Libanius's description — my version of which is free — in *Libanii Opera*, VIII, ed. R. Foerster, Leipzig, 1915, pp. 465–8:

Ἀγρὸς ἦν καὶ οἰκήματα ἀγροίκοις πρέποντα, τὰ μὲν μείζω, τὰ δὲ ἐλάττω. πλησίον δὲ τῶν οἰκημάτων ἀνατρέχουσαι ἑωρῶντο κυπάριττοι. ὅλας μὲν οὐκ ἦν ἰδεῖν, ἐκώλυε γὰρ τὰ οἰκήματα, τὰ δὲ ἄκρα τῶν δένδρων ἐφαίνετο τὸ τέγος ὑπεραίροντα. ταῦτα, ὡς εἰκός, ἀνάπαυλαν παρεῖχε τοῖς ἀγροίκοις σκιᾷ τε τῇ ἀπὸ τῆς κόμης καὶ ὀρνίθων φωναῖς, οἳ χαίρουσιν ἐπὶ τῶν δένδρων ἱζάνοντες. ἐκδραμόντες δέ τινες ἐκ τῶν οἰκημάτων τέτταρες, ὁ μὲν παρεκελεύετό τι μειρακυλλίῳ πλησίον ἑστῶτι, τοῦτο γὰρ ἐμήνυεν ἡ δεξιά, ὡς ἄρα τι ἐπιτάττοι, ὁ δὲ ἐπεστρέφετο πρὸς τούτους οἷα φωνῆς ἀκούων τοῦ ἐπιτάττοντος. ὁ δὲ δὴ τέταρτος ὀλίγον προελθὼν τῶν θυρῶν τὴν δεξιὰν ἐκτετακὼς ῥάβδον τῇ ἑτέρᾳ φέρων ἐφαίνετό τι βοᾶν πρὸς τοὺς πονοῦντας περὶ τὴν ἄμαξαν. ἄρτι γὰρ ἄμαξα φορτίου πλήρης, οὐκ ἔχω δὲ εἰπεῖν εἴτε ἄχυρα ἦν εἴτε ἄλλο τι φορτίον, τὸν ἀγρὸν ἀφεῖσα μέσην εἶχε τὴν ὁδόν. ἅτε οὖν οὐκ ἀκριβῶς καταδήσαντες τὸ φορτίον, ἀλλὰ ῥαθύμως βοηθεῖν ἐπειρῶντο, ὁ μὲν ἔνθεν, ὁ δὲ ἔνθεν, ὁ μὲν γυμνὸς πλὴν διαζώματος βακτηρίᾳ τὸ φορτίον ἀνέχων, τοῦ δὲ ἐφαίνετο μὲν τὸ πρόσωπον καὶ μέρος τι τοῦ στήθους, ὅσα δὲ εἰκὸς ἐκ τοῦ προσώπου, ταῖν χεροῖν καὶ αὐτὸς ἤμυνε, τὰ δ' ἄλλα ὑπὸ τῆς ἁμάξης ἐκρύπτετο. ἡ δὲ ἄμαξα οὐ τετράκυκλος, ὡς ἔφησεν Ὅμηρος, ἀλλὰ δυοῖν τροχοῖν, ᾗ καὶ τὸ φορτίον περιέρρει καὶ ἐδέοντο τῶν ἀμυνόντων οἱ βόες ἄμφω τὸ χρῶμα φοίνικες καὶ εὖ τεθραμμένοι καὶ τοὺς αὐχένας πλατεῖς. τῷ βοηλάτῃ δὲ τὸν χιτωνίσκον ἀνέστελλεν εἰς γόνυ ζωστήρ. τῇ μὲν οὖν δεξιᾷ λαβόμενος τῶν χαλινῶν εἷλκε, ῥάβδον δὲ ἔχων ἐν θατέρᾳ οὐδὲν αὐτῇ ἐδεῖτο εἰς τὸ προθύμους ποιῆσαι τοὺς βοῦς, ἀλλ' ἠρκεῖτο τῇ φωνῇ. καὶ γὰρ ἡδύ τι πρὸς αὐτοὺς ἔλεγεν οἷα δή τι φθεγγόμενος ὢν ἂν ξυνίῃ βοῦς. ἔτρεφεν ὁ βοηλάτης καὶ κύνα, ὡς ἂν ἔχοι καθεύδειν ἔχων τὸν φύλακα. καὶ παρῆν ὁ κύων τοῖς βουσὶ παραθέων. χωροῦσα δὲ ἡ ἄμαξα πλησίον ἦν ἱεροῦ. τοῦτο γὰρ ἐσήμαινον οἱ κίονες καὶ τὰ ὑπερκύπτοντα δένδρα.

Kenneth Clark on the *Baptism of Christ* in his *Piero della Francesca*, London, 1951, pp. 11–14, the cited passage on p. 13.

3. A more exasperated version of this account of the indirect lexicon of art

criticism in M. Baxandall, 'The Language of Art History', *New Literary History*, X, 1979, pp. 453–65.

Senses of 'design' extracted from the entry in the *Concise Oxford Dictionary*.

4. This section is obviously coloured by speech act philosophy of the general kind surveyed in, for instance, J.R. Searle (ed.), *The Philosophy of Language*, Oxford, 1971. This would, I think, point to the 'performative' or 'perlocutionary' character of art criticism, but I do not want to claim consistency with this style of analysis and so do not use its terminology.

I

1. The distinction between teleological and nomological traditions of explanation is clearly laid out in Georg Henrik von Wright, *Explanation and Understanding*, London, 1971, especially Pt. I, but also in many other books. The issue is the main feature of most collections of readings on the philosophy of history and can be conveniently pursued in, for example, Patrick Gardiner (ed.), *Theories of History*, London/New York, 1959, Pt. II; William H. Dray (ed.), *Philosophical Analysis and History*, New York, 1966; Patrick Gardiner (ed.), *The Philosophy of History*, Oxford, 1974.

For Collingwood's conception of 're-enactment', R.G. Collingwood, *The Idea of History*, Oxford, 1946, Part V, especially pp. 282–302. It should be said that Collingwood's idealist theory of art led him (pp. 313–14) to exclude art from the subject-matters open to historical explanation. For Collingwood's idea of art, his *The Principles of Art*, Oxford, 1938, and for its position within aesthetics Richard Wollheim, *Art and its Objects*, 2nd ed., Cambridge, 1980, Sections 21–3. Collingwood's philosophy of history is the subject of a growing literature. A thorough recent study with good bibliography is Rex Martin, *Historical Explanation: Re-enactment and Practical Inference*, Ithaca, 1977. The most convenient statement of Popper's position is in Karl R. Popper, *Objective Knowledge: An Evolutionary Approach*, Oxford, 1972, Ch. 4, especially pp. 166–90. This includes both an example — an explanation of Galileo's erroneous theory of tides — and Popper's own account of how his position differs from that of Collingwood.

2. The best general book on the Forth Bridge is still W. Westhofen, *The Forth Bridge*, London, 1890 (reprinted from the periodical *Engineering*, 28 February 1890). Also useful is Thomas Mackay, *The Life of Sir John Fowler, Engineer, Bart., K.C.M.G., Etc.*, London, 1900, Ch. XI ('The Forth Bridge'), with the comments of Morris and Waterhouse and the extract from Baker's address to the Edinburgh Literary Institute, pp. 314–15. The general technological context of the Bridge is well sketched by L. T. C. Rolt, *Victorian Engineering*, Harmondsworth, 1970. The best technical account of the construction of the Bridge is, significantly, G. Barkhausen, *Die Forth-Brücke*, Berlin, 1889. A fine series of photographs of its construction was published as Philip Phillips, *The Forth Bridge and its various stages of construction . . .*, Edinburgh, n.d.

3. Maurice Mandelbaum, *The Anatomy of Historical Knowledge*, Baltimore, 1977, both touches on the sorts of cause-sorting mentioned here and elaborates on the

distinction between general and special history. This is an unusually helpful book for art historians wishing to reflect on their activity.

7. This is no place for a bibliography of studies of Early Cubism but accessible studies of the kind this account derives from include: Edward F. Fry, *Cubism*, London and New York, 1966, particularly for its collection of translated documentary texts; John Golding, *Cubism: A History and an Analysis 1907–1914*, 2nd ed., London, 1968; Douglas Cooper, *The Cubist Epoch*, New York and London, 1971; Pierre Daix and Joan Rosselet, *Picasso: the Cubist Years 1907–16*, Boston and London, 1979.

II

1. The discussions of intention in aesthetics and literary theory do not mesh very well with those in the methodology of history. A good short bibliography for the first is in Richard Wollheim, *Art and its Objects*, 2nd ed., Cambridge, 1980, pp. 254–5. A good selection of papers in David Newton-de Molina (ed.), *On Literary Intention*, Edinburgh, 1974, the items by F. Cioffi and Q. Skinner being particularly helpful. For the second, Georg Henrik von Wright, *Explanation and Understanding*, London, 1971, Ch. III ('Intentionality and Teleological Explanation'), with bibliography, addresses the issues directly; but they are immanent in much of the more general philosophy of history represented in readers such as those cited in the references to I. 1, where however one must look less to 'intention' than things like 'motive' and 'rational explanation'. There are also Diltheyan, Phenomenological and other lines of discussion of intention in hermeneutics which I do not pursue.

2. The three functions of the religious image were a commonplace, sometimes attributed to Thomas Aquinas; two representative formulations, one thirteenth-century and the other fifteenth-century, are translated in M. Baxandall, *Painting and Experience in Fifteenth-Century Italy*, Oxford, 1972, p. 41.

The first edition of Kahnweiler's book — a shorter version of which had come out in the periodical *Die weissen Blätter* in 1916 — was Daniel-Henry Kahnweiler, *Der Weg zum Kubismus*, Munich, 1920. An English translation exists, called *The Rise of Cubism*, trans. Henry Aronson, New York, 1949; there are substantial extracts in Edward F. Fry, *Cubism*, London and New York, 1966, and in such readers as Herschel B. Chipp, *Theories of Modern Art*, Berkeley, 1968.

5. Roger-Marx's comment on the history of Salons is part of his untitled preface to the *Catalogue des ouvrages* of the Societé du Salon d'Automne, 6 October–15 November 1906, pp. 21–3:

La cour de Louis XIV s'accommodait de voir assemblés, chaque deux ans, les *Tableaux et pièces de sculpture* des membres de l'Académie; les étroites limites de la curiosité et de la production n'exigeaient point davantage. Dès les successeurs du Grand Roi s'ouvre l'ère des expositions dissidentes: Expositions de l'Académie de Saint-Luc, Expositions du Colisée, sans compter les passionnantes Expositions de la Jeunesse. Le XIXe siècle est jalonné jusqu'à son terme, par des manifestations, individuelles ou collectives, affectant parfois un caractère nettement protestataire: telle celle qui se produisit en 1863, sous le couvert de l'Etat. Plus tard (1890), s'instituera, en face du Salon bi-séculaire, le Salon de

la Societé Nationale et, voici que depuis 1903 les doubles assises de mai trouvent, dans le Salon d'Automne, une suite inattendue, bientôt jugée logique et normale.

Ses libres allures le rapprochent du Salon des Indépendants ou encore des Expositions impressionistes, de glorieuse mémoire; mais le programme paraît plus vaste et les éléments constitutifs sont plus variés à raison de l'ambition évidente de faire la somme des initiatives d'où qu'elles viennent, en quelque sens qu'elles soient dirigées. . . . On y peut suivre l'essor des derniers venus dont le labeur n'apparait, au cours de l'an, que disséminé, morcelé, fragmenté: on y goûte le talent inédit, dans la verde parfois un peu acre de ces prémices: on s'y édifie au long sur ce que Duranty appelait naguère les tendances de la 'Nouvelle Peinture'.

For Picasso's ambience and market in these years: Douglas Cooper, 'Early Purchasers of True Cubist Art', in Douglas Cooper and Gary Tinterow, *The Essential Cubism 1907–20*, Tate Gallery, London, 1983, pp. 15–31; Daniel-Henry Kahnweiler, *Mes Galeries et mes peintres*, Paris, 1961 (*My Galleries and Painters*, trans. Helen Weaver, London, 1971), especially Ch. 2; Fernande Olivier, *Picasso et ses amies*, Paris, 1933 (*Picasso and his Friends*, trans. Jane Miller, London, 1964); Roland Penrose, *Picasso: His Life and Work*, London, 1958, Chs. 4–6; Harrison C. and Cynthia A. White, *Canvases and Careers: Institutional Change in the French Painting World*, New York, 1965.

For the early criticism of Cubism, Fry, *op. cit.* Apollinaire's criticism has been well edited: *Guillaume Apollinaire: Chroniques d'Art (1902–1918)*, ed. L.-C. Breunig, Paris, 1960, and *Méditations esthétiques: les peintres cubistes* [1913], ed. L.-C. Breunig and J. A. Chevalier, Paris, 1965. Braque's remark about him was made to Francis Steegmuller who reports it in his *Apollinaire: Poet among the Painters*, Harmondsworth, 1973, p. 130.

6. An attempt to systematize influence statements is Gören Hermerén, *Influence in Art and Literature*, Princeton, 1975, with bibliography.

My instances of Picasso's address to Cézanne are mainly drawn from John Golding, *op. cit.*, pp. 49–51 and 68–71.

7. On the matter of accommodating sub-reflective dispositional actions within a pattern of rational explanation, C. G. Hempel, 'Explanation in Science and History', in W. H. Dray (ed.), *Philosophical Analysis and History*, New York, 1966, pp. 95–126, especially 115–23, is helpful.

For Protogenes not knowing when to stop, Pliny, *Naturalis Historia*, XXXV, 80. For *Apelles faciebat*, Pliny, *Naturalis Historia*, Praef. 26. Picasso's agreement with Kahnweiler is often reproduced: for instance in Daniel-Henry Kahnweiler, *My Galleries and Painters*, London, 1971, fig. [9] and pp. 154–5.

8. Kahnweiler on Picasso's 'problems', *Der Weg zum Kubismus*, Munich, 1920, pp. 18–20:

Der Beginn des Kubismus! Der erste Anlauf. Verzweifeltes, himmelstürmendes Ringen mit allen Problemen zugleich.

Mit welchen Problemen? Mit den Urproblemen der Malerei: der Darstellung des Dreidimensionalen und Farbigen auf der Fläche, und seiner Zusammenfassung in der Einheit dieser Fläche. 'Darstellung' aber und 'Zusammenfassung' im strengsten, höchsten Sinne. Nicht Vortäuschung der Form durch Helldunkel, sondern Aufzeigung des Dreidimensionalen durch Zeichnung auf der Fläche. Keine gefällige 'Komposition', sondern

unerbittlicher, gegliederter Aufbau. Dazu noch das Problem der Farbe, und endlich, als schwierigster Punkt, die Verquickung, Versöhnung des Ganzen.

Tollkühn greift Picasso alle Probleme auf einmal an. Harteckige Gebilde setzt er jetzt auf die Leinwand, Köpfe und Akte zumeist, in buntesten Farben, gelb, rot, blau, schwarz. Die Farben sind fadenförmig aufgetragen, um so als Richtungslinien zu dienen und im Verein mit der Zeichnung die plastische Wirkung zu bilden. Nach Monaten angestrengtesten Suchens sieht Picasso ein, dass auf diesem Wege das Problem nicht vollkommen zu lösen ist. . . .

Ein kurze Periode der Ermattung folgt nun. Reinen Aufbauproblemen wendet sich der flügellahme Geist zu. Eine Reihe von Gemälden entsteht, in denen allein die Gliederung der Farbenflächen den Maler beschäftigt zu haben scheint. Abkehr vom Mannigfaltigen der Körperwelt, zur ungestörten Ruhe des Kunstwerks. Doch bald wird Picasso der Gefahr inne, seine Kunst zur Ornamentik zu erniedrigen.

Im Frühjahr 1908 schon finden wir ihn von neuem an der Arbeit, um nun die Aufgaben, die sich stellen, einzeln zu lösen. Vom Wichtigsten hiess es ausgehen. Das Wichtigste scheint ihm die Veranschaulichung der Form, die Darstellung des Dreidimensionalen und seiner Lage im dreidimensionalen Raume, auf der zweidimensionalen Fläche. Wie er selbst einmal sagte: 'Auf einem Gemälde Raffaels ist es nicht möglich, die Distanz von der Nasenspitze bis zum Munde festzustellen. Ich möchte Gemälde malen, auf denen das möglich wäre.' Zugleich bleibt selbstverständlich das Problem der Zusammenfassung — des Aufbaus — stets im Vordergrunde. Vollkommen ausgeschieden dagegen wird das Problem der Farbe.

Picasso against 'research': the passage was originally printed in 'Picasso Speaks', *The Arts*, New York, May 1923, pp. 315–26, and being part of his first published statement has been much reprinted (for instance, Edward F. Fry, *op. cit.*, pp. 165–8). Since it only exists in English translation from Spanish one may worry a little about authenticity of terms, and particularly about the term 'research'.

III

1. For a strong argument in favour of attending to the pictorial process, a dialectic of style, as the painter's thought, see James Cahill, 'Style as Idea in Ming Ch'ing Painting', in *The Mozartian Historian: Essays on the Works of Joseph R. Levenson*, Berkeley, 1976, pp. 137–56.

For Cubism and Bergson, Edward F. Fry, *Cubism*, London and New York, 1966, pp. 38–40. For Cubism and Nietzsche, John Nash, 'The Nature of Cubism: A study of conflicting explanations', *Art History*, III, 1980, pp. 435–47. For Cubism and Einstein, Linda Dalrymple Henderson, *The Fourth Dimension and Non-Euclidean Geometry in Modern Art*, Princeton, 1983.

2. The core of the Lockean view of visual perception is most conveniently read in his *An Essay Concerning Humane Understanding*, II. ix (Of Perception). A good sense of eighteenth-century developments can be got from N. Pastore, *Selective History of Theories of Visual Perception 1650–1950*, New York, 1971, Chs. 3–6, and particularly from M. J. Morgan, *Molyneux's Question: Vision, Touch and the Philosophy of Perception*, Cambridge, 1977.

Porterfield on colour: William Porterfield, *A Treatise on the Eye: The Manner and Phaenomena of Vision*, Edinburgh, 1759, II, p. 334. This book is useful as an orthodox mid-century synthesis.

Francesco Algarotti, *Il Newtonianismo per le dame, ovvero Dialoghi sopra la luce e i colori*, Milan, 1739, pp. 46–7:

Seriamente, disse la Marchesa, io ho sempre creduto che quel colore, che io ho nelle guancie, qual'egli siasi, fosse veramente nelle mie guancie, e che i colori nell'Iride non vi fossero che apparentemente. Spiegatemi di grazia questo paradosso, che per dir il vero m'imbarazza, e fate che il rassomigliarmi all'Iride, per bella ch'ella sie, non mi debba più dar pena. Cotesto si è pur, rispos'io, un ridur le cose al semplice, levando via quella distinzione, che avevavi tra i colori veri, e gli apparenti. Ma il vostro interesse e l'amor proprio, che vi fa temere di non perdere i vostri gigli e le vostre rose, per parlarvi nel nobile stile pastorale, â prevaluto questa volta al vostro amore per la simplicità. . . . Ne' corpi altro non v'â, come abbiam detto, che una certa disposizione e tessitura di parti, e ne' globetti della luce un certo moto di rotazione, che queste parti dan loro; e questi poi solleticando e scuotendo in certa maniera i nervetti della retina, che è una sottilissima membrana o pellicella nel fondo dell'occhio, ci fanno concepire un certo colore, che noi coll'animo al corpo, da cui ci vengono i globetti di luce, riferiamo. Ma mi pare che vengan già avvertire esser tempo, che andiamo a sentire qual sapore noi questa mattina riferiremo coll'animo alla zuppa. Riferiremo coll'animo? ripigliò ella.

3. For Chardin's *A Lady Taking Tea*, Pierre Rosenberg (ed.), *Chardin 1699–1779*, Catalogue of Exhibition at the Grand Palais, Paris, 1979, No. 64, pp. 216–218 (English version, Cleveland, 1979, same No. and pp.), with bibliography.

Diderot's comments on Chardin are usually more positively assessed than here; for instance, Else Marie Bukdahl, *Diderot critique d'art*, trans. Jean-Paul Faucher, 2 vols., Copenhagen, 1980–82, especially I, pp. 190–94, 373–5, 416–17.

4. Algarotti on accommodation, *op. cit.*, pp. 106–7:

Qual mutazione adunque bisognerà egli, che si faccia nell'occhio, acciò guardando noi a quegli alberi dopo aver guardato a queste colonne, i raggi che vengono da essi si uniscano sulla retina, che vale a dire, acciò li veggiamo distintamente? Bisognerà, diss'ella, far avvicinar la retina all'umor cristallino, siccome per aver l'immagine distinta degli oggetti più lontani avvicinar conviene la carta alla lente nella camera oscura.

La spiegazione, rispos'io, l'avete trovata voi, e a questo effetto di avvicinare, e di allontanare dall'umor cristallino secondo i vari bisogni la retina, dissero alcuni, servire certi muscoli, che circondan l'occhio, oltre al servire ch'essi fanno ad alzarlo, ad abbassarlo, a girarlo a destra, e a sinistra, e a dargli un certo moto obliquo, che Venere principalmente â la cura di regolare. Con questi Amore

——Sott'occhio
Quasi di furto mira,
Nè mai con dritto guardo i lumi gira.

e con questi, gli occhi si dicono molte volte gli uni agli altri ciò, che la lingua non osa nominare. Alcuni altri dissero, che la retina stando immobile, l'umor cristallino s'avvicina, e si allontana di essa, o pure che l'umor cristallino muta solamente figura, rendendosi più convesso per gli oggetti vicini, e meno per li lontani, e fuvvi infine chi pretese l'uno, e l'altro farsi nel medesimo tempo; le quali cose tutte prestano il medesimo effetto, che se la retina si avvicinasse o allontanasse da lui; il che voi suppor potrete come ciò, che è più facile all'immaginazione.

James Jurin's 'Essay upon Distinct and Indistinct Vision' is printed as an appendix to Robert Smith, *A Compleat System of Opticks in Four Books*, Cambridge, 1738, unpaginated. I refer particularly to Jurin's Articles 9–12, 16, 96, 105–8 and 132.

Petrus Camper, *Dissertatio Optica De Visu*, Leyden, 1746 (Facsimile with translation and introduction by G. ten Doesschate, *Dutch Classics on History of Science*, III, Nieuwkoop, 1962), p. 8:

Retina, quae ab insertione nervi optici in oculum, usque ad coronam ciliarem procedit non ubique aeque sensibilis est, in insertione nervi nullo modo, a latere vero huius maxime, estque hic locus, qui axibus opticis opponitur. Oculos ideo invertimus docente *de la Hirio* (Differens accidens de la Vue §. 10) ut pictura ibidem fieret. *Briggsius* (Ophthalmographia, p. 252) fibras in illo loco consertiores esse autumat, et ideo sensationem esse perfectiorem concludit. idemque a *Hookio* (Micrographia, p. 179 obs. 39) demonstratur. quaestionis specie §. IX. proposuimus an non prope axin pictura nitidior, quia radii ibi fere paralleli intrantes in puncto unico tantum distinctissime depinguntur? Sane, non pro certo habere vellem hoc unice a retinae sensibilitate pendere.

Hamilton on peripheral astigmatism and the arc of vision: J. Hamilton, *Stereography, or a Compleat Body of Perspective*, London, 1738, p. 3.

Sébastien Le Clerc, *Systeme de la vision fondé sur de nouveaux principes*, Paris, 1719, pp. 117–18 (Art. XXIV):

Quoique l'on découvre assez bien d'un seul coup d'oeil de grandes campagnes, cependant on observe qu'on ne voit que peu de chose distinctement à la fois, et il y a deux raisons de cela. La premiere, que les objets ne se peignent distinctement dans les yeux que sous un angle assez petit, comme on vient de voir; et la deuxiéme, que l'ame ne pouvant se rendre attentive à considerer plusieurs choses à la fois, elle n'examine les objets que partie à partie. Ainsi, encore qu'on apperçoive d'un premier coup d'oeil quelque objet considerable, un Palais, par exemple, et qu'il s'en peigne une image dans nos yeux qui nous en fait avoir aussitôt une bonne ou une méchante idée, c'est neanmoins toûjours sans distinction de parties, parce que l'ame n'y fait d'abord aucune application particuliere. Mais voulant sçavoir de quel ordre en est l'Architecture, et si elle est de bon ou de méchant goût, alors elle en parcourt de l'oeil, ou pour mieux dire, de son axe, toutes les parties les unes aprés les autres, pour avoir une connoissance exacte de chacune en particulier.

Modern notions of accommodation, acuity and attention are laid out in any student's handbook of visual perception; a widely accessible one is R. N. Haber and M. Hershenson, *The Psychology of Visual Perception*, 2nd ed., New York, 1980, specifically Chs. 1, 4, 7 and 16–17.

5. For Cochin's lecture of 2 June 1753, *Procès-verbaux de l'Académie Royale de Peinture et de Sculpture 1648–1793*, ed. A. de Montaiglon, VI, Paris, 1885, p. 352.

6. For La Hire see the article by René Taton in C. C. Gillispie (ed.), *Dictionary of Scientific Biography*, VII, New York, 1973, pp. 576–9, with bibliography.

On colour changes in dim light, Philippe de La Hire, *Dissertation sur les differens accidens de la Vüe*, I.v, various editions, but in his *Mémoires de Mathematique et de Physique*, Paris, 1694, pp. 235–6:

La lumiere qui éclaire les couleurs les change considerablement; le bleu paroît vert à la chandelle, et le jaune y paroît blanc; le bleu paroît blanc à une foible lumiere du jour, comme au commencement de la nuit. Les peintres connoissent des couleurs dont l'éclat est beaucoup plus grand à la lumiere de la chandelle qu'au jour, au contraire il y en a plusieurs quoique tres-vives au jour, qui perdent entierement leur beauté a la chandelle. Par exemple le vert de gris paroît d'une tres-belle couleur à la chandelle, et lorsqu'il est tres foible en couleur, c'est-à-dire lors qu'on y mesle une tres-grande quantité de blanc, il

paroit d'un assez beau bleu. Les cendres qu'on appelle ou vertes ou bleuës paroissent à la chandelle d'un fort beau bleu. Les rouges qui tiennent de la lacque paroissent tres-vifs à la chandelle, et les autres comme la mine et le vermillon paroissent ternes.

La Hire on means of assessing distance, *op. cit.*, I. p. ix, *ed. cit.*, p. 237. Porterfield on means of assessing distance, *op. cit.*, II. p. 409. On Smith's, Le Cat's and the opticians' interest in this aspect of painting, M. Baxandall, 'The Bearing of the Scientific Study of Vision on Painting in the Eighteenth Century: Pieter Camper's *De Visu* (1746)', in Allan Ellenius (ed.), *The Natural Sciences and the Arts* (*Acta Universitatis Upsaliensis, Figura*, N.S. XXI), Uppsala, 1985, pp. 125–32.

For Le Clerc, Maxime Préaud, *Bibliothèque Nationale, Département des Estampes, Inventaire du fonds français, Graveurs du XVIIe siècle*, VIII–IX, *Sébastien Leclerc*, 1–2, Paris, 1980.

For Camper, the article by G. A. Lindeboom in C. C. Gillispie (ed.), *Dictionary of Scientific Biography*, III, New York, 1971, pp. 37–8.

7. Roger de Piles, *Cours de Peinture par Principes*, Paris, 1708, especially pp. 106–8 and the 'Reponses à Quelques Objections' on pp. 122–3. The passage has been discussed by E. H. Gombrich in *The Sense of Order*, Oxford, 1979, pp. 99–100.

Camper criticized Albinus in a public letter, *Epistola ad anatomicorum principem, magnum Albinum*, Groningen, 1767. A convenient short account of the controversy with extracts from Albinus's reply in L. Choulart, *History and Bibliography of Anatomic Illustration*, trans. and ed. M. Frank, Chicago, 1920, pp. 276–80.

For an account of the evolution of descriptive geometry in the eighteenth century, René Taton, *L'Oeuvre scientifique de Monge*, Paris, 1951, Ch. II. For the educational mechanisms of diffusion, René Taton (ed.), *Enseignement et diffusion des sciences en France au XVIIIe siècle*, Paris, 1964, Parts 4 and 5. One clear account of the different systems of technical drawing is Fred Dubery and John Willets, *Perspective and Other Drawing Systems*, 2nd ed., London, 1983, Ch. 2.

9. La Hire and distances for viewing, *Procès-verbaux de l'Académie Royale d'Architecture*, ed. H. Lemonnier, III, Paris, 1913, pp. 174–5.

IV

1. For the provenance and condition of the *Baptism of Christ* see Martin Davies, *The Earlier Italian Schools* (National Gallery Catalogues), 2nd ed., London, 1961, pp. 426–8; E. Battisti, *Piero della Francesca*, Milan, 1971, II, pp. 17–19; Marilyn Aronberg Lavin, *Piero della Francesca's Baptism of Christ*, New Haven, 1981, pp. 165–72.

For the views expressed here on contract stipulations, the functions of the religious image, and commercial mathematics as a vernacular visual skill, M. Baxandall, *Painting and Experience in Fifteenth-Century Italy*, Oxford, 1972, pp. 5–14 and 20, 40–43, and 86–102 respectively. For Michele Savonarola on painters' proportions, Lynn Thorndike, *History of Magic and Experimental Science*, IV, 1934, p. 194, referring to Savonarola's 'Speculum Physiognomiae' (Paris, Bibliothèque Nationale, MS. 7357, fol. 57r.). For the bearing of Renaissance

concepts of cause on the sense of the artist's responsibility for works of art, M. Baxandall, 'Rudolph Agricola on Patrons Efficient and Patrons Final: A Renaissance Discrimination', *Burlington Magazine*, CXXV, 1983, pp. 424–5.

2. For more sophisticated discussion of the distinction between observer's and participant's knowledge, Arthur Danto, 'The Problem of Other Periods', *Journal of Philosophy*, LXIII, 1966, pp. 566–77; papers in Bryan R. Wilson (ed.), *Rationality*, Oxford, 1970, including the helpfully clear statement of the issue in the Editor's Introduction, pp. vii–xviii; Rex Martin, *Historical Explanation: Re-enactment and Practical Inference*, Ithaca, 1977, Ch. XI ('Other Periods, Other Cultures'); Michael Podro, *The Critical Historians of Art*, New Haven and London, 1982, pp. 1–4.

3. On the three parts of painting, Piero della Francesca, *De perspectiva pingendi*, ed. G. Nicco Fasola, Florence, 1942, p. 63:

La pictura contiene in sé tre parti principali, quali diciamo essere disegno, commensuratio et colorare. Desegno intendiamo essere profili et contorni che nella cosa se contene. Commensuratio diciamo essere essi profili et contorni proportionalmente posti nei luoghi loro. Colorare intendiamo dare i colori commo nelle cose se dimostrano, chiari et uscuri secondo che i lumi li devariano.

Ficino, *Sopra lo amore, ovvero Convito di Platone*, ed. G. Renzi, Lanciano, 1914, p. 66:

Sono alcuni che hanno oppenione la pulcritudine essere una certa posizione di tutti i membri, o veramente commensurazione e proporzione, con qualche suavità di colori.

Luca Pacioli, *Summa de Arithmetica geometria, Proportioni, et Proportionali*, Venice, 1494, p. 68b (V. vi.):

Tu troverai la proportione de tutte esser madre e regina, e senza lei niuna poterse exercitare. Questo el prova prospectiva in sue picture. Le quali se ala statura de una figura humana non li de la sua debita grossezza negli ochi de chi la guarda, mai ben responde. E ancora el pictore mai ben dispone suoi colori, se non atende a la potentia de luno, e de laltro, cioe che tanto de bianco (verbi gratia per incarnare) over negro, o giallo etcetera vol tanto de rosso etcetera. E nelli piani, dove hanno a posare tal figura, molto li convene haver cura de farla stare con debita proportione de distantia. . . . E cosi in altri liniamenti e dispositioni de qualunche altra figura si fosse. Del qual documento, acio ben sabino a disponere. El sublime pictore (ali di nostri anchor vivente) maestro Piero de li franceschi, nostro conterraneo del borgo San Sepolchro, hane in questi di composto un degno libro de ditta Prospectiva. . . . Nela quale opera, dele diece parolle le nove, recercano la proportione.

4. For the matter of transhistorical concepts, Rex Martin, *op. cit.*, pp. 223–5. The allusion to 'making strange' invokes and disclaims consistency with the notion of defamiliarization or *ostranenie*, one accessible account of which is in Fredric Jameson, *The Prison-House of Language*, Princeton, 1972, pp. 50–59.

5. For criteria of validity, a sense of the discrete universes being sidled past in this section can be got from: William Dray, *Laws and Explanation in History*, Oxford, 1957, pp. 142–55; E. D. Hirsch, *Validity in Interpretation*, New Haven, 1967, pp. 235–44; Maurice Mandelbaum, *The Anatomy of Historical Knowledge*,

Baltimore, 1977, Ch. VI ('Objectivity and its Limits'); Georg Henrik von Wright, *Explanation and Understanding*, London, 1971, pp. 110–17.

6. The two iconographies I refer to are those of Marie Tanner, 'Concordia in Piero della Francesca's *Baptism of Christ*', *Art Quarterly*, XXXV, 1972, 1–21, and Marilyn Aronberg Lavin, *Piero della Francesca's 'Baptism of Christ'*, New Haven, 1981. Neither should be judged on my summary.

S. Antonino on the Three Baptisms and on water in Baptism in his *Summa Theologica*, various editions, XIV.xiii. Praef., and XIV.ii. 1:

Aqua est corpus diaphanum, idest transparens, unde et susceptiva luminis; ita et baptismus praestat lumen fidei; unde dicitur sacramentum fidei.

On visualizing Jerusalem and the life of Christ, *Zardin de Oration*, Venice, 1494, p. X.iib.:

La quale historia [i.e. the Passion] aciò che tu meglio la possi imprimere nella mente, e piú facilmente ogni acto de essa ti si reducha alla memoria ti serà utile e bisogno che ti fermi ne la mente lochi e persone. Come una citade, laquale sia la citade de Hierusalem, pigliando una citade laquale ti sia bene praticha.

7. S. Antonino's sermon on Baptism is printed as XIV.ii. of his *Summa Theologica*. For his account of Angels, *Summa Theologica*, XXXI.v. and vi.

8. S. Antonino's exposition of the meanings of water and dove in the Baptism, *Summa Theologica*, XIV.ii. 1 and 3.

INDEX OF SUBJECTS

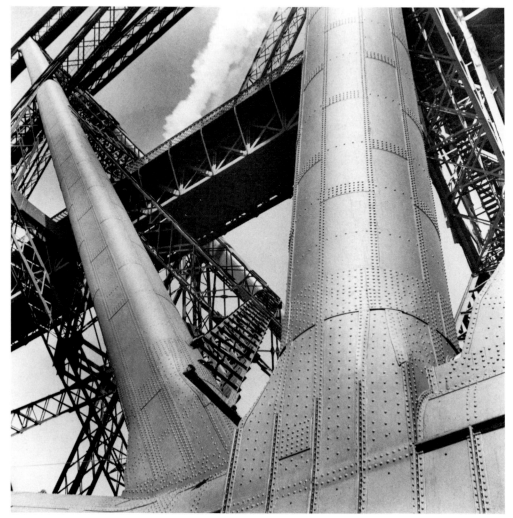

1. The Forth Bridge, detail of steelwork.

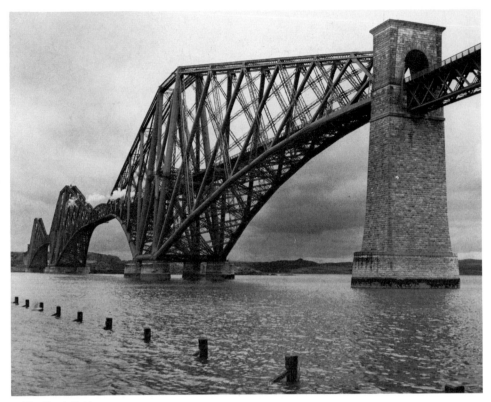

2. The Forth Bridge.

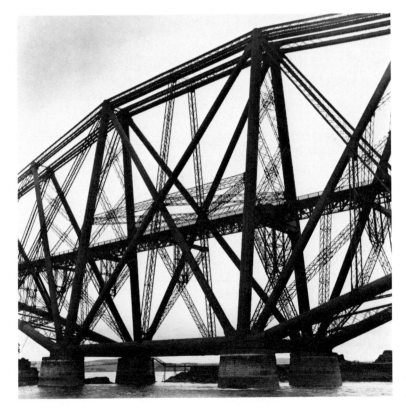

3. The Forth
Bridge, tube and
lattice girders.

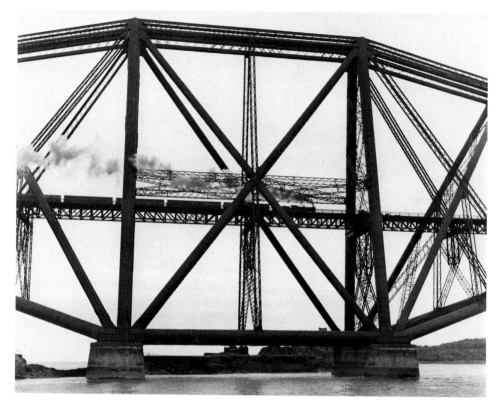

4–5. The Forth Bridge, central pier and its S. cantilever.

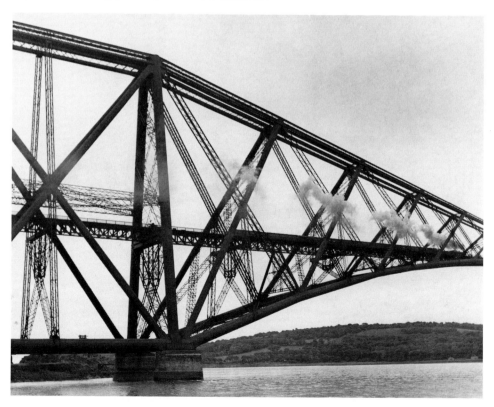

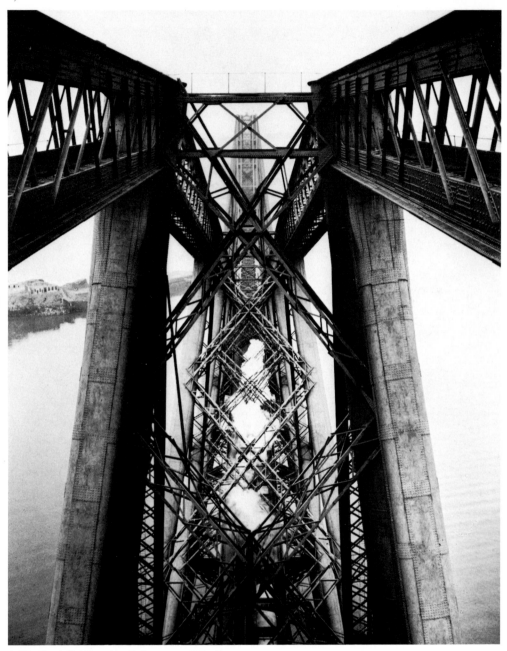

6. The Forth Bridge, view S. from top of N. pier.

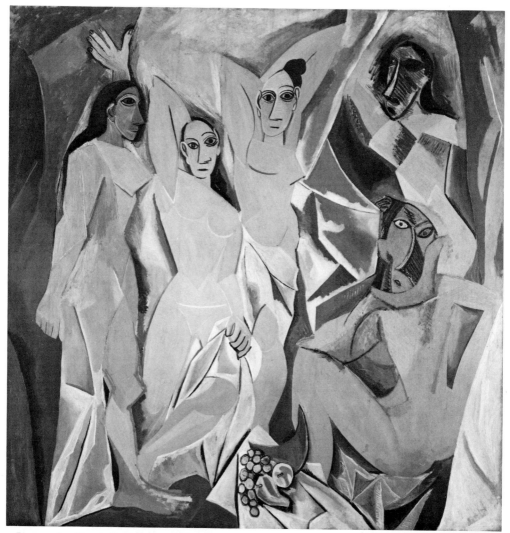

7. Picasso, *Les Demoiselles d'Avignon*. Oil on canvas, 1907. The Museum of Modern Art, New York (Lillie P. Bliss Bequest).

9. Picasso, *Nude with raised arms*. Oil on canvas, 1907.
Thyssen-Bornemisza Collection, Lugano.

8. Picasso, Study for *Les Demoiselles d'Avignon*. Pen
and indian ink, 1907. Musée Picasso, Paris.

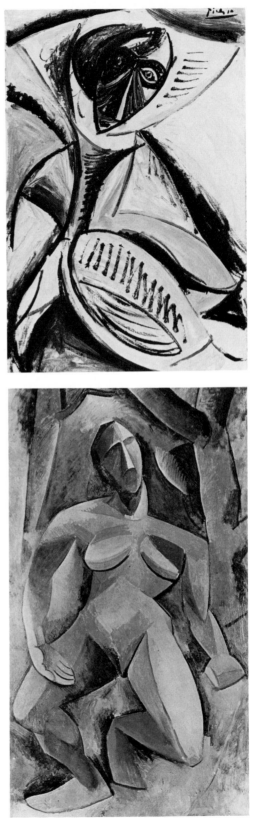

10. Braque, *Study*. Pen and ink, 1907 or 1908. Original
lost; reproduced in *The Architectural Record*, New
York, 1910, p. 405.

11. Picasso, *Nude in Forest* (or *Dryad*). Oil on canvas,
1908. Hermitage Museum, Leningrad.

12 (left). Picasso, *Head of Fernande Olivier*. Oil on canvas, 1909. Kunstsammlung Nordrhein-Westfalen, Düsseldorf.

14. Picasso, *Factory at Horta de Ebro*. Oil on canvas, 1909. Hermitage Museum, Leningrad.

13 (top right). Picasso, *Still Life with Pears*. Oil on canvas, 1909. Hermitage Museum, Leningrad.

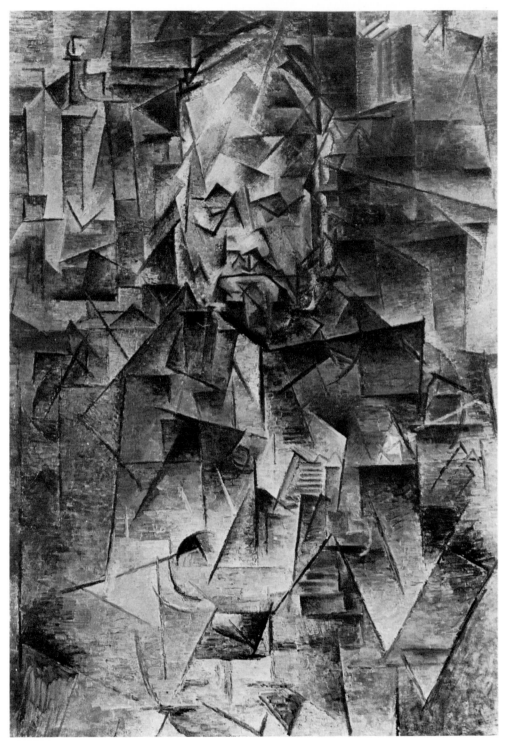

15. Picasso, *Portrait of Ambroise Vollard*. Oil on canvas, winter 1909–10. Pushkin Museum, Moscow.

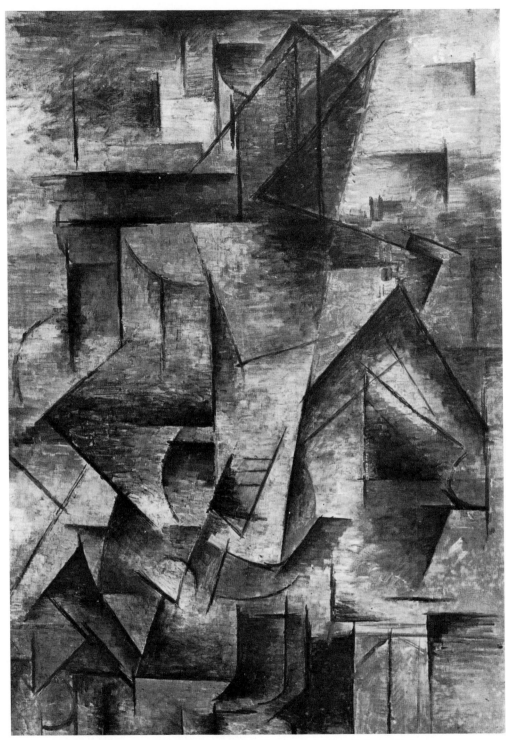

16. Picasso, *Guitarist*. Oil on canvas, summer 1910. Musée National d'Art Moderne, Paris.

17. Gabriel de Saint-Aubin, Sketches after Chardin in *Livret* of the 1769 Salon. Cabinet des Estampes, Bibliothèque Nationale, Paris.

18. [M.-A. Laugier], *Jugement d'un Amateur sur l'Exposition des Tableaux*, Paris, 1753, pp. 42–3, on Chardin.

19. Pierre Filloeul, Engraving after Chardin's *A Lady Taking Tea*. Undated.

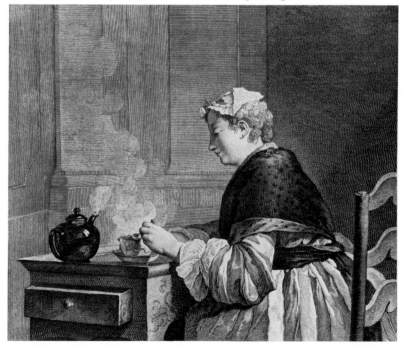

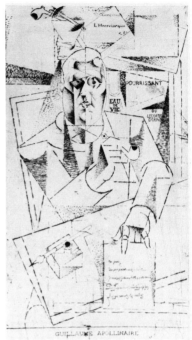

20. Picasso in his studio, beneath a figure-drawing of summer 1910. Musée Picasso, Paris.

21. Louis Marcoussis, *Portrait of Apollinaire*. Drypoint, 1912.

22. A room in the house of Leo and Gertrude Stein, about 1907, with six paintings by Picasso and six by Matisse. Published in Leo Stein, *Journey into the Self*, ed. E. Fuller, New York, 1950.

25 (right). Cézanne, *Still Life with Jug and Fruit*. Oil on canvas, about 1900. National Gallery of Art, Washington (Gift of the W. Averell Harriman Foundation).

23. Albert Gleizes, *Portrait of Jacques Nayral*. Oil on canvas, 1910–11. Tate Gallery, London.

26 (right). Cézanne, *Les Baigneuses*. Oil on canvas, about 1900. National Gallery, London.

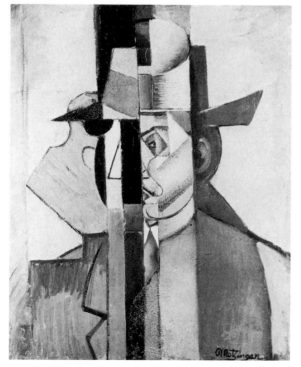

24. Jean Metzinger, *Portrait of Albert Gleizes*. Oil on canvas, 1912. Museum of Art, Rhode Island School of Design, Providence.

27. Picasso, Photograph of Kahnweiler in 1910 (cf. Pl. 20). Musée Picasso, Paris.

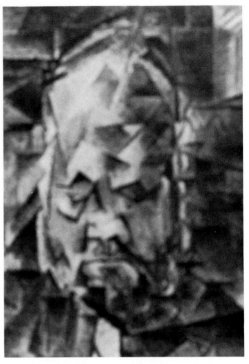

28. Picasso, Detail from the *Portrait of Vollard* (cf. Pl. 15). Pushkin Museum, Moscow.

29. Rephotograph of Pl. 28 with blurred focus.

30. Picasso, *Portrait of Kahnweiler* (cf. Pl. 10). The Art Institute of Chicago, bequest of Mrs. Gilbert Champion.

31. André Derain, Detail from *Cadaquès*. Oil on canvas, 1910. National Gallery, Prague.

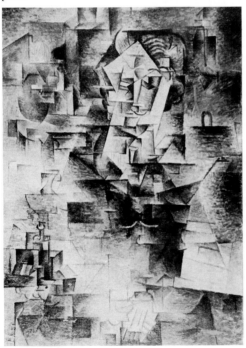

32. Chardin, *A Woman Scraping Vegetables*. Oil on canvas, about 1738. Bayerische Staatsgemäldesammlungen, Alte Pinakothek, Munich.

33. Chardin, *A Lady Sealing a Letter*. Oil on canvas, 1733. Staatliche Museen Preussischer Kulturbesitz, Schloss Charlottenburg, Berlin.

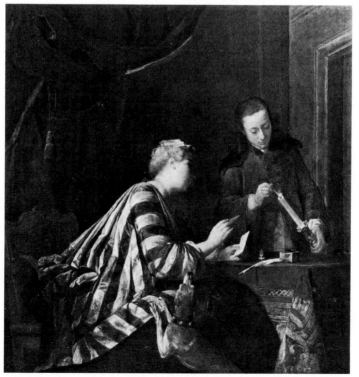

34. Nicolaes Maes, *A Woman Scraping Parsnips*. Oil on panel, 1655. National Gallery, London.

35. Paolo Veronese, *Allegory of Marriage*. Oil on canvas, about 1565. National Gallery, London.

36. Chardin, *Cellar Boy*. Oil on canvas, 1738. Hunterian Art Gallery, University of Glasgow.

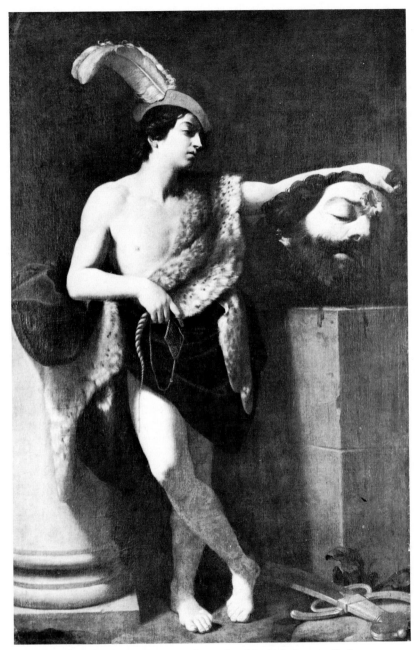

37. Guido Reni. *David*. Oil on canvas, about 1605. Musée du Louvre, Paris.

38. Bernhard Siegfried Albinus, *Tabulae sceleti et musculorum humani*, Leiden, 1747, Muscula Pl. IX. Engraving by J. Wandelaar.

39. Pieter Camper, Drawing of 1752 for an engraving in William Smellie, *Sett of Anatomical Tables*, London, 1754. Royal College of Physicians, Edinburgh.

40. Godfried Schalcken, *Girl Reading a Letter*. Oil on panel, last quarter of the seventeenth century. Gemäldegalerie, Dresden.

41. Adriaen van der Werff, *Allegory of Education*. Oil on panel, 1687. Bayerische Staatsgemäldesammlungen, Alte Pinakothek, Munich.

42–43 (above). Roger de Piles, *Cours de peinture par principes*, Paris, 1708. Engraved plates illustrating (at p. 108) centralized distinct vision and (at p. 382) consequences drawn for composition.

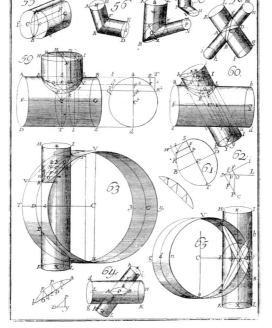

44. Amédée-François Frézier, *La Théorie et la pratique de la coupe des pierres et de bois . . .*, 2nd. ed., Paris, 1754–68, Vol. I, Pl. 5.

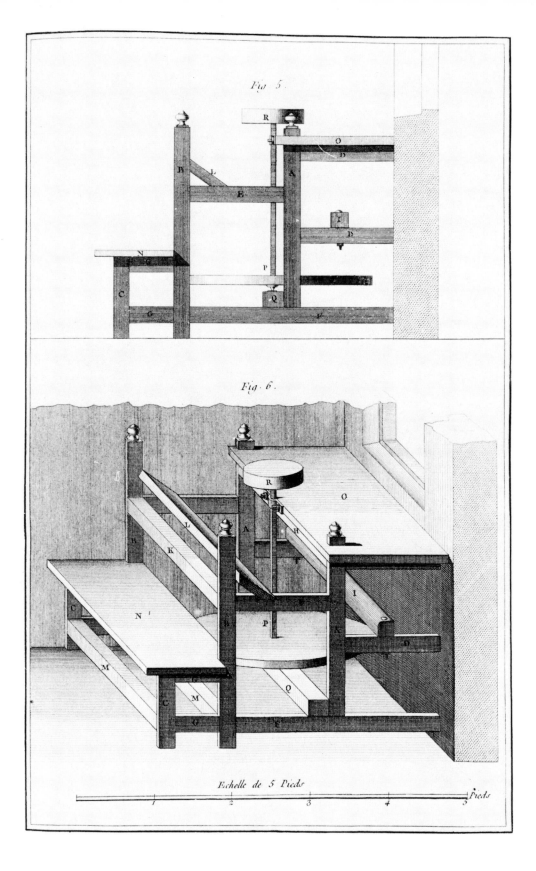

Fig. 5.

Fig. 6.

Echelle de 5 Pieds

Pieds

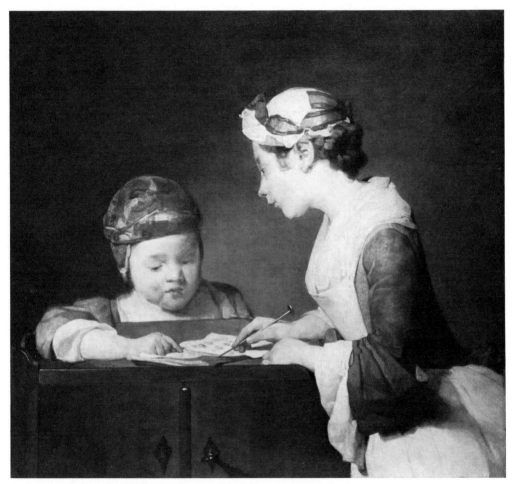

46. Chardin, *The Schoolmistress*. Oil on canvas, about 1735–40. National Gallery, London.

45. J. R. Lucotte, A Potter's Wheel, from *Encyclopédie, ou Dictionnaire raisonné des sciences, des arts et des metiers*, ed. D. Diderot and J. d'Alembert, Paris, 1751–80 (Recueil de Planches, VII, 1771, Potier de Terre, Pl. XV). Engraving by R. Bénard.

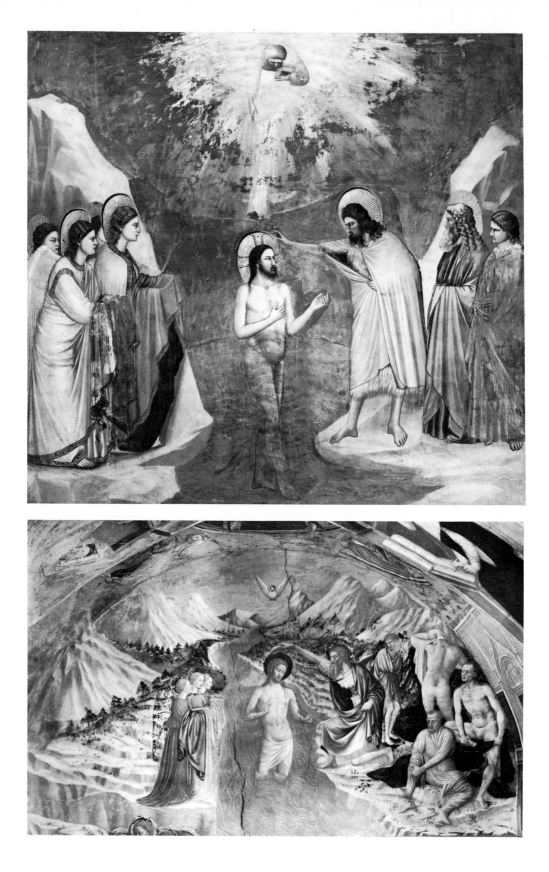

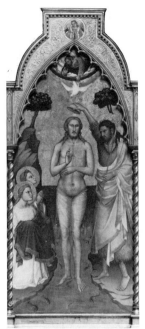

49. Giusto de'Menabuoi, *Baptism of Christ*. Fresco, about 1375. Baptistry of the Cathedral, Padua.

50. Ascribed to Niccolò di Pietro Gerini, Detail from the *Baptism of Christ*. Panel, 1387 (?). National Gallery, London.

47 (facing page top). Giotto, *Baptism of Christ*. Fresco, about 1303–13. Scrovegni Chapel, Padua.

48 (facing page bottom). Masolino, *Baptism of Christ*. Fresco, about 1435. Baptistry, Castiglione d'Olona.

51. Giovanni di Paolo, *Baptism of Christ*. Panel, mid-fifteenth century. National Gallery, London.

52. Piero della Francesca, Detail from *Discovery of the True Cross*, with view of Arezzo. Fresco, about 1452–59. San Francesco, Arezzo.

53. Piero della Francesca, Detail of river from the *Battle of Constantine and Maxentius*. Fresco, about 1452–59. San Francesco, Arezzo.

54. Piero della Francesca, *Virgin and Child with Angels*. Panel, about 1470. Galleria Nazionale delle Marche, Urbino.

55. Piero della Francesca, *Virgin and Child with Angels*. Panel, about 1465. Clark Art Institute, Williamstown, Massachusetts.

57. Niccoló Fiorentino, Reverse of the Medal of Giovanna Tornabuoni, with the Graces. Bronze, late fifteenth century. Bargello, Florence.

58. Donatello. Angels from the Second Cantoria of Florence Cathedral. Marble, 1433–39. Museo dell'Opera del Duomo, Florence.

56 (facing page). Piero della Francesca, Detail of Angels from the *Baptism of Christ* (cf. Pl. IV). National Gallery, London.

59. Luca della Robbia, Angels addressing the Eucharist, from the predella of an altarpiece. Enamelled terracotta, about 1460–70. Chapel of the Cross, Collegiata, Impruneta.

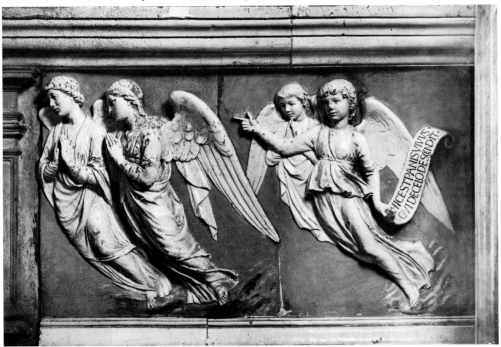

60–61 (following pages). Piero della Francesca, Details of plants and landscape from the *Baptism of Christ* (cf. Pl. IV). National Gallery, London.

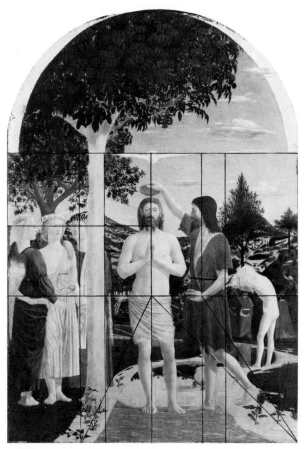

62. Piero della Francesca, *Baptism of Christ*, with indication of halves and thirds (cf. Pl. IV). National Gallery, London.